D1590286

BOOKWOMEN

Print Culture History in Modern America

BOOKWOMEN

Creating an Empire in Children's
Book Publishing, 1919–1939

Jacalyn Eddy

THE UNIVERSITY OF WISCONSIN PRESS

East Baton Rouge Parish Library 2346 7428
Baton Rouge, Louisiana

The University of Wisconsin Press
1930 Monroe Street
Madison, Wisconsin 53711

www.wisc.edu/wisconsinpress/

3 Henrietta Street
London WC2E 8LU, England

Published online by
University of Wisconsin–Madison Libraries
Office of Scholarly Communication and Publishing
http://parallelpress.library.wisc.edu/books/print-culture/bookwomen.shtml

In collaboration with
Center for the History of Print Culture in Modern America
A joint project of the Wisconsin Historical Society and the
University of Wisconsin–Madison
http://slisweb.lis.wisc.edu/~printcul/

Copyright © 2006
The Board of Regents of the University of Wisconsin System
All rights reserved

5 4 3 2 1

Printed in the United States of America

Library of Congress Cataloging-in-Publication Data
Eddy, Jacalyn.
Bookwomen : creating an empire in children's book publishing,
1919–1939 / Jacalyn Eddy.
p. cm.—(Print culture history in modern America)
Includes bibliographical references.
ISBN-13: 978–0-299–21794–5 (pbk. : alk. paper)
ISBN-10: 0–299–21794–9 (pbk. : alk. paper)
1. Children's literature—Publishing—United States—History—
20th century. 2. Women in the book industries and trade—
United States—History—20th century. 3. Children's books—
United States—History—20th century. I. Title. II. Series.
Z480.C48E33 2006
070.5′083′0973—dc22 2005021513

To my father and first history teacher,
Charles Nelson Eddy,
for believing the rose blooms twice,

AND

In memory of my mother,
Nancy Kerns Eddy,
who inspires me, still.

CONTENTS

ACKNOWLEDGMENTS

I owe an immense debt of gratitude to several individuals in connection with this project. In its early stages, I had the good fortune to work with a fine dissertation committee whose active engagement and consistent enthusiasm were vital to its success. In particular, Joan Shelley Rubin and Lynn Gordon offered insights that always challenged me to shift the lens and see more. Support from the Susan B. Anthony Institute for Gender and Women's Studies at the University of Rochester in the form of research funding and a dissertation fellowship was most beneficial and greatly appreciated.

In later stages, this study benefited tremendously from other individuals whose scholarship I deeply respect. I am especially indebted to Wayne Wiegand and James Danky for invaluable perspectives, ongoing encouragement, and outstanding editorial support. Christine Jenkins, Betsy Hearne, and Melanie Kimball read the manuscript, generously offering comments that distinctly enriched my understanding of the subject. I am grateful to each of you.

Special thanks are also owed to David Mitchell, curator pro bono at the Miriam Snow Mathes Historical Children's Literature Collection at the State University of New York at Albany, for his unfailing willingness to share with me his rich understanding of children's literature, and to Shelly Rafferty, a fine bookwoman herself, who offered a listening ear, energetic conversations, and, as always, extraordinary friendship. I am thankful to Donna Webber, archivist at Simmons College, for assistance in locating photographs, and to Lolly Robinson at the *Horn Book* for reprint permission.

Many individuals, by their love and support, have also made this book possible. Jerry Turk, thank you for building the bookshelves. Your confidence in me has been an indispensable component of every achievement. Finally, I am deeply grateful to my four daughters, Heather, Melissa, Rachel, and Sarah. Their relationships, to each other and to the world, remind me continually of the richness and complexity of being female.

Thanks to each of you for everything, spoken and unspoken.

BOOKWOMEN

Introduction

I N A WIDE VARIETY OF retail settings across the nation, children's books are so ubiquitous as to be nearly invisible. Perceived by many adults as an important aspect of child culture, they are taken for granted. Some of these books have proved remarkably durable, continuing over the years to delight thousands—probably millions—of children. The books of E. B. White, Kate Douglas Wiggin, Kenneth Grahame, Laura Ingalls Wilder, J. R. R. Tolkien, Dr. Seuss, and others remain reassuringly constant, having attained the mysterious stature of "classic" that denotes an imprecise combination of a book's age, profit history, and "timelessness."

Less ambiguous than the definition of a classic children's book, however, is the fact that the authors and illustrators who created them were (and are) supported by individuals, with contingent interests in the book publishing enterprise, who help ensure the success of books by producing, promoting, and evaluating them. Historically, such individuals considered themselves "bookmen," denoting a passionate devotion to and substantial knowledge of books. This study considers a group of female bookmen— I call them "bookwomen"—whose persistent and innovative efforts helped to shape the specific economic and cultural niche of the modern children's book industry between 1919 and 1939. The group consists of two librarians, Anne Carroll Moore and Alice Jordan; two editors, Louise Seaman Bechtel and May Massee; and the two founders of the important children's periodical the *Horn Book*, Bertha Mahony and Elinor Whitney Field.

The institutions bookwomen represented were situated in a complex historical moment that is particularly rich for investigation, in part because of widespread contemporary concerns about children. A growing number

of self-identified experts had sustained their agitation on behalf of "good" books for children for several decades in the late nineteenth century. While their efforts had been far from successful, since young people did not discontinue reading serial and pulp fiction in favor of books with more erudite and uplifting themes, the campaign on behalf of children was in full swing by 1919. It was framed by a view of childhood, first, as a distinct time of life with unique social and cultural requirements, and second, as an inherent right in need of protection. These concepts, and the reforms stemming from them, represented one way in which America's more affluent citizens articulated their vision of the world, simultaneously satisfying a culture-wide demand for expertise and specialization in the early twentieth century. Bookwomen were part of the advance guard of the crusade to ensure that children received what they regarded as the best reading material possible, affirmed in their efforts both by personal conviction and by discursive communities within their institutions. So affirmed, bookwomen engaged in a variety of activities that exerted substantial influence over the institutions in which they worked and the book-buying public.

Yet, much more was at stake for bookwomen than the quality of children's books. However important that was to them, they were also interested in building their own careers. This study, therefore, investigates ways in which bookwomen helped to alter permanently not only the infrastructure supporting the production of children's books but also the American workplace for women during the early twentieth century. In some instances, bookwomen achieved professional identity by seeking admission to professions heretofore closed to them; in others, by expanding— or transgressing—boundaries of careers already open to women. In either case, their strategies are significant markers in understanding women's relationships to each other and to society.

The debate over women in the American workplace had stretched from the nineteenth into the twentieth century, but during the period between the two world wars it intensified, kept alive in periodicals prominently featuring articles warning the public about the dangers of women in the workforce. A repertoire of explanations for this existed: working women were more likely to bear unhealthy children, working women might consciously limit their family size, home life would suffer. During the 1920s, middle-class periodicals like *Ladies' Home Journal* and *Harper's* routinely described the social consequences of working, urging women to surrender their career aspirations and return to traditional domestic responsibilities. Themes of imperiled physical health were expanded to suggest that women

who chose work over traditional home life were "unnatural." For married women especially, the message was clear: a woman must choose between a family and a career.[1]

In the midst of this debate, however, women were achieving higher educational levels than ever, and new professional opportunities for them emerged. Editorship, to which a substantial part of this study relates, provides one example. Driven largely by a proliferation of print and specialized knowledge that necessitated area-specific experts, the appearance of the modern editing profession near the end of the nineteenth century signaled an important change in the organizational structure of modern publishing. As a new layer of middle management, editorship opened career opportunities within an industry traditionally noted for its tight, often nepotistic, control over meaningful decision making, and women were hard-pressed to gain access to them. In the case of publishing, it had not been unusual to find women in publishing during the seventeenth and eighteenth centuries, but their presence had become increasingly rare during the nineteenth century. A few women, certainly, attained successful careers in publishing, frequently as a result of kinship ties with the publisher, but the industry did not offer real professional opportunities to most, or even many, qualified women until the 1920s, a decade of particular prosperity for the publishing industry.

Despite such gains, it is nonetheless true that educated women in the 1920s were more likely to marry than in the previous generation, resulting in an overall decline of females in the workforce. Moreover, while women pursued college degrees as never before, education did not necessarily translate into careers outside the narrowly defined boundaries of "women's work." Nearly 40 percent of educated women of the late nineteenth and early twentieth centuries entered teaching, either for long- or short-term employment. Social work was also available, a vocation popular with educated progressive reformers who did not wish to become teachers, along with nursing and librarianship. Thus, women faced a workforce offering severely limited options despite unprecedented levels of education.

Several arguments have evolved to explain women's exodus from the workplace during the 1920s. Primary data drawn from studies about women's career aspirations convinced some mid-twentieth-century historians that the departure was the result of the alleged sexual revolution. Other midcentury historians attributed the diminishing presence of women in the workplace to disillusionment with suffrage and its failure to produce the job satisfaction and sociopolitical changes many women

had anticipated. Disappointed, the narrative went, women reverted to traditional female roles as wives and mothers.

More recently, historians have disputed the theory of disillusionment, insisting that it does not fully explain female professional life during the interwar period. The result of seeking more detailed explanations about who stayed in careers, why, and how they managed to do so has been a valuable literature examining such topics as the relationship of male professional authority and family claims to women's careers, the impact of professional associations and mentoring on career women, and the sometimes precarious balance between the old female ideal of public service and the new ideal of professionalism.[2] This study contributes to that dialogue.

As a corollary, this study also engages the longstanding issue of professional ghettoization. It is clear enough that entering child-centered careers was frequently an evolutionary process rather than one of forethought and decision; women were sometimes channeled into careers they did not necessarily desire. Several bookwomen would have preferred careers unrelated to children but considered them unattainable. Instead, they entered child-related careers either because they lacked the financial means to pursue their primary interests or because they were "guided" into them by the cultural institutions within which they worked. Evidence dealing with bookwomen suggests that, in the late nineteenth and early twentieth centuries, career-minded women were most likely to achieve and maintain professional success when their careers accommodated the prevailing social belief that women possessed special nurturing qualities and an innate knowledge of children. As nurses, teachers, social workers, and librarians, women generally found the comfort of social approval, and the early careers of the bookwomen in this study reflect the effectiveness of this strategy.

To accept the traditional narrative that women were merely forced into unwanted careers, however, simplifies a complex phenomenon. An examination of bookwomen contradicts the notion that child-helping careers necessarily led to a professional "dead end." By organizing their professional lives around children and cooperating with generally accepted beliefs about "women's work," bookwomen were rewarded with relative (and highly coveted) autonomy within their work environments, a crucial precondition for genuine professional authority. Authority, however, also derived from "pioneership," a concept with deep resonance in American culture and not necessarily easy to claim in child-centered careers. That authority rested both in adherence to tradition and in claims to

"firsthood" is highly significant to the story, creating tensions difficult and often impossible to reconcile.

While it seems unlikely that bookwomen could have anticipated the impact of their career strategies on expanded options for future generations of women, their willingness to mentor younger colleagues suggests a level of awareness of their significance to professional women. Recognizing that professional survival was linked to identity creation, bookwomen actively participated in shaping their unique place among child experts rather than passively accepting widespread notions of "women's work" or roles as pawns of ill-defined "market forces." By consistently expanding the boundaries of their careers, becoming active agents in market creation, participating in establishing the standards, credentials, and rewards defining their professions, and promoting new talent in the field, bookwomen simultaneously reinforced the importance of their roles in the literary world. As critics, bookwomen enhanced the visibility of women in literary careers. As authors, they had an impressive publishing record, ranging from fantasy to literary criticism. Five are the authors of what Betsy Hearne and Christine Jenkins have called "sacred texts," the canon of modern children's literature.[3]

The process of creating or augmenting professional identity relied partially upon appropriating traditional material and cultural structures, such as publishing firms, libraries, literary criticism, and book reviewing, and ownership of bookshops and printing presses. Once on the inside of the well-established and well-organized apparatus of book production, bookwomen interacted with it in innovative ways, exercising liberty to move outside existing publishing structures whenever those structures proved inadequate to their purposes. Unlike their female counterparts in what Robyn Muncy has called the political "dominion" of children's work, bookwomen were not constrained by legally mandated lines of authority.[4] The luxury of such fluidity allowed them to reconfigure space, both literally and figuratively, in which to negotiate their authority.

One specific consequence of this fluidity was the establishment of the *Horn Book,* a periodical without precedent in American publishing. Founded in 1924, and ostensibly a "children's magazine," the *Horn Book* became the fulcrum for bookwomen's community of practice and a critical site of affirmation for them at a time when no other such forum existed. As the *Horn Book*'s founding generation, they dedicated the magazine to discussing struggles and celebrating achievements among themselves and among those striving for literary success as children's authors, illustrators,

and editors. As a critical component in the professionalization of book-women at the time under investigation, therefore, the *Horn Book* figures prominently in this study.

In the 1930s, pressure on women to abandon their careers intensified. The impact of the Great Depression on female employment is indisput-able, but additional factors help to explain why some women lost ground in the workplace during this decade. Basing claims to authority on inher-ent female knowledge of children became increasingly precarious through-out the 1920s, relentlessly assaulted by those child experts who preferred scientific certainty to what they considered maternalist platitudes. On the surface, at least, the target of this attack was motherhood, historically linked to instinctual knowledge of children. By extension, however, any woman's claim to special knowledge of children became dubious, includ-ing those in professions related to children. "Natural" knowledge, here-tofore a typical and fundamental element in professional identity among women, was thus compromised, leaving those professionals, including bookwomen, challenged to clarify the basis of their authority. Confronted directly by the growing popularity of, and demand for, professions based on scientific knowledge, bookwomen responded to the issue, in general, by ignoring it, determined to cling to their particular vision of childhood. In the short run, scientific knowledge seemed to prevail; physicians and psychologists, often male, replaced mothers and female reformers as the acknowledged authorities over children, resulting in the apparent loss of women's most traditional source of power. Taking the long view, however, challenges to "natural" knowledge helped to dislodge assumptions about what constituted appropriate careers for women; if women had no partic-ular special knowledge of children, then society had no particular reason to assume that certain careers were "women's work."

Over the years, the bookwomen discussed here have received varying degrees of attention. Biographies of Moore and Mahony, although quite useful, were written by colleagues and therefore bear the marks of personal knowledge and friendship. More recently, scholars have situated some mem-bers of this group within other groups of bookwomen. Margaret Bush, for example, grouped three of the women discussed here with another early librarian, Caroline Hewins.[5] The particular group configuration offered here is unique and intended to enrich rather than contradict other group arrangements. Indeed, many circles existed, typically in overlapping and dynamic relationship to each other, making multiple membership quite likely. But however they are grouped, bookwomen generally inspire many

questions, succinctly captured by Rita Smith in an article entitled "Just Who Are These Women?"[6] Kay Vandergrift and Jane Anne Hannigan also raise questions when they challenge scholars to investigate the nature of bookwomen's professional power and decision making, the criteria for their success, and their relationships to youth and to each other.[7] Such questions have produced a growing body of research designed to restore literary women to the historical record and to understand them with a depth worthy of their contributions.

I undertook this project largely because, while these particular bookwomen have been recognized, their collective story is scattered; they are everywhere, and nowhere. Despite the substantial trail of information they left behind, they remain as much literary folklore as scholarship, in part because of the very trail itself. Personal correspondence among bookwomen, for example, upon which a significant part of this study turns, contains minor discrepancies over dates; friends whose primary purpose was not attention to historical accuracy wrote much of it from memory, making it difficult at times to understand the precise flow of events. This fact, however, should not deter scholars' attempts to assess the significance of bookwoman culture.

Such discrepancies, in fact, are not the only way language presents a problem to the researcher. In 1946, the famous illustrator James Daugherty complained to Bertha Mahony about "the rosy school of criticisms" he detected in the *Horn Book*.[8] The diplomatic but straightforward remark aptly captures a central tension surrounding bookwomen: the class discourse of power and the gender discourse of politeness were often difficult to merge. Subscribing to the culture of their middle-class status also involved performing the role of "woman"; thus, "niceness," "mannerliness," and "civility" set the boundaries of their language and social behavior. They consistently situated the terms of their discussion in an older, romantic tradition, relying on vague and ill-defined language; how does one measure "joy," "beauty," or "happiness"? In the minds of bookwomen, the meaning of such language was self-evident, regularly employed, for example, by preachers or politicians. But beneath the soft metaphor deemed appropriate for their gender lay a not-so-soft meaning circumscribed by class: "beauty" and "joy" were defined by the affluent and educated class.

The irritation scholars sometimes feel about such propriety reveals more about current cultural attitudes than it does about the past. Bookwomen and a good many of their contemporaries, weaned on republicanism, were not as troubled by the notion of elitism as we are today. Just as

individuals were not equally equipped for roles of political leadership, neither were they equally equipped for literary leadership. To be sure, the opinions of ordinary citizens were a factor for consideration, but as the republic was based on enlightened statesmanship, the republic of letters was based on enlightened bookmanship. This attitude was fully consistent with deeply embedded political culture.

Still, Daugherty's frustration over the seeming contradiction between "rosy" and "criticism" raises a question for the historian as well: how seriously are we to take the polite, at times precious, language of bookwomen? Does it constitute meaningful discourse among colleagues in the process of honing professional skills? What are we to make of language that is at once hopelessly vague and forcefully presumptive? When bookwomen spoke of "good" books, interpretation rather than uncritical acceptance becomes the scholar's task: what *were* "good" books to bookwomen? Qualities such as imagination, creativity, or timelessness were praised, but do little to decode the meaning.

Many of the books of which bookwomen approved were part of the Western European—and especially British—literary tradition. Thus, the authors and illustrators held in high regard by bookwomen included individuals such as Rudyard Kipling, Beatrix Potter, Randolph Caldecott, Leslie Brooke, Walter Crane, Kate Greenaway, Arthur Rackham, and Kenneth Grahame. They also esteemed highly works not specifically written for children but considered "classic," including the authors and illustrators of America's first so-called golden age, such as Louisa May Alcott, Joseph Altsheler, Howard Pyle, N. C. Wyeth, Jessie Wilcox Smith, and Kate Douglas Wiggin. Conversely, bookwomen disliked sectarian or sentimental books, or those espousing violent or criminal behavior. They approved of certain kinds of realism but preferred books that avoided controversial themes, such as divorce, alcoholism, child abuse, or poverty. Traditional stories, such as medieval folktales, were encouraged, along with healthy doses of fantasy.

Bookwomen's speech also frequently employed metaphors that, like their imprecise language, carried a naïve presumption of self-evidence. Simple, easily comprehended, and deeply resonant to most readers, the metaphors typically included images of nature (forests, streams), place (gates, bridges), or movement (paths, roads). An example from the *Horn Book* illustrates the point. In 1925, the magazine claimed that the best books written for children were like "broad meadows, and woodlands rich in spruces, hemlock, beech, oak, and birches, with riotous brooks flowing

through, and boulders adding to the interest of the landscape. Or they are like the ocean with its bold waves and windswept sky, and its calm blueness of sunshiny days."[9]

The power of these tropes rested in their simplicity and universality, qualities that eased the tension between the popularization and monopoly of knowledge. As Joanne Brown notes, metaphor "advertises without disclosing, and sells without delivering." Thus, in the very vagueness of the metaphor lay its capacity to encourage approval and diminish difference.[10] Consensus, even if chimerical, was important for professional identity creation, and language was a key element in achieving it.

This palpable consensus exasperated Daugherty and left bookwomen vulnerable to charges of elitism. The group has, in fact, been noted for its homogeneity, a "closed world" that virtually always agreed about what constituted "good" reading and, in fact, constituted a "metaphorical matriarchy."[11] Apparent consensus among bookwomen derived from what Anne Scott MacLeod refers to as an "implicit code of values" among its members.[12] Beneath the surface of vague metaphor, in other words, lay specific criteria for good books understood by all bookwomen.

The values binding the group together stemmed, in part, from similar cultural and class backgrounds. Most of the six bookwomen were native New Englanders, born between 1870 and 1894 and raised in relatively affluent circumstances. They shared similar recollections of childhood literacy and began their professional lives in other fields, primarily teaching. Three of the six married relatively late, and none had children. Although members of the "inner circle" brought to the book field different educational preparations, a powerful insistence on the necessity of "good" books for children provided one remarkably durable link. Thus, the professional titles of the bookwomen in this study—librarian, editor, bookseller— obscure fundamentally similar cultural beliefs about books, reading, and reading markets that undeniably led to intimate and enduring bonds, both personal and professional. Over time, the relationships among them were enriched by their comprehension of those bonds that contributed to an ability to smooth the rough edges of professional territorialism and establish common ground.

Still, even granting similarities of class, upbringing, and cultural values, the existence of a "metaphorical matriarchy" among bookwomen is somewhat astonishing given the traditional antagonisms of their professional fields. Librarians frequently accused publishers and booksellers of succumbing to a naked profit motive; publishers and booksellers accused

librarians of idealistic (and unrealistic) attempts to remain disconnected from market concerns and overbearing self-righteousness in their attitude toward America's publishing industry; even publishers and booksellers, who might be expected to be allies, frequently argued over books.

This study reveals that relationships among bookwomen were more complex than consensus theories have suggested. Polite language notwithstanding, the group represents more than a mutual admiration society and its tensions more than simple personality clashes. Their relationships demonstrate remarkable range, shifting from periods of alliance to episodes of dispute. Bertha Mahony and Alice Jordan, for example, were friends and allies from the start, despite sharp personality differences. On the other hand, the relationship between Anne Carroll Moore and Louise Bechtel remained significantly defined by professional territory, while Mahony and Bechtel gradually developed extensive professional common ground.

In addition to issues arising from the presumed consensus, vagueness, and folkloric features of the bookwomen's language, an understanding of their achievements is further complicated by the traditional narrative of children's book history itself, dominated by a "golden age" conceptual model. In this narrative, the first golden age of children's literature occurred during the latter half of the nineteenth century and the second commenced around the middle of the twentieth. This periodization obscures bookwomen's important contributions to children's literature by relegating them, and the interwar years, to space holding. If, as some insist, a second golden age did occur, it was in no small part the result of the efforts of bookwomen, who established the critical mass of professionals necessary to sustain its momentum.[13]

Despite its limitations, connotations of expansion, colonization, authority, conflict, and cooperation make "empire" a useful trope. In terms of expansion, the study explores the individual careers of the bookwomen, their "guiding hand" in children's book publishing, and their remarkably direct influence on the careers of other bookwomen. The list of editors professionally nurtured by May Massee or Louise Seaman Bechtel is impressive, including Doris Patee, Eunice Blake, Alice Dalgliesh, Margaret Lesser, Dorothy Bryan, Gertrude Blumenthal, and Edith Patterson Meyer. Other editors, such as Marian Fiery, Elizabeth Bevier Hamilton, Margaret McElderry, and Mary Silva Cosgrave, spent their early careers under the supervision of Anne Carroll Moore at the New York Public Library. Still others, like editor Lee Kingman Natti and author Eleanor Estes, recalled the powerful impression left by Bertha Mahony at the Bookshop for Boys and

Girls. Presumably inspired by the success of bookwomen, one editor was, by 1930, bold enough to propose the establishment of a children's department in the publishing firm where she worked.[14]

Nurturing the careers of others, however, did not imply that bookwomen regarded such "outsiders" as equals. They tended to create colonial relationships with the female professionals they nurtured, often by status reinforcement; claiming "pioneership" effectively assigned second-class citizenship to their peers in the children's book industry. More passively, they excluded many talented editors from the "inner circle" by ignoring them. It is fair to say that, while espousing a "reading democracy," bookwomen established hierarchical, though informal, lines of authority among their ranks. Although my discussion of those women marginalized by bookwomen is not extensive, their presence is important, serving as reminders that the six women in this study were by no means the only "bookwomen." The scholarship of Christine Jenkins, Betsy Hearne, Melanie Kimball, and others has made clear that under the strong leadership of other women, such as Frances Jenkins Olcott and Effie Power, children's services in cities like St. Louis, Cleveland, and Pittsburgh were already exemplary by the time the six women under discussion here entered their professional lives.

The study is organized chronologically to demonstrate the expansion of influence and relationships necessary to support the argument for empire building among bookwomen. It is also a useful organizational structure in considering escalating power dynamics among groups of child experts during this period. The first chapter, therefore, situates bookwomen in the broad context of traditional and evolving attitudes about women, children, and reading. Chapters 2, 3, and 4 explore the personal and professional backgrounds of each bookwoman through 1919 and thus are crucial to comprehending later developments. Chapter 5 examines strategies for establishing professional authority, the development of personal friendships, and the relationship of bookwomen to other groups contending for authority over children. Chapter 6 investigates the expansion and consolidation of group identity, the specific influence bookwomen exerted in the publishing industry, and the emergence of the *Horn Book*. Chapter 7 considers bookwomen during the Great Depression, with particular emphasis on the internal discord and external criticism sustained by their community, and their increasingly complex relationship to the marketplace.

By 1939, children's book publishing was recognizably modern, and this change rested, in part, on the creation of a narrative among bookwomen

that began with talking and writing to each other. In this sense, this study is concerned with both a neglected slice of literary life and, more importantly, female friendship. Bookwomen's determined and successful effort to institutionalize the narrative of their relationship to publishing and of their friendships was, at the time, unusual. For this reason, the study's significance does not lie primarily in acclaiming the books they created and advocated, though many of their books have achieved "classic" status. Nor does it rest on exposing elitist cultural beliefs and bizarre personal eccentricities, though these are evident. It lies, ultimately, in the fact that bookwomen, borrowing Carolyn Heilbrun's phrase, "thought of women as 'we.'"[15] That others have recognized this—then and now—is demonstrated by the persistent use of the language of family to depict them. Bookwomen have been called "sisters," "aunts," "matriarchs," "midwives," "foremothers," and "godmothers." It is difficult to say with absolute certainty how bookwomen themselves would respond to these characterizations, but they nonetheless imply a close kinship with the present. This proximity challenges us to restore them to the historical record, not merely as quaint memorabilia or even as exhibits of women's past contributions to national life, but as voices that continue to be worthy of hearing. Beyond language and beliefs that date them to a specific historical moment, the lives of bookwomen contained complicated decisions with sometimes ambiguous outcomes that, in one way or another, remain recognizable today. Their unrelenting concern for youth, in particular, might well continue to resonate in a nation that claims, at least, to value children highly.

Troublesome Womanhood and New Childhood

W HEN ANNE CARROLL MOORE AND ALICE JORDAN began their professional lives as librarians in the late 1890s, they became part of a public library system in the process of modernization. The charter members of the American Library Association (ALA), a small group of gentlemen bibliophiles who had met in 1876 to restructure America's library system, had every reason to envision the revitalized library as one of the nation's premier cultural institutions. A critical technology for many Americans, print represented "social currency" and provided the basis for the library's claim to authority and legitimacy. Other factors, including the heightened popular appeal of democracy, greater access to education, increasing literacy rates, a burgeoning national organizational matrix that altered America's geographically bound communities, and the newly exalted position of expertise in American culture, all contributed to a new and more urgent demand for accessible libraries to offer citizens the opportunity for self-education, self-improvement, and hence, an expanded public sphere. The result of such urgency was increased municipal funding in several cities and the support of benefactors like Andrew Carnegie, further evidence to the charter members of the ALA, including Melvil Dewey, Justin Winsor, and William Frederick Poole, that the library was fortuitously poised for success.[1] Although far from consensus about the particulars of its vision, members of the group shared at least a broad optimism about the potential impact of the modern public library on both individual and collective national life, reflected in ambitious, if contested, goals.

To bolster its prestige and reassure the public of its value, early library leaders developed powerful narratives about the library that tapped directly

into broader national narratives about education, achievement, social mobility and responsibility, and the democratic process itself. Readers, according to the ALA, were more "civilized" and stood a better chance at upward mobility than nonreaders.[2] The "civilizing" influence of the library would be evidenced, went the narrative, by civic-minded Americans actively engaged with a rational political process. Advocates frequently and enthusiastically declared that the library could fulfill democratic ideals, and insisted that reading be viewed as a "vital part of civic life."[3] The modern library, boasted the *Library Journal*, had expanded, creating a "reading democracy" and providing a crucial foundation for citizenship. "We want citizens," one contributor to the *Journal* remarked, "and the public school and the public library are the places where citizens are made."[4]

Although certainly not new, the belief that citizenship rested on education was critical in emerging library narratives. Despite steadily increasing enrollment in secondary schools after 1890, only about 11 percent of America's youth attended high school in 1900.[5] This made the mission of the library all the more important, asserted leaders, since the library provided educational opportunities still unavailable to the majority of America's children in formal school settings. Thus, the library was billed as the capstone of the educational system and librarians frequently encouraged citizens to patronize the library in order to engage in lifelong learning. In addition to developing educated, patriotic citizens, the library promised to be "a destroyer of class distinctions, sectional antagonisms, and international ill will."[6]

But libraries were, as Abigail Van Slyck notes, "much more than they seem from the sidewalk."[7] The pace of social change in late nineteenth-century America produced tensions militating against the easy fulfillment of such cherished goals. In the context of the nation's radically altered economic and class structures as well as its rapidly shifting cultural composition, many traditional attitudes, including those related to women, children, and education, were in a state of renegotiation. Beneath the gleaming surface of its public claims, therefore, the library struggled with darker issues that threatened to compromise the realization of its purpose. The library's voluntary nature, amateurism, and a mounting challenge to the traditional texts that it protected all complicated the library's ability to collect and consolidate authority.[8] Overcoming these obstacles was a strenuous process, producing long-lasting tensions within the institution; lengthy, ongoing debates proved that generating abstract and high-flown rhetoric was easier than creating measurable goals.

One immediate issue facing library visionaries in terms of authority was the development of professional culture, a process that necessarily included defining the term "librarian." The term implied a certain level of education, but how much and what kind was open to debate. It is true that the ALA gradually expanded its emphasis on education as one part of an overall plan to create professional culture for librarianship. Such education suggested the development of a specific knowledge base and clearly defined standards.[9] As early as 1902, for example, the New York State Library School, then located in Albany, was placed on a graduate footing, requiring all applicants to have completed a course of study at colleges registered by the University of the State of New York. But some libraries did not enjoy ready access to individuals who had graduated from such library schools and continued to employ librarians with no such advanced education. So, while "librarian" increasingly implied formal education, the early definition of the term was much more likely to reflect qualities such as "character." However problematic this term may seem today for its subjectivity, it cannot be viewed as mere professional window dressing in the late nineteenth century. Character was intimately linked to education since educated women, often from "good" families, were assumed to possess it. But because character connoted the *potential* for improvement, it was also an important signifier for librarians who lacked formal education. With or without formal education, "character" was considered a solid indicator of one's suitability for librarianship.[10]

Intersecting with the process of professionalization was another important issue and one gaining significant ground in America during the last half of the nineteenth century: efficiency. This notion, and the excitement it generated, carried powerful implications for library discourse about the type and amount of education librarians needed. Of those present at the 1876 meeting, Melvil Dewey, an energetic force in the early library movement, most spiritedly supported a vision of an efficiency-driven library.[11] Traditionalists were less convinced by what seemed reductionist thinking on Dewey's part. Efficiency mattered, of course; simple proliferation of print demanded it. Still, some library leaders resisted seeing the library succumb to practical questions. Efficiency could be taken too far, they warned, causing the library to look more like a factory than a place of learning and culture. If the library became *too* practical, in other words, it ran the risk of losing respect in the eyes of patrons. On the other hand, the rapidly growing number of libraries required a ready supply of librarians. The broad and frequently advanced education for which their antebellum counterparts were noted was now unrealistic and, some thought, unnecessary.

In an efficiency-minded institution responsible for more and more books, the only realistic goal was training to monitor books, not understand them. In that case, adequate training for librarians would feasibly consist of a high school education supplemented by brief technical preparation. This view fostered the development of a profession wherein expertise and authority were not equivalent: librarians became experts in information brokering without retaining authority over the information itself.[12]

The modern definition of "librarian" was thus a response to both new, pressing social attitudes and practical necessity, not only because of the efficiency issue but also as a result of changing attitudes concerning the role of women in American society. The ALA's discourse over cultural property, in fact, prominently engaged gender. Gender jurisdiction, particularly in middle-class culture, was frequently divided into "spheres," where private was associated with female, and public with male. Broadly accepted during the nineteenth century, separate spheres ideology limited women's access to formal political life and helped to determine the boundaries of their public engagement.[13]

On closer inspection, however, the trope's ostensible simplicity obscured a highly complicated dynamic: gender was less an actual circumstance than metaphoric negotiation. Far from being confined to their homes in any literal sense, nineteenth-century American women participated substantively in the nation's organizational life. Moreover, an increasing number of females, with ambitions that extended beyond those dictated by tradition, entered professions. In exchange for higher education and careers, some were willing to forgo marriage and/or children. Yet, excluded from positions of political and professional power, women were generally allowed into those professions frequently associated with children, such as teaching and social work. Thus, women with outstanding credentials and high energy entered such professions precisely as the meaning of childhood was under significant reconsideration.[14] By entering the workplace, women expanded the site of gender negotiation, but this process by no means led to the abandonment of notions about what constituted women's proper work. Commonly receiving multiple and contradictory messages about their appropriate role in American culture, women were expected to be both "submissive helpmates" and "pillars of strength," repositories of cultural, but not intellectual, authority.[15]

"Separate spheres" reflected more than a gender norm, however, because of its reference to the concept of space. The distinction between public and private space existed before, but grew sharper during the nineteenth

century. Space mattered, both literally and symbolically representing power and success in a complex world. Increasingly associated with distinct function, space was consistent with the modern sentiment that specialization confirmed progress.[16]

Space and specialization achieved this level of importance, in part, from nagging anxieties about modern life, including a perceived loss of moral and intellectual fortitude. As old belief systems threatened to disintegrate in the context of rapid change, many worried that authentic experience had been the cost of modern conveniences.[17] Because such anxieties coincided with women's heightened visibility in the public sphere, gender became a convenient code for expressing them, resulting in allegations of cultural feminization. Further heightening fears of feminization by the early twentieth century, the new field of psychology offered a therapeutic orientation that advocated introspection—privatized space—as its primary vehicle. Excessive self-scrutiny, however, was viewed as obsessive and morbid, resulting in psychic conditions such as neurasthenia, sometimes regarded as the prime characteristic of the modern age and often associated with "female."[18]

Fear of feminization made institutions like the library sensitive to their public image, which was frequently situated in gendered terms. The library's insistence on connecting itself with preparation for political responsibility—from which women generally remained formally disconnected—constituted a de facto claim about the nature of the library: some of its most fundamental characteristics would be "male." If, as many librarians envisioned, the library represented serious intellectual pursuit, it needed to reflect "male" values. If, on the other hand, the library offered leadership in cultural matters, the library should exhibit "female" traits. For many librarians, some combination of the two was ideal; that is, the library could and should evidence institutional characteristics associated with "maleness" and others associated with female identity.

Ironically, library leaders sought to establish an institution that upheld and reinforced traditional gender attitudes precisely as librarianship was rapidly feminizing. Indeed, only two years after the ALA was founded, two-thirds of the nation's librarians were women, although solid reasons certainly existed for allowing women into the field.[19] Chronic labor shortages and modest library funding made it difficult to refuse female applicants who would work for less than men in the growing number of public libraries. Then too, women seemed well suited to the mundane, task-oriented operational details that promoted efficiency. Of equal or greater importance, however, was the widespread belief in the moral superiority of

women, an invaluable asset to an institution whose self-determined mission was tied to supervising the integrity of the public's reading taste.[20] The editor Montrose Moses, for example, compared the library to a "temple of treasures," wherein the librarian functioned as the "high priestess."[21]

Female influence in public institutions was simultaneously embraced and resisted, resulting in a complex moment in women's professionalization. The astounding pace of feminization in librarianship suggests that women were granted admittance to the profession unchallenged.[22] But moral influence and smaller paychecks, while desirable, were insufficient to induce library leaders to embrace women unreservedly. By advertising the library as civic-minded space, leaders emphasized its "male" qualities. Yet, most admitted that women made appropriate guardians of the public's reading selections because "culture" was part of their proper domain. The hesitation about the potentially excessive influence of "female" traits in public spaces thus sat uncomfortably adjacent to positive attitudes about feminine morality.

The protracted debate over fiction throughout the last half of the nineteenth century provides a powerful illustration of the library's institution-specific response to concerns over feminization. The growing presence of fiction on library shelves concerned library leaders, who feared it would dilute the connection between the library and citizenship by luring patrons to read books merely for recreation rather than civic duty or self-education. Typically, fiction and female were conflated, not only because of the preponderance of women novelists but also because the genre was associated with hypothetically female traits of emotionalism and sensationalism. As one library commissioner in Indiana complained, "Women are more emotional, certainly more sentimental, than men . . . We naturally expect women to read more . . . fiction."[23]

The fiction question was deeply rooted, extending back to Puritan beliefs about recreation and books that were not "true" since truthful books were considered especially important for children. Opinions as to exactly when children reached an age of spiritual accountability differed, but all agreed it occurred early. The content of children's reading material—and the themes of much adult material, for that matter—reflected that belief, resulting in a scarcity of fiction in colonial America.[24] During the late eighteenth century, "sturdy republicanism" depended heavily on education, giving nonfiction fresh importance by its use in preparing children for the grave responsibilities of citizenship.[25] But by the early years of the nineteenth century, fiction became more popular and, to the distress of some, more

available. Major authors, such as Jacob Abbott, Samuel Goodrich, Lydia Maria Child, and Catharine Sedgwick, used the genre to create didactic and sentimental stories focused less on the child's spiritual status in the event of untimely death, and more on appropriate behavior in American society.[26] Whether or not the author of sentimental fiction was a woman, the nature of the genre was, to many, "female."

By the time the modern library movement was underway, Americans nonetheless demanded fiction to an unsettling degree. By 1880, fiction was the leading category of books published and consumed in America, a lead it maintained until 1909. To the consternation of *Publishers Weekly*, Americans preferred fiction rather than books of "solid character."[27] To some, this preference suggested an emasculated reading public suffering from a loss of independence,[28] exemplifying the weakening of American culture through feminine influence. To make matters worse, women librarians began compiling lists of recommended books in 1882, powerful tools for setting literary standards and further evidence of female control.[29] Furthermore, the presumed "nurturing" qualities of women librarians might signal the public that the library was "female" space. Library leaders were not anxious to foster a "homelike" image, since it would diminish the library as "strong" space.

The library devised several methods for discouraging the public's taste for fiction, and subsequently, female influence. One was to limit the amount of fiction that a library patron could borrow. In 1915, for example, only one of the four books allowed to be charged at the New York Public Library at a time could be fiction.[30] Another method was to segregate "cheap" and sensational books from other reading material. At Boston Public Library, such books were kept together in what was known among employees as "The Inferno." But when one employee, upset about what he considered immoral books, launched a one-man crusade against the library, the administrative response revealed that not all fiction was considered bad. The library, administrators said, "is not a goody-goody Sunday school library . . . kept up for the benefit of the Puritan New Englander . . . [but] also intended to meet the requirements of the Roman Catholic Irishman, the atheistic German, the radical Frenchman, all of whom are citizens of Boston, paying their taxes . . . and therefore equally entitled to be considered in the selection of books."[31] Yet, while not all fiction was considered bad, and library boards did not always become embroiled in moralistic campaigns to censor fiction, tolerance frequently represented the hope that fiction would be a stepping-stone to "improved" reading selections.

Changing attitudes about women also paralleled the tensions marking changing attitudes about children. In colonial America, as in Europe, children were tied both to the practical necessities of the household economy and to the spiritual piety of their elders. Beginning in the eighteenth century, and especially by the nineteenth, childhood took on a more modern look as children increasingly became "economically useless but emotionally priceless."[32] The more affluent, especially, whose children were no longer an ingredient for economic survival, could afford the luxury of reconsidering their perceptions about the natures of children and the purpose of childhood. The severe childhood lessons preferred by an earlier generation softened, as adults increasingly believed that children represented innocence to be protected rather than corruption to be eradicated. Responding to this change, adults adopted child-rearing strategies reflecting new appreciation for such qualities as imagination and creativity.

Children were special people, the new narrative went, and needed special space. Moreover, children were a community concern that extended beyond parents alone; adults, as Ronald Cohen notes, "worried about children—everyone's children, not just their own."[33] Given the grand importance of the outcome of child raising, therefore, an infrastructure of cultural institutions, including libraries, evolved to lend a watchful eye over children. One consequence of this "gaze" was that authority over children now resided with adults, including librarians, outside the family. Another was that, by the 1890s, children represented a distinct cultural entity. Taking their place alongside the nation's other demarcated groups, whether economic, ethnic, or otherwise, children were increasingly segregated from adults in literal as well as figurative ways.[34] Library leaders, affected by this important attitude shift toward children, debated the advantages of segregating children from adults in the library and, by the 1890s, several libraries had dedicated space in their facilities to children's use.

The drift toward age segregation, however, represented only one aspect of changing notions of childhood. Children not only occupied special space but also required special study.[35] Since the 1870s, various organizations had emerged to study children, but by the 1890s that movement gained significant momentum, creating a climate of preoccupation with children. In 1890, parents established what became the largest of such organizations: the Child Study Association of America (CSAA); four years later, the National Education Association (NEA) created a Department of Child Study. By the end of the decade, twenty or more states had established similar organizations.[36]

The informal but undisputed head of the child study movement during its early years was the social scientist Granville Stanley Hall, who urged adults to recognize and respect "natural" stages of child development. Children, he insisted, should be allowed spontaneous self-expression.[37] Adults should therefore resist the temptation to impose uniformity on educational requirements and goals. Through his lectures to diverse audiences, including schoolteachers, Hall's "scientific" pedagogy became enormously popular. His views, however, as they related to education, rested more on the intellectual tradition of romanticism than on either older precepts of intellectual development or science. Child study organizations, in fact, were suspected by some, including John Dewey, of promoting little more than sentimentality about children under the guise of science. Dewey was particularly disturbed that child study had divorced itself from psychology, which might have at least provided the movement with a theoretical basis.[38]

However devoted they might have been to developmental theory, Hall's followers did not speak for everyone interested in children. Many more were persuaded by the thought of individuals like Lester Frank Ward than by Hall. To Ward, children were more than interesting objects of study; they were the means to a just society. By more evenly distributing its resources, they claimed, society could ameliorate social ills. In contrast to Hall's "live and let live" philosophy about children's natural exuberance and curiosity, Ward regarded children's education as the master key to social progress.

In any case, adults interested in children typically identified several "problems" among troublesome youth, including feeblemindedness, stubbornness, strong wills, and emotional disturbance. Frequently, the children most likely to illustrate these traits were poor immigrants in urban settings. Scientific experts like neurologists and physicians in charge of asylums validated these findings and warned of the long term danger of such traits: poor and unreformed habits in children resulted in mentally ill adults. Taking such warnings seriously, adults turned their attention to "saving" children from their "problems."

According to child-savers, the problem was not so much children as the system in which they lived; change the system, they believed, and the child would be reformed. Their solution thus frequently took the form of legislation designed to improve the economic conditions of families, including child labor, compulsory education, and mothers' pensions. Since the system, rather than children, was at the root of the problem, child-savers viewed "problem" children with the same sentimentalism with which they viewed

middle-class children.[39] Reformers argued for a sheltered childhood for *all* children, although they viewed children hierarchically according to class and ethnicity.[40] Considering themselves "doctors to a sick society,"[41] they agitated for broad social changes that, they believed, would ameliorate the living conditions of children. By 1919, they achieved several of their goals, including more or less universal education, a reduction in infant mortality rates, improved health care, and a decrease in the exploitation of child labor.[42] The White House Conference on Dependent Children in 1909 was a milestone in such reform efforts, establishing a clear link between children and rights. The conference resulted, three years later, in one of the child-savers' greatest achievements: the U.S. Children's Bureau.

For children refusing more benevolent forms of child saving, however, a reforming institution of a legal nature was instituted. Consistent with new middle-class attitudes about the value of segregating children from adults, the United States established a federal court system in 1899, specifically designed to deal with juvenile offenders.[43] But the juvenile court failed to produce the reduction in delinquency for which its founders, including Julia Lathrop, first chief of the Children's Bureau, had hoped. Turning to science for help, progressives hoped to solve the most difficult child cases.

The "scientific" approach to children's problems was not altogether new in the early years of the twentieth century when reformers became disappointed with the juvenile court system and, at the outset, science and social reform mingled well. When, for example, in 1909, a committee was formed to study juvenile delinquency, Lathrop—representing "old" forms of child-saving—sat side by side with psychiatrist Adolf Meyer—representing "scientific" forms of child-saving—to create the National Committee for Mental Hygiene (NCMH), determined to promote mental health rather than cure mental illness. Such cooperation was possible because the overlap between scientifically minded and child-oriented individuals was substantial. Individuals intimately associated with progressive reform hailed scientific child study as an important breakthrough. Jane Addams regarded it as a "tool for social betterment" by getting "at the root" of why children "go wrong"; the Harvard philosopher William James supported a scientific approach to children as well. Indeed, much of the funding for child guidance came from progressive philanthropies such as the Commonwealth Fund and the Laura Spelman Rockefeller Foundation.

As a result of the shift toward a scientific model of child helping, Ethel Sturges Dummer, a progressive philanthropist, both inspired and financed the Juvenile Psychopathic Institute (JPI) in 1909. The JPI was intended to

serve as an expert body upon which the courts could rely for medical and psychological evaluations, especially in cases involving recidivism. Until a second clinic was established in Boston in 1917, the Chicago-based JPI was the nation's center for psychiatric research. Its director was William Healy, a student of William James at Harvard and a graduate of the Rush School of Medicine in Chicago. Healy's child research became the basis of new and improved methods of combating juvenile delinquency. Together with Augusta Bronner, the clinic's first psychologist, Healy quickly bolstered the prominence of the JPI by writing and by speaking to national conferences.

Eventually, however, the relationship between the psychologically oriented study of children carried on at the JPI and the broad, legislatively oriented agenda of social reformers grew uneasy; their views about the causes and solutions of delinquency were fundamentally contradictory and defied reconciliation. In the view of Healy and others, interventions directed at improving living conditions addressed the symptom but not the root of the problem, which lay in psychological distress exhibited as maladjustment and emotional complexes of various kinds. Unlike pediatricians ("pediatrists") who agreed with reformers that economic deprivation tended to cause problems with children, Healy was persuaded, in fact, that the overindulgence of affluent families toward their children produced "bookish" children who, unaccustomed to physical labor, became vulnerable to hysteria. Children with such problems, Healy claimed, would have a difficult time assuming prescribed social roles later in life.[44]

Two books, published within three years of each other, illustrate the difference of opinion between old and new child-savers. Their conclusions are all the more interesting because they were drawn from observations of delinquents in the same city. In 1912, Edith Abbott and Sophonisba P. Breckinridge published a study of Chicago delinquents, entitled *The Delinquent Child and the Home*. In typical progressive fashion, the book explained its findings in environmental terms, citing poverty, poor parenting and family relationships, substandard education, and lack of healthy recreation as the causes of delinquency.

Three years later, Healy published *The Individual Delinquent*. He acknowledged the importance of environmentalism so central to progressive reform, but emphasized the individuality of the child, insisting that the "emotional content of the child's mind" would ultimately subvert the broad legislative reforms that child-savers typically advanced. In addition to rejecting reformers' theories that delinquency stemmed from broad social causes, he also rejected theories of biological determinism. Going beyond

child study's developmentally based search for the "normal" child, Healy wanted not only to observe personality but also to change it.[45] Indeed, he questioned whether "normal" and "abnormal" were useful terms in considering delinquency.

To get at the "content" of a child's mind, Healy used the psychiatric interview. This treatment modality, Healy believed, would unearth deeply buried emotions that offered explanations for delinquent behavior. Each child had a unique "story"; by exposing it, behavior would change, and juvenile delinquency could be prevented. This approach was agreeable to the court both because it was "scientific" and because it avoided institutionalizing children, either in jails or asylums.[46]

Thus, by the early twentieth century, psychiatry not only began paying more attention to children but also shifted its focus from institutional to outpatient care, from curative to preventive treatment modalities. These changes were particularly critical as the search for workable solutions to juvenile delinquency proceeded. Equally significant, ties to the juvenile court system enhanced the position of the relatively small group of psychiatrists who focused their attention on children, positioning them as serious contenders for authority over children. To a concerned public, the therapeutic view of children carried appeal; science now seemed more impressive than traditional folk wisdom.

The influence of the child study movement, psychology, and legal-political forms of child-saving on the library was informal but unmistakable, and activities in the library both were affected by and validated the child study movement. Children's rooms, especially, reflected clearly the impact of new theories about children and, at the same time, advanced those theories by giving them tangible expression. A librarian in Tacoma praised the "new" library for eliminating the "old-fashioned idea of the child . . . that he should be seen and not heard. His existence as an individual was not recognized; his natural desires were ignored; the necessity for right training in youth was yet to be appreciated. While this idea of childhood was in vogue, there was a similar old-fashioned conception of the library . . . But such a narrow conception of things could not continue . . . Nations began to wake up to the fact that for their future strength the right training of youth was a vital necessity. Very soon this forced educators to consider . . . the psychology of childhood."[47] Library programs for children modeled child study's most fundamental belief—the "natural" expression of children—by fostering imagination and encouraging curiosity in children's rooms. Yet, believing that children were important keys to a more

just society, librarians also set limits, by creating expectations that presumably led to responsible adulthood. As education became increasingly regarded as a means to "saving" children from crime or insanity, librarians felt confident that their role in child-helping was crucial.

Concern over children was also evident in the popular press. Advertising campaigns advised parents that books were an indispensable part of the well-maintained, closely scrutinized, lovingly nourished, and well-educated child's life.[48] Such advice fit well with the library's dual image as educator/cultural supervisor. With this advice, parents looked to public libraries for help and the ALA felt qualified to offer it. By formalizing its work with children in 1900, the organization revealed its belief that children were part of its repertoire of expertise and anticipated that parents would turn confidently to libraries, such as those in Boston and New York, for expert advice about their children's reading.

The Boston Public Library (BPL) was the older of the two. By the time the ALA was created, the Boston Public Library was already more than twenty years old, and one of about seven hundred public libraries nationwide. Its original structure on Boylston Street, opened in 1858 at a cost to the city of $364,000, was established in response to public demand and through the efforts of benefactors like George Ticknor and Edward Everett.[49] With an annual circulation of 179,000 volumes, the library initially required the services of twenty-two employees: the superintendent, chief librarian, eleven male and eight female attendants, and a janitor.[50] Patronage increased steadily and reports to the examining committee made the need for improvements clear, particularly in the area of children's services. Administrators were informed that children were frequently standing outside the library in cold weather, waiting for space inside to become available. There were routinely twice as many children as space allowed, and even inside, half remained standing because there were not enough chairs.[51]

Such observations made BPL leaders acutely mindful of children's reading needs, and in the 1870s, well in advance of other libraries, BPL bolstered its commitment to children and reading. Although children had to be ten years old to borrow books, the examining committee's report in 1895 declared that the children's room should be "the most important place in the city for the training of those readers without whom the Library is a mere ornament . . . instead of the nursery of good citizenship which it was meant to be."[52] Based on this commitment, the library purchased three thousand volumes and doubled the size of the space designated for children within three years.[53] By 1900, Boston's services for children were significant

enough to require a full-time director, and Alice Jordan was appointed to the position.

Like Boston, libraries in New York were also undergoing dramatic changes. When its new facility officially opened on May 23, 1911, the New York Public Library (NYPL) represented nothing short of a temple of American Progressive idealism. Sixteen years in the making, the impressive neoclassical building became home to a not-so-new library in the process of carving out a place for itself in American culture, merging its traditional function as a depository of knowledge with its new goal of knowledge dissemination. Located on New York's Fifth Avenue, the marble structure was described as a "temple to the tutelary goddess of Democracy, Popular Education."[54]

Considering the size of New York City, NYPL developed relatively late, possibly because of the heterogeneity of the city's population and relative lack of a middle class, from which the impulse for a strong library often sprang. Until their consolidation in 1895, New York's libraries ranged from the ostentatious and scholarly Astor and Lenox reference libraries to small, audience-specific circulating libraries scattered throughout the city. The need for a consolidated and organized library was discussed frequently in the press for nearly twenty years before it actually occurred, the Astor and Lenox being routinely lampooned for their sometimes less-than-friendly treatment of visiting scholars and inaccessibility to the general public. In addition to the fact that the library system, lacking even a pretense of unity, seemed unwieldy and outdated, periodicals like *Scribner's* and the *Nation* had complained since the 1880s that poor ventilation and lighting were "scandalous" and "humiliating."[55] These facts prompted the general public to view libraries as both physically remote and philosophically irrelevant at a time when the idea of physically and ideologically accessible institutions was gaining strength.

Once consolidated, NYPL's board generally consisted, unsurprisingly, of aged men of Anglo-Saxon descent and ample means. Such a board hardly represented the cultural composition of the city; by 1910, the population was 41 percent foreign born. But unlike libraries in other cities, NYPL was entitled to municipal funds only on a discretionary basis, forcing it to beg for support and to prove its worth. In such a fiscally dependent position, politically connected board members were crucial to NYPL's survival.

The process of consolidation segmented NYPL into reference and circulation departments, the result of marrying the Astor and Lenox holdings with common circulating libraries. John Shaw Billings, the library's chief

executive, retained supervision of reference material, while Arthur Elmore Bostwick was made chief of circulation. Bostwick, a nervous, talkative man, was open to innovation at NYPL, since he viewed the library as an active agent of popular education, but struggled with the unenviable task of bringing the hodgepodge of libraries scattered throughout New York in fraternals, YMCAs, settlement houses, and workingmen's reading rooms under NYPL's direction. Reporting directly to Billings, his overall task— and a large one—was to coordinate, integrate, and supervise all the branch libraries that fell to NYPL as a result of the consolidation.[56]

Bostwick's work proceeded slowly because, despite the fact that he was committed to efficiency, NYPL had no reputation for it. Frederick C. Hicks, president of the New York Library Club, for example, complained to R. R. Bowker that New York's librarians lacked efficiency because "most of them have not made a direct application of the principles of scientific management and of individual efficiency to the activities in their own libraries." Hicks added that he had "asked the Efficiency Society to speak to [librarians] on the general principles of the movement."[57] Whatever Hicks may have imagined, however, creating an efficient library was not a simple matter of sending guest speakers to NYPL to teach the principles of scientific management. New York's librarians, accustomed to autonomy in their branches, did not always view centralized supervision in a positive light. Thus, Bostwick received external pressure to create efficiency and internal resistance to the implications of doing so. But one key to achieving efficiency, he felt certain, lay in creating an expert staff.

To make his point clear and to remedy the situation, Bostwick created two groups of experts in 1903. First, he organized a group of outside consultants, including Franklin Giddings (sociology), John Dewey (philosophy), and Frank Damrosch (music) to offer the public the highest possible quality of information available on any given subject.[58] Second, he created a board of library specialists, including supervisors of various NYPL departments, to advise him on internal matters. Significantly, Bostwick was able to draw certain kinds of expertise from within the library, but actual content knowledge came from outsiders who, by association, lent their authority to the library. He intended to give a degree of autonomy to his internal board of experts, but they would remain accountable to him.[59] Among those departments was one specifically devoted to children. Its first head would be Anne Carroll Moore.

Protecting Books

*Anne Carroll Moore, Alice Jordan,
and the Public Library*

IN 1919, FREDERIC MELCHER, editor of *Publishers Weekly,* and Franklin
K. Mathiews, chief librarian of the Boy Scouts of America, hit upon
the idea of a Children's Book Week to encourage juvenile reading. The
two men had strong feelings about the subject; Mathiews, in particular, had
waged a series of bitter battles against Edward Stratemeyer, author and edi-
tor of books Mathiews considered morally unfit for America's youth. Five
years earlier, an article he wrote for the *Outlook* castigating Stratemeyer's
use of such unsavory topics as murder and arson in books for juveniles had
caused a distinct though temporary decline in Stratemeyer's sales.[1] Now,
continuing his campaign in the cause of improved books for children,
Mathiews joined Melcher to promote Book Week, an annual event designed
to emphasize better reading choices than those offered by Stratemeyer
and his ilk. The two men had more than one reason for viewing the public
libraries in New York and Boston as ideal locations to inaugurate their
plan. Not least, Melcher and Mathiews realized that in selecting those pub-
lic libraries for Children's Book Week activities, they were, by extension,
inviting Anne Carroll Moore and Alice Jordan, the supervisors of children's
work in those libraries, to host the event.

Anne Carroll Moore has been variously described as a shepherdess, the
godmother of fairy books, a pioneer, a world citizen, a commander in chief,
and a comrade in arms.[2] Carl Sandburg called her "an occurrence, a phe-
nomenon, an apparition not often risen and seen among the marching
mannikins [*sic*]of human procession."[3] Most often, she was known simply
as "my dear Miss Moore." Some of her correspondents belonged to a who's
who of American letters and progressive reform; others—branch librarians

in their first professional jobs, young patrons of the library, grateful parents—were known only to her. Moore was already forty-eight years old and a veteran librarian and literary critic when Melcher and Mathiews invited her to host Book Week.

Well aware of Moore's reputation as the nation's foremost authority on children's books, both as a librarian and as a children's book critic, Melcher and Mathiews regarded her as an ally who agreed with their dual goals: more and better books for children, and more and better children's authors.[4] The planners of New York's recently opened public library had generously designated well over three thousand square feet, albeit in the basement, for children and their books. This design reflected a growing need: NYPL circulated over two and a half million books a year through the children's room in its first year of operation.[5] Its two large rectangular rooms, separated by an arched alcove, with polished wood walls, and windows set deeply to allow children sitting room, had earned the Children's Reading Room a reputation as "the showplace of the city." Moreover, since the conclusion of the First World War, NYPL had become the acknowledged center for municipal entertaining. Outdoor ceremonies for visiting international dignitaries routinely took place on the grand steps leading up to the library.

Individuals concerned with children's books often visited Moore's office at NYPL—the famous room 105—to consult her or to attend one of her well-known and frequent celebrations in the children's room. Frances Clarke Sayers, Moore's successor at NYPL and her biographer, acknowledged that library trustees, architects, editors, artists, and representatives of foreign countries came "to check all points of the compass" with Moore. Her dedication to multiple uses of the Children's Room encouraged individuals both in and out of the library movement to view NYPL as a professional meeting place. Consequently, the room was regarded as the accepted "hatching ground" for new concepts in children's books, and became associated with an interprofessional collegiality that, Sayers remarked, "created an outward flow of shaping waters that edged on beaches far beyond the margins of the library."[6]

Moore was born in Limerick, Maine, on July 12, 1871, and nicknamed Shrimp by her seven older brothers. Her first reading experience was with the Gospel of St. John, and throughout her life she insisted that while she loved books, she had never been bookish. She was particularly close to her father, a lawyer and president of the Maine state senate in the 1850s, whom she described as "a boy at heart." He encouraged independence in his

daughter, and from him Moore developed the strong notion of childhood that shaped her professional endeavors. She hoped, in fact, to read law with her father, although she realized full well that "women lawyers were far and few" at that time. She recalled particularly how moved she was by cases involving children affected by divorce, homelessness, or abuse. She also considered her father to possess "qualities of pioneering," primarily because he purchased a large tract of woodland and swamp considered a "wasteland."[7] Watching him convert the worthless property into usable land inspired Moore, creating lifelong passions both for nature and for progress. After the death of her parents when she was nineteen, Moore attended the library school at Pratt Institute in New York, then under the direction of Mary Wright Plummer, an early leader in the library movement. Moore went to Pratt initially not to study children and their books but to pursue her interest in research and reference work, hoping that library work would offer a "quaint, congenial life."[8]

Boston, one of the nation's oldest literary cities, was also a good choice for Book Week activities. In advance of most American municipalities, Boston had consistently demonstrated its commitment to reading by providing generous financial support for its public library. As a result, BPL had been, until recently, second only to the Library of Congress in the number of volumes it owned. The prominence of the library derived not only from its size, however, but also from the crucial leadership it had provided to the national library movement. Alice Mabel Jordan, as supervisor of children's work at BPL, was, like Moore, considered by many to be an expert in children's books. For that reason, she was routinely consulted, both in her official capacity at BPL and as the founder of the New England Round Table of Children's Librarians (NERTCL), which she had established some years earlier.

Jordan was born in Thomaston, Maine, on November 7, 1870, at a large colonial home in the center of the seventeenth-century shipbuilding town. The Jordans were powerfully linked to Thomaston through their family's own connection to the sea; three generations of Jordan men had been sea captains, including Joshua, Jordan's father. The presence of maps and charts in the home, as well as her father's tales of the sea, familiarized the child with geography at an early age; indeed, her two older siblings, Edwin and Mary, were born on their father's ship, *Pride of Port*. He loved children and frequently sang and chanted stories and fairy tales to them "with great gusto and drama."[9] Her mother instructed her four children—James was the youngest—about literature and art, reading "quantities of poetry" from

Longfellow and Whittier. Likewise, several English and American children's magazines, including the *Peep-Show, St. Nicholas,* and the *Nursery,* were available in the Jordan home.[10]

When her father retired from the sea and moved the family to Newton, Massachusetts, Jordan was ten years old. Her parents enrolled her in school and she later graduated from Newton High School. After graduation, she taught at the Carroll School, a private school in West Newton. She became interested in library work as a result of her association with Margaret McGuffey, an employee at the Boston Public Library and daughter of the creator of the famous McGuffey's readers.[11]

As young, professionally trained women, Moore and Jordan were quickly drawn to national library politics, caught up in the crucial decisions facing their profession at the beginning of the twentieth century. As noted, early library politics reflected attitudes about women and children that were in a state of renegotiation, the result of which was an ambiguous mixture of traditional and new attitudes, strikingly evident in annual ALA conventions. By the 1890s, a cadre of outspoken women librarians within the organization, including Moore and Jordan, converged around the issue of library services for children. In addition to Plummer, whom Moore credited with being the first librarian to offer children's work departmental status, Moore and Jordan admired Clara Whitehill Hunt of the Brooklyn Library, Frances Olcott of Cleveland, and especially Caroline Hewins, librarian at Hartford, Connecticut, and legendary for her work on behalf of children's books.[12] These women constituted part of a professional nucleus that helped to develop the "library faith," a subcategory of the progressive "gospel" of social welfare. Articles of the faith among its members included beliefs in the resilience of children, the "near-sacred communion between reader and text," the uniqueness of each child, children's services as comprising an "egalitarian republic of readers," the power of literature to enhance the intellectual and moral capacity of individuals (and establish improved relations among them), and the "friendly and unsentimental older sister's attitude toward children." These tenets laid the groundwork for "the religion of children's librarianship" and represented "the collective wisdom of the profession."[13]

This nucleus of women professionals persistently urged the ALA to offer formal acknowledgment of the importance of library work with children, although organizational resistance to their demand stemmed from a powerful historical precedent against age segregation. Despite recent trends toward viewing children as a distinct group, the ALA, and much of America,

continued to expect children to read adult books as part of their prepara-
tion for adulthood. Adulthood would be rigorous and demanding; child-
hood was no time to mislead children about their future. Activities failing
to portray adulthood realistically deserved scrutiny.[14]

Yet as libraries moved from closed to open shelf systems, adult patrons
of public libraries complained that children were nuisances. Sensitive to
this criticism, the ALA became increasingly amenable to segregated library
services so that children would "cause no annoyance to the adults."[15] As
an added bonus, age segregation would also facilitate supervision of chil-
dren's reading selections and behavior, goals well within the province of the
library's activities.[16]

Establishing formal organizational support for children's work, however,
implied a willingness to place women in charge, another source of ambiv-
alence for ALA leadership. Women seemed the logical choice to supervise
children in public spaces, as they traditionally did in private, and most
librarians agreed that "sympathetic and sane-minded" women were likely
to have a positive effect on children.[17] Unlike other feminized professions,
indeed, women were allowed full ownership of the professional hierarchy
of children's services.[18] Yet, as noted, library leaders were uneasy about
immoderate female sway over children's reading.

To offset the perceived dangers of feminization, library leaders frequently
urged discipline in the library and advocated the recruitment of women
who did not necessarily care for children. As one leader put it, "assistants
who are 'fond of children' are often the very worst persons to do work in a
children's room."[19] The message, if not the method, was clear: supervise
children, but not so much as to rob them (particularly boys) of natural
curiosity and personal exploration. Sensitive to this message, librarians
sometimes became defensive. In 1897, a Denver librarian reassured readers
that children were not unduly supervised in the library: "Having got his
card [the young boy] walks into the room in a subdued sort of way and
wanders aimlessly about for a time with half an eye on the people at the
counter, as if expecting every moment some lover of childhood would rush
in and impose upon him books which he ought to read."[20] To avoid the
problem of excessive supervision, the librarian's desk in Denver was placed
"at such a distance that she would seem not to be acting as an overseer, but
simply as a good-natured person willing to give assistance if asked."[21]

In 1900, eighteen years after Caroline Hewins made her initial appeal to
the ALA, the organization established the Children's Section, thereby ex-
tending formal recognition to its work with children.[22] This decision was

multilayered, benefiting adults as much as children. But once the ALA accepted its role in children's work, it heartily recognized such work as an appropriate space in the public library for women, creating, in effect, a group of experts (children's librarians) within a group of experts (the ALA). In the process, professional opportunities for women in the library were enlarged by this "natural" power base within which they might establish and exert authority. It might have been less clear at the time that claiming children as their special province also carried less positive consequences for library women. By accommodating the prevailing gender ideology of "spheres," women accepted the necessity of segregation—figurative as well as literal— for themselves as well as for children, along with pay consistently among the lowest in the profession. For the moment, however, Moore and Jordan began their careers in the context of perceived victory within the ALA, a victory that carried implications for professionalization, including education.

Many women in the ALA approved of the organization's broad educational aims. If, as Jordan believed, the librarian was to be "the major liaison between a person and a book," education was crucial.[23] Regarding the library as the pinnacle of those connected with books, Moore agreed. But, they argued, a generalist library education like that offered by the New York State Library School at Albany would be inadequate in a society that placed a high premium on specialization. To remain valuable, librarian experts were needed in various subject areas. Moore and others insisted that expertise have a place on the older, loosely defined list of professional qualifications: culture, technical training, and executive ability. Throughout the first two decades of the twentieth century, therefore, women librarians founded specialized training programs in children's work. Normally within established library schools or within their own libraries, these courses generally focused attention on children's literature, the creation of a children's room within the library, and methods for dealing with the special interests and needs of young patrons.

Aside from her ALA activities, Moore also worked full time as a librarian. After graduating from Pratt in 1896, she was appointed to head the new children's library there, one of the first rooms in the nation specifically designed for children.[24] For ten years that position provided her with important opportunities to experiment with professional self-expression, fine-tune her attitudes about the role of the library in children's literary lives, and develop her management style. These activities set the pace for the remainder of her working life.

Determined from the start to cultivate a powerful relationship between

children and the library by whatever means necessary, Moore insisted on gaining personal knowledge of children who patronized the library and on making the library a visceral experience for them. Young patrons were allowed to help adults in the children's rooms, performing such tasks as shelving modification, putting up books, and even mending. Together with an open shelf system, such efforts, she believed, enhanced the relationship between the library and the child and resulted in "marked improvement" in "personal appearance and . . . bearing," as well as "contented minds and subdu[ed] animal spirits."[25] Evidently, children became civilized by handling books as well as by reading them.

The concept of the library as a visceral experience found special expression in storytelling and hands-on exhibits, which contributed to a nationwide trend.[26] Storytelling, in fact, was a hallmark of children's work at Pratt. Marie Shedlock, Moore's friend and an internationally known storyteller, persuaded her that reading aloud was a lost art containing the power to encourage an appreciation of "the best in literature." Shedlock's goals for stories were to give "dramatic joy," to develop a sense of humor, to present by means of "example, not precept," and to develop the imagination—all qualities of the literature Moore favored.[27] Chronic book shortages, particularly in rural school districts, gave storytelling strong practical application. The storyteller Ruth Sawyer complained that "West Virginia supplies no textbooks; there were none here, either to be read or studied out of, save those few the teachers had bought and brought. Most of the children had never owned a book. Not one of them had ever heard a story before."[28] Moore utilized storytelling "not for amusement . . . not to tempt children to come to the library . . . not to help in discipline," but to bring children to books.[29] To raise its prestige, Moore enlisted the help of literary figures like William Butler Yeats for the children's room, a practice she continued throughout her career.[30]

Likewise, Moore viewed art as critical to enriching children's experience with books, and art was central both to her exhibits and to the decorating scheme of the children's rooms. Colors and lighting were soft, vases of fresh flowers sat on librarians' desks, and artwork was often drawn from the work of well-known illustrators, such as Howard Pyle. Most often, exhibits were either biographical or natural; Moore regularly created displays featuring famous authors in celebration of their birthdays, or exalted nature with seasonal arrangements of flowers, leaves, and plants. Taken together, story hours and exhibits complemented each other by placing children's literature in what Moore considered a "living context."[31]

Moore's work eventually came to the attention of Arthur Bostwick, still struggling to organize NYPL's circulation departments after consolidation. Like many libraries in the nation, NYPL had established children's rooms, but by the end of 1905, it seemed clear to Bostwick that a supervisor was needed to assume direct responsibility for children's work, now in desperate need of organization and leadership. Moore's innovative activities with children made her an appealing candidate for the position and, in 1906, he called upon her to bring her ideas and organizational skill to NYPL. Especially impressed by her attention to efficiency, Bostwick intended to make the new supervisor a member of his board of experts.

Without hesitation, Moore accepted Bostwick's invitation despite the overwhelmingly transitional state of the library overall and the daunting task of organizing the haphazard conglomeration of work with children that she faced in particular. Some of Moore's library friends in other cities, in fact, viewed NYPL as a "wasteland" and a "wilderness,"[32] but just as her father had worked wonders with a wasteland, so could she. Always interested in new professional experiences, Moore found the change refreshing and brought to NYPL the skills she had honed at Pratt.

Moore proceeded to recreate her successes at NYPL. Traditional age restrictions related to book borrowing were eliminated, still a relatively new and controversial idea, although in some cities restrictions either never existed or had already been removed.[33] Story hours, successful at Pratt, were embraced with equal enthusiasm at NYPL. During her first year as supervisor, Moore offered two hundred story hours in the children's room, sometimes conducted in the foreign languages of various New York neighborhoods; by 1913, the annual number had risen to almost two thousand, excluding those held around the city.[34]

Under her direction, NYPL's children's room became a prime example of the literary and civic infrastructure being designed for children, an infrastructure that operated on both the individual and collective level.[35] Viewing the library as more than a quiet place for reading and solitude, Moore made the children's room available to a variety of organizations, thereby enlarging the scope of the library activity and challenging its traditional definition. Scouting chapters used the library as both a meeting place and a source of suggestions for plays and stories, and on occasion missionaries visited the children's room to get book ideas to take back to the field.[36] In 1908, Moore organized some of the nation's early library clubs, and within four years NYPL was home to forty-two clubs, twenty-five for boys and seventeen for girls.[37] Their purpose, in her mind, was to "deal . . . with the

restless [children] who throng the streets and make trouble because of nothing better to do."[38] The club season corresponded roughly to the calendar school year, running from October 1 until the end of May. Club titles often expressed a particular literary interest, such as the Shakespeare Club or the Dickens Club. Clubs were supervised by NYPL staff, but remotely; members selected officers and established their own reading agendas. Intraclub competition was encouraged, as were debates over current issues designed to make youngsters more politically aware and active. The term "library club," therefore, is somewhat misleading since the clubs often had little to do with books. Activities also included woodworking, basketry, domestic science, or physical exercise. Agreeing that they needed to satisfy their "natural desire for self-development and expansion," Moore even allowed dancing in the children's rooms. The name is also misleading since clubs frequently met outside the library, in places such as juvenile court rooms, club members' homes, and settlement houses.[39]

By opening the children's rooms to such activities, Moore increased library patronage and demonstrated agreement with views of the library as a civilizing agent that struck a balance between freedom and order, frequently a class concern since certain children were thought to be in special need of civilizing. A Buffalo librarian, for example, declared that "these children are almost all from the poorer classes, some of them . . . from the very poorest. . . . The lesson hardest for them to learn is the proper handling of books; and this, considering their homes, is not surprising."[40] Thus, the children's rooms were part of what Christine Pawley calls "a class system unobtrusively at work": grown up in the context of industrialization and profound social change, libraries operated as a values-transfer mechanism.[41] Story hours and reading clubs instructed children that reading was not only important as an individual activity, but also served as rehearsals for adult sociability, since positive childhood group experiences might encourage sturdy social and political engagement in the future.[42]

Furthermore, this practice illustrated her belief that children's lives— along with the library—were "expanding."[43] She considered the library a "mental resource" with ties to, but a distinctive role from, schools or social organizations. The library's greatest attribute was its voluntary nature, Moore believed, because it underscored self-education, one of the library's main goals.[44] Bostwick, while admiring Moore's work, sometimes reflected his colleagues' concerns about female influence; he insisted that expanded activities should not be allowed to replace the primary mission of the library: reading.

In 1900, the library trustees appointed Alice Jordan, then thirty years old, to direct its work with children. She, like Moore, viewed the library as "nurseries of citizenship"; books, she claimed, had the power to preserve American ideals "in the hands of boys and girls. . . . Through books Americanism can be taught. . . . Save the children for the country and save the country through the children."[45] But Jordan also believed that children's rooms were "nurseries of the imagination" and, before assuming her responsibilities at BPL, visited Moore at Pratt. The visit profoundly affected Jordan, largely because she found a "kindred spirit" in Moore. By sharing her beliefs about children's services with Moore and others, Jordan left New York with a clarified vision of children's services at BPL.[46] Subsequently, Jordan mimicked Moore's decorating scheme, including large, round study tables with green shaded lamps, original Pyle artwork hung on the lower level, and a comfortable second floor balcony. The typical decor of children's rooms made them "metaphoric homes," part of the way bookwomen advocated for the rights of children.[47] The ways in which they defined the space for children in libraries revealed their belief that children were entitled not only to the functional literacy they encountered in the classroom, but also to social, imaginative, and self-directed literacy.[48]

Jordan accomplished her tasks so successfully that library administrators quickly broadened the scope of her function to include supervision of the children's work in branch libraries. In 1906, as an outgrowth of her expanded role, Jordan invited children's librarians from ten public libraries in the greater Boston area to meet and discuss policies related to children's work. From that meeting, the New England Round Table of Children's Librarians (NERTCL) was launched. Jordan chose "Work with Schools" as the topic for its first meeting, an issue of great personal interest to her since she was particularly disturbed by the lack of school libraries.[49] Many shared her concern. Librarians, frequently regarding the public library as "the people's university," desired to attach themselves to the public school system as its logical complement. Students, they argued, learned to read and then had nothing to read. Moreover, the infamous recitation system taught students the skill of reading without cultivating good taste. Such "formal" teaching was, therefore, not "intelligent" teaching; it lacked the critical component of instilling comprehension. Moreover, the boredom of reciting passages they did not understand heightened pupils' interest in sensational books, resulting, librarians claimed, in a "literate but nonliterary" population. This made teachers the unwitting allies of the very books against which they fought. On this basis, librarians insisted on a role distinct from,

but strongly connected to, schools. Libraries would supply what the schools did not: good taste in literature. For their part, teachers resisted viewing librarians as educators and colleagues, and were inclined instead to view them as clerks. Jordan helped to ease such professional tensions by using NERTCL as a training forum for her "girls."

Schools and libraries had a long history of defining their relationship, but there was essential agreement that the library complemented the school. Mutuality was the goal, but libraries were generally regarded as "helpers." Recognizing the need to cultivate cooperative working relations with educators, Jordan instituted several services to schools, including special borrowing privileges for teachers and special schoolbook lists, complete with budgetary suggestions. To some extent, such measures were successful, for by the end of the nineteenth century, the National Educational Association allowed librarians to present their views at national conferences, and established a library section within its organization. Further, educators began to acknowledge the importance of creating libraries within public schools.

Pleased with the activities of NERTCL, Jordan was nonetheless concerned that it lacked the formal structure required of a professional organization. In 1912, therefore, she drew up a constitution that, in part, authorized the election of officers.[50] Now, as a professional woman's organization, NERTCL developed aims and activities reflecting progressive ideals. Like Moore at NYPL, Jordan encouraged librarians to become involved in charitable work that was, she believed, intimately connected to library work. Boston City Hospital was a regular visitation site for Boston's children's librarians, because Jordan believed that it represented a "new opportunity for extending library work with children."[51]

In part, expanded activities at NYPL and BPL reflected a degree of enthusiasm for progressive reform, particularly those intended to Americanize immigrants or "civilize" children. Determined that neither the new urban-industrial order nor the changing cultural composition of America should subvert their vision of a cultured, educated citizenry, reformers moved into urban neighborhoods to provide various types of assistance to those considered at high risk for poverty, criminal behavior, or unemployment. For adults, the settlement house movement provided a host of services, including food, clothing, job training, and language and civics instruction. For children, settlements provided day care, recreational activities, and summer camps. Despite periodic accusations that they had become "too tender-hearted," resembling "welfare workers" with a "missionary spirit," librarians increasingly embraced home, hospital, and settlement house visitation.[52]

Such activities, attached to coercive as well as to humanitarian ambitions, became a significant part of the librarian's daily routine. One of the first orders of business for a librarian was to familiarize herself with the neighborhood in which the library was situated, often by studying and contacting organizations she believed would benefit from her help, or with which she could establish cooperative working relations.

Librarians often divided cities into territories to facilitate such investigation, and results were submitted to the chief librarian of the city's public library. Librarians at the Logan branch of the Minneapolis Public Library, for example, sometimes went shopping with children, recommended books containing medical advice, assisted with finding jobs for homeless individuals, provided instruction on mothering skills, attended PTA meetings, advised wives about intemperate husbands, counseled children about their spiritual lives, and even offered fashion advice.[53] Although, as Abigail Van Slyck comments, libraries remained tightly connected to "elite roots," librarians were nonetheless a visible presence in America's communities, redefining the role of the library and expanding it beyond the erudite confines of tradition.[54] Moore and Jordan were in the forefront of such changes.

As she brought organization to NYPL, Moore began to believe that the real wasteland was not NYPL but children's literature itself. She rejected the "stepping-stone" argument, that is, that poor books would lead the way to better ones. A good children's library, to Moore's mind, included books that were, conveniently, steady sellers, including the work of Beatrix Potter, Mary Mapes Dodge, Kenneth Grahame, Kate Greenaway, Arthur Rackham, Leslie Brooke, N. C. Wyeth, Howard Pyle, Louisa May Alcott, Kate Douglas Wiggin, Rudyard Kipling, Joseph Altsheler, and Frances Hodgson Burnett. Overall, she approved of books that encouraged an appreciation of tradition, such as fairy tales, nursery rhymes, and folklore; books involving nature or animals, such as Beatrix Potter's, or books generally viewed as "classics," such as the writing of Washington Irving. Moore's canon generally reinforced—or at least, did not challenge—prevailing social norms, and avoided topics generally considered unacceptable for children's books. Likewise, good books were not "sensational," meaning they should not cause anxiety or agitate unhealthy imagination about such things as murder or kidnapping. They should, conversely, be soothing. The lessons derived from approved books were social rather than moral in any religious sense, reinforcing positive qualities (courage, loyalty) rather than instilling fear of, or interest in, negative behavior. Moore generally preferred illustrations that were idyllic. Gentle pastel illustrations, she believed, ideally complemented

the text and encouraged children's imaginations. Stories and illustrations, in short, contained happy endings.

These books were readily available, Moore conceded, but competed with books of distinctly poorer quality. Publishers' attitudes about children's books were, to Moore's way of thinking, narrow minded and careless, owing to the uncertainty of the market for children's books.[55] Mediocrity in children's book publishing was the norm, she declared, and she was tired of it. By "mediocre," Moore often meant "sentimental." Sentimental books, for Moore, might be old or new; she did not value a book simply because it was old, nor dismiss a book only because it was new. "Pollyanna," she noted dryly, "may be more wholesome than 'Elsie Dinsmore', but she is no more real."[56] Although she approved of "classics" of an earlier generation, she considered herself progressive, and did not perceive the canon of "good" children's literature in a static manner. Indeed, she regarded the body of children's literature as a work in progress.

Sentimentalism annoyed Moore for reasons other than its potential to dilute American reading taste; she also objected to its formulaic plot lines, stock characters, and simplistic solutions, particularly in books intended for girls. She detected "poverty" in literature for girls, characterized by obsession with "self-analysis and the reformation of characters . . . introspective, sentimental, moralizing and didactic." "Why," she wondered, "do the writers for girls always send their heroines to the country to be made over or bring the country girls to the city to reshape the artificial lives of their cousins?" This tendency she attributed to a lack of literature generally about the lives of women. "No girl has been free to live her own life. She has been at the mercy of some author who had her life all mapped out for her." Moore claimed that a girl "cannot afford to waste her emotions nor her time. She has need of every resource that may fortify her spirit, sharpen her native wit and challenge the full powers of mind and heart."[57] Good books were one of those resources.

Evaluation of sentimentalism in Moore's outlook reveals an interesting paradox. Repudiation of sentimentalism has been viewed as an important marker of a "modern" outlook. Yet Moore herself behaved in ways that can only be interpreted as sentimental. Her intensely personal concept of "good" books was most often expressed by vague, nostalgic metaphors of nature and innocence. Ultimately, we are left with images of the sentimental Moore, reverently placing lilacs beneath the picture of Louisa May Alcott in an exhibit for the children's room, and the unsentimental Moore, tearing books from library shelves for containing characters whose traits,

ironically, resembled her own. A clear contradiction exists, although evidence does not suggest that Moore was aware of it. To be successful as the supervisor of the Children's Department at NYPL—an exemplar of the "modern" library—Moore needed to cooperate with library policy by distancing herself from unpopular styles of writing, such as didacticism. But the consistency and passion with which she criticized sentimentalism suggests that her view represented more than simple accommodation to the attitudes of her superiors.

To improve the quantity and quality of books available to children, Moore demanded a larger portion of NYPL's fiscal attention. During her first year at NYPL, she requested a budgetary increase of ten thousand dollars for acquisition of juvenile titles more to her liking, claiming that the amount was about a tenth of what was necessary to overhaul the children's library. That she received it, considering the uncertain financial condition of NYPL, suggests that she was persuasive with her superiors although, pressured to create a "modern" institution, they did share her commitment to children's books. Moore instructed branch librarians to discard outdated books and carry duplicate copies of standard juvenile titles, despite her promise to Billings that she would allow books to remain on shelves until they wore out. To ensure compliance, she routinely visited branch libraries, searching for "remnants of Sunday-school libraries and cheap sensationalism" beneath which "the skeletal beginnings" of "professional concern" could be seen.[58]

Once branches in the library had been pruned, Moore invited librarians to submit purchase requests to replenish their now scant inventories, but only about half of the seventy-five thousand requests met her definition of "good" books. Most significantly, Moore remained in charge of making that decision. Still, some branch librarians, like Elizabeth Shumway, were delighted with the changes Moore instituted. "Wonderful things began to happen [after Moore came to NYPL]," Shumway averred. "One after another children's rooms were opened or remodeled, our book stock was revised and replenished." If NYPL was the wilderness, in other words, at least some library workers saw Moore as the voice in it. Librarians who later scattered to libraries in other cities frequently credited their training under Moore as essential to their "vision of the whole great scheme."[59]

Not all librarians who answered to Moore shared Shumway's enthusiasm about the new supervisor of children's work. In her early years at NYPL, Moore experienced resentment and outright rejection from branch librarians. If subordinates viewed her anxiously, the feeling was sometimes

mutual, since she perceived branch librarians as "untrained" and resistant to supervision. At times, she played the diplomat. When Bostwick once inquired how she had come to terms with a particular branch librarian with whom she had had a difficult time, she responded that it was "very simple. . . . She has no interest in and no knowledge of library organization. I talk to her about books and plays and Woodrow Wilson and she lets me do anything I want to with work with children in her branch."[60]

When diplomacy (or manipulation) failed, Moore relied on other strategies. She did not tolerate "complacency" or "doldrums." Some librarians felt slighted, exasperated that Moore was not liberal with praise for what she considered merely the fulfillment of professional tasks. Others might have disliked what they perceived as an overbearing management style, but Moore's commitment to professional advancement for children's librarians was undeniable. The NYPL staff represented a variety of professional backgrounds and education. In contrast to the cultural homogeneity characteristic of other NYPL departments, Moore prided herself on multicultural hiring practices. Free to operate outside the hiring constraints of other departments, since funding for the children's room derived from the reference department rather than public funds, Moore selected new staff on the basis of her intuitive responses to applicants, rather than race or ethnic background. In fact, her staff was consistently multiracial and multiethnic, although by no means proportionally representative of New York.

Moore routinely met with branch librarians, delivering fervent lectures intended to inspire her subordinates. Her credo, invariably, was "admit no defeat." Another consistent message to staff members was what Frances Clarke Sayers referred to as "the four respects": respect for children, respect for books, respect for fellow workers, and respect for the professional standing of children's librarians (which meant women). At times, Moore viewed the library organically, regarding librarians as part of a larger contingent of book-related professions. At other times, she saw children's work hierarchically, at the top of which was the library.

Moore's concern for books did not, however, remove her from financial realities. Her attempts to ameliorate librarians' poor pay and bolster professional prestige belied an attachment to middle-class liberal thought: hard work, more education, and patience with the system would rectify employment issues facing women. Recognizing the link between pay and expertise, Moore gained professional status for children's librarians at NYPL in 1908 by demanding—and receiving—a pay grade for children's librarians that included a fixed salary rate and defined specific training qualifications

for children's librarians.[61] She did not, however, win this concession single-handedly. Bostwick confirmed to library trustees that the upgrade was necessary for NYPL to remain competitive and attract "competent persons" into children's work. A pay raise accompanied the grade, and a new position of assistant was created in children's rooms throughout the city. Qualifications included peer recommendations, a six-month rotating internship that provided the applicant with interbranch familiarity, and a paper written about the library.[62] Librarians from around the country vied for internships in the children's room under Moore's supervision.[63] Librarians coveted the position, in part, to enlarge paychecks that did not normally reflect the claims of those who insisted that librarianship was the "highest calling."

Public libraries in Boston and New York were part of the nationwide trend to pay librarians substandard wages; at times, librarians did not receive even subsistence wages. In Boston, despite relatively generous municipal funding, library administrators remained obliged to cut corners, which normally meant holding wages down. In 1908, Boston librarians received eight dollars a week, a dollar less than the living wage.[64] The rate of pay, however, is more informative when examined in the context of gender. In 1907, excluding department heads, 134 of the 219 individuals employed by BPL were women whose average annual salary was $575.22, while men received $610.12 for similar tasks, making an overall average of $585.34. The following year, pay increases appropriated by the city raised the average to $719.43. But the gender discrepancy enlarged substantially, since the salaries of male librarians under the new wage scale then stood at $903.66, while women received $630.45. Men's salaries had increased by one-third, therefore, while women's salaries rose only about one-tenth—about $55—annually.[65] In New York, Bostwick repeatedly appealed to the trustees to raise salaries, but salaries for the lowest pay grades still ranged from $30 to $40 monthly in 1908.[66] Thus, as more women entered librarianship, they lost financial ground, thanks to popular perceptions of librarians as clerks. Despite the efforts of Moore and Bostwick, librarians' pay remained so poor that library administrators faced serious staffing shortages.

Little changed in the next five years. In 1913, the U.S. Bureau of Education reported that the average salary for librarians nationwide in libraries containing five thousand or more volumes was $871; in the Northeast, the average was $744.[67] These figures were so low, relative to other feminized professions, that in 1916, 16 percent of NYPL's staff left to take better paying positions; by the end of 1917, more than 20 percent had done so.[68] Responding to assumptions that they did not really need the income, librarians in

Brooklyn reported that of 287 female employees, 260 were dependent upon their own earnings, with 120 supporting others as well. Only 27 of this total lived at home, avoiding the cost of room and board, or had outside income.[69] Moreover, NYPL employees pointed out that "service to the public" had increased by 75 percent between 1907 and 1916, while staff had grown only 47 percent.[70] It is hardly surprising that Moore advocated higher rates of pay and further training, including internships, or that women employed by NYPL and BPL eagerly sought such training. With it, they could hope for promotions within those libraries or, if necessary, secure higher positions elsewhere.

Some librarians, however, rejected Moore's vision of professionalization and her gradualist strategies for achieving it. Refusing the notion of "working on the inside" to effect change, they advocated unionization as a more effective and immediate means of obtaining better pay and benefits. One example of this occurred in 1917 when the New York Public Library Employees' Union (LEU) was created, an unprecedented event in library history. Membership in the union was predominantly female; its first executive board, in fact, consisted entirely of women. The LEU identified itself with other women's reform groups, including the New York Federation of Women's Clubs, the Federation of Women's Civil Service Organizations, and the Women's Trade Union League of New York, as well as with the AFL. LEU publicity head Maude Malone clearly articulated the organization's primary goal: abolition of discriminatory hiring and promotional policies, including equal pay for equal work.

Library unions and their organizers received immediate and severe criticism from library administrators and the public, who claimed that unions undermined the librarian's role as a selfless public servant. Union activities, opponents charged, demonstrated unfeminine and unprofessional conduct, selfishness, disorderliness, and even fanaticism—all violations of "the library faith."[71] But in May 1918, ignoring the "general feeling" among librarians that mentioning salaries was "not ladylike,"[72] some fifty BPL employees, the majority of whom were women, started a union and made demands echoing those in New York. The Library Workers Union of Boston Public Library resulted, in no small measure, from changes implemented as a result of recommendations made the previous year in a formal report by Edwin Andersen and Arthur Bostwick calling for increased education. Those librarians without college degrees were thus threatened, perceiving that, for them, the consequence of "professionalization" might be unemployment. In addition, they claimed, professionalism was the *real* cause

of discriminatory employment practices. Maude Malone accused "professional" librarians such as Anne Carroll Moore of elitist attitudes that contradicted rhetoric about democratic reading and declared the very notion of professionalism itself undemocratic, since it necessitated one group imposing its reading preferences on another.[73]

The response of library leaders to unionization was swift and reflected themes of patriotism and anticommunism, potent rhetorical markers in wartime America. The recent revolution in Russia allowed Charles K. Bolton, librarian at the Athenaeum, to invoke the traditional, if often unfounded, connection between unionization and communism. Writing to the Boston *Herald,* Bolton claimed that, "the obvious result [of a union] will be to break down discipline . . . With the experience of Russia before our eyes, it should not be necessary to use a column of argument to justify orderly government. . . . A good deal of time was taken up [at the union meeting] in the denunciation of college-bred women. . . . It was said that young women without college education 'considered themselves fully as equipped to carry on the work as any of the college graduates.' . . . Have we not reached a Russian standard of 'self-determination' in the Boston Public Library?"[74]

Given the degree of social pressure to behave as proper, patriotic citizens (and the very real legal consequences of failing to do so), it is perhaps not at all surprising that unionization attempts—perceived as "boat rocking"—failed. A national mood of fear and conformity, together with longstanding middle-class disapproval of labor movements, no doubt contributed to the failure of these efforts. But they also failed because the majority of women in the library, despite impoverished paychecks, maintained genuine confidence in liberal attitudes about education and patience over direct action as a means of raising professional status. Direct action might improve conditions in the short run but held little long-term value in terms of establishing professional authority, achieved more by carefully constructed relationships with middle-class institutions than picket lines.

The strength of this belief was demonstrated clearly in 1919, when unionists demanded an ALA vote on measures urging library administrators to increase salaries and end discriminatory hiring and promotion practices. The proposed measures were overwhelmingly defeated by the general membership, four-fifths of which was female.[75] The concept of service, for most, remained more powerful than poverty, although continued adherence to it, like the insistence on "natural" knowledge, contained disadvantages as well as advantages for working women. In the short run, the service ideal

served as a legitimizing agent for women in search of careers. In the long
run, however, it reinforced gendered professions, making it difficult for
women both to quantify their worth and to bargain assertively on their
own behalf in the workplace.

As the war drew to a close, Eugene Saxton, new managing editor for the
Bookman under the publishing efforts of George H. Doran, invited Moore
to take over the periodical's discussion of children's books beginning in the
November 1918 issue.[76] This kind of work was not entirely new to Moore;
she had contributed to the *Library Journal* since publisher R. R. Bowker
asked her to "get the point of view of the children's librarian" into that
journal in 1912.[77] But because the *Bookman* had a wider readership than the
Journal, and because Moore contributed on a regular basis, the *Bookman*
essays became a significant instrument through which Moore established
herself as a literary critic.[78]

 Bookman essays varied in length, generally from one to five pages, and
virtually always contained anecdotes from Moore's experiences as a librar-
ian, praise for books that had impressed her, and identification of problems
in children's book publishing. In them, Moore came as close as she ever
would to offering her definition of "good" reading material for children.
Good books should emphasize a love of nature, create heroes, contain orig-
inal story lines (or illustrations, in the case of traditional tales), respect
historical tradition, avoid moralism, be clearly written, have international
appeal to children, and satisfy both "the lover of fairy-tales and . . . the
believer in 'tell nothing but the truth to children.'"[79] The *Bookman* essays
had an impact on the publishing world. Before the Christmas selling season
in 1918, publishers and booksellers began demonstrating an interest in a
renaissance of children's literature; some publishers even announced plans
to bring out "good modern books" for children, and Moore was thrilled,
hopeful that the time was ripe for such a renaissance.[80]

 For the moment, "natural instincts" remained unquestioned, work with
children remained a crucial, and possibly singular, arena of authority ac-
quisition in the public library, and Moore used these facts to create an
atypical professional advantage.[81] Women with aspirations in other pro-
fessional venues were also beginning to discover that professional author-
ity could be had in return for acknowledging and promoting themselves
as "naturals."

Selling Books

Bookshops, the WEIU, and
Bertha Everett Mahony

WHILE THE STRUGGLE FOR female professional identity took place in formal cultural institutions like the library, a similar process was underway in women's social organizations. The club movement of the late nineteenth century developed a new agenda for dealing with a long-recognized problem: women's economic and intellectual dependence on men. To engage effectively with these problems, women's organizations sought to manipulate urban landscapes by undertaking activities geared toward self-improvement and designed to strengthen women's relationship to the workplace. This was no simple rhetoric; clubs assisted women by offering employment bureaus, childcare centers, vocational training, and financial backing for causes deemed significant. Clubs also provided leisure activities for members that must be seen as both supportive and simultaneously intrusive, particularly where a class gap existed between leaders and the rank and file. Nonetheless, club culture offered access to invaluable networks with a range of benefits, including financial support, political voice, social vision, and friendship.

In the early twentieth century, however, women's organizations frequently remained closely tied to the service ideal. Attempts to reconcile these beliefs—economic autonomy and voluntary service—presented challenges to club members resembling those faced by library women. As in the library, clubwomen sometimes appropriated the traditional image of women as nurturers in order to achieve their goals. Like librarians, clubwomen brought private qualities to public space, but these qualities represented far more than a "home away from home." While cooperation with the gender line was advantageous in some cases, cooperation with the

public/private line was not as forthcoming. Bertha Mahony's career pro-
vides a classic illustration both of the tensions that arose from balancing
voluntarism and professionalism, and of the lasting influence of women's
organizations on their members.

During the summer of 1919, while Anne Carroll Moore and Alice Jordan
prepared for Children's Book Week, Bertha Everett Mahony was in Boston
overseeing the construction of a large, custom-made vehicle known as
the Book Caravan. Painted gray with its name lettered in orange along the
sides, the Caravan was not, Mahony insisted, a lending library but rather
a bookstore on wheels, able to carry some twelve hundred volumes at a
time.[1] Mahony had hatched the idea as part of a community outreach pro-
gram, designed to bring books to children in towns lacking ready access
to libraries and bookshops.[2] The Caravan was to be an extension of her
Boston-based business, the Bookshop for Boys and Girls, in operation
since 1916.

Like Moore and Jordan, Mahony was a native New Englander. Born on
March 13, 1882, in Rockport, Massachusetts, she was part of a close-knit
family and a ninth-generation American on her mother's side. Her father,
Daniel, was a passenger agent and telegraph operator at the train station in
Rockport and a second-generation Irish Catholic, although he attended the
Congregational Church with his wife and children. He was also a passion-
ate lover of poetry. Three siblings followed Bertha: Daniel in 1884, George
Everett in 1885, and Ruth Ellen in 1887. Their mother, Mary, was an accom-
plished musician who served as the town's piano teacher and gave lessons
to her older daughter. She was an enthusiastic storyteller, in the habit of
chanting nursery rhymes and fairy tales to her children, as well as telling
them stories about her own childhood in New London, Connecticut. Filled
with music, stories, and a small library, the Mahony household seems to
have influenced the child's development substantially, and Mahony could
read before her fifth birthday. The Mahony women, especially, exerted a
powerful influence over the children, providing the girls with an early and
strong sense of female community. When Bertha was eleven, her mother,
frequently ill, died. The loss was devastating to the child.

Graduating from high school at nineteen, Mahony entered the normal
school at Gloucester. In 1902, after one year, she moved to Boston to attend
the School of Secretarial Studies at the brand new Simmons College. She
would have preferred to attend the School of Library Science there, but lack
of funds prevented her from doing so. Simmons offered two program
options at the secretarial school: a four-year course of study or, for college

graduates, a one-year certificate program. The school's standards were rigorous and "utilitarian," preparing women to become office assistants, private secretaries, registrars, and teachers of commercial subjects. Mahony, an exceptional student, was allowed to enroll in the one-year certificate program.[3]

Inhabited by roughly a half million individuals, and struggling to recover from the severe nationwide financial disruptions of the 1890s, Boston had assumed, more or less, its modern outlines by the time Mahony arrived. Replete with a myriad of civic organizations, including the Boston Public Library, the city was in the midst of significant reshaping by middle- and upper-class women determined to help others perceived as less fortunate and to create for themselves a place at the city's political bargaining table. The Women's Educational and Industrial Union (WEIU), to which Bertha Mahony belonged, was part of this rapidly expanding web of organizations emphasizing women's economic success and particularly dedicated to the issues facing working women who, by the turn of the century, made up one-third of the city's workforce.[4] Begun in 1877 as the outgrowth of a project sponsored by the New England Women's Club to study the economic condition of sewing women in Boston, the Union was more than a charity organization. It was, rather, an investigative agency—one of many—determined to assist women working in the industrial workforce. The committee, instructed to focus its attention on the problems of female wage earners, quickly outdistanced its parent organization's membership and ventured out on its own.[5]

Founders Harriet Clisby and Abby Morton Diaz made it abundantly clear that they had created the WEIU for the advancement of members as much as for traditional charity work, consistent with other women's organizations after the Civil War. Like Charlotte Perkins Gilman, whose *Women and Economics* rapidly went through several printings after its publication in 1898, Diaz viewed marriage as a "private charity" designed to provide security for women, but argued that true security was impossible without economic autonomy. Comparing economic dependence with prostitution, Diaz and others viewed charity, no matter how well intentioned, as a poor substitute for job skills contributing to economic independence. To say the least, however, gaining such independence was difficult in the context of the abysmal conditions under which many women worked; labor, therefore, was a major concern of the Union.

To rectify matters, union leaders like Diaz and Clisby envisioned a socially fluid organization resting on cross-class gender solidarity, an important

and frequently successful strategy of women's organizations involved in labor issues.[6] Authority, they believed, would derive from the traditional belief in women's aptitude for promoting positive community change, from the Union's ability to bargain effectively for women's betterment, and from the development of distinct programs to foster job placement and structured leisure time. Consequently, WEIU chapters typically established employment bureaus and domestic service bureaus, and secured arrangements for affordable housing at local boardinghouses. Union-backed day care centers and job training programs were among its most successful endeavors.

The consequences of the Union's attempts to structure leisure time were more ambiguous, in part because of class differences between leaders and the rank and file. Despite the vision of cross-class alliance, college-educated professionals were heavily represented in Boston's Union leadership and drew on a complex set of ideals and assumptions about class and gender to create an agenda for female working-class leisure. Three of its eight original members were physicians and others came to the organization with well-established literary careers, yet they were all working women. Thus, in Boston, Union leadership represented a mediating class of social reformers who both resembled and differed from rank-and-file membership, a significant fact in terms of its leisure programs. Middle-class reformers, fearing that working women were subject to the same temptations as their male counterparts, were concerned that women might compromise their moral integrity. Jane Addams lamented that "this desire for adventure . . . and the thrill of danger" affected "girls" who were interested in "being daily in the shops . . . and the glitter of 'down town.'"[7] The YWCA observed that, in the absence of appropriate alternatives, "young girls . . . are apt to grow noisy and bold."[8]

In response to such concerns, middle-class reformers regarded "innocent recreation" an appropriate means of avoiding moral "erosion."[9] For this reason, they created a host of institutional safeguards to shape the culture of working-class leisure and "encourage purity of life, dutifulness to parents, faithfulness to employers and thrift."[10] These institutional supports—often club-sponsored entertainment and activities—reminded women that home was the fundamental female institution, even for women temporarily living outside its boundaries.[11] Paradoxically, while Union leaders compared marriage to prostitution and supported cross-class alliances, entertainment programs often reflected, rather than challenged, class distinctions. Working women sometimes became the literal

as well as metaphoric audience for expounding the cultural values of the leisured class rather than equal partners in reciprocal relationships. Information about working women's response to Union entertainment efforts is slim, but not all women were as receptive to the scope of union activity as Mahony. Indeed, evidence suggests that working women frequently regarded such events either apathetically or suspiciously.

Within the broad concerns of work and leisure, Union politics played out prominently in two arenas: language and space. The organization normally displayed an avid interest in developing and expanding physical space for club activities. Such space was often noted for its "feminine" qualities, resulting, like children's rooms in public libraries, in a "home away from home."[12] In this sense, the Union reassured the public that it was a reliable reflection of charity and nurture. The "homelike" atmosphere of the Union's physical space, in fact, revealed that clubwomen had no desire to surrender their claims to domestic authority; indeed, as Sarah Deutsch has shown, they often imposed their own notion of "home" on others. But the important point is that it *was* public space and not home, however it may have resembled one. Like librarians, clubwomen challenged traditional urban geography, expanding their jurisdiction from home to include space—factories and streets—normally off limits to women. But clubwomen simultaneously interrogated the invisible but palpable line separating public/private: both were necessary, but wholly separating them was detrimental, both to individual citizens and to the perceived common good.

Importantly, therefore, the WEIU situated its "homelike" club space in the business and political heart of the city. Members understood the connection between location and political visibility, aggressively manipulating the urban environment to position themselves for interaction with municipal and corporate power sources.[13] The organization's presence near both business and politics was both unmistakable and intentional, reminding businessmen and politicians of the Union's importance in the urban landscape. In addition, organizational expansionism—both in terms of building space and programs—characterized Union development in Boston. The organization owned three buildings, which, by the turn of the century, made the Union an undeniable and forceful presence on Boylston Street.

Language, too, underwent change. Municipal alliance, not part of the original organizational plan, became crucial in persuading the city government to assume responsibility for WEIU programs. So, by the 1880s,

its leaders began shifting its organizational rhetoric from a transcenden-
talist emphasis on "unity" and "self-reliance" to a Darwinian language of
efficiency. Moving toward the organizational goal of "justice, not charity,"
Boston women replaced the language of kinship with a linguistic strategy
that allowed them to negotiate effectively with politicians and business-
men. Individuals running for municipal office, for example, encountered
aggressive lobbying from lawyers and college interns hired by the Union
for this purpose. In short, in a city with literally hundreds of social service
organizations, a distinctive voice was critical to success; the language of
personal relationship could no longer be trusted to negotiate social re-
form. The Union was, as Deutsch describes it, "learning to talk more like
a man."[14]

Changes in language symbolized new, tough integrationist politics in
the Union, in the process of moving from a woman's reform organization
to a businesslike agency in a large urban setting. The organization altered
its way of doing business in the community by decreased reliance on
voluntarism, thus allowing it to resemble the corporations with which
it sought alliance. Indeed, by the early years of the twentieth century, the
Union had more than a hundred staff members on payroll, performing a
variety of functions, including lobbying. Moreover, its heterosocial nature
was further indication of the organization's desire for alliance rather than
opposition. Recognizing that men had access to the financial resources re-
quired for its projects, the organization opened its doors to men by offer-
ing them associate membership in 1903.[15]

In part, the new fountain of the organization's integrationist politics
sprang from an old well. Clean government resulting from direct citizen
participation was hardly new, and WEIU leader Mary Follett avidly sup-
ported both. To Follett, the organization's participation in municipal nego-
tiations was the logical expression of that "great spiritual force evolving
from men"—the ever-widening democratic community. Community, she
insisted, would be the hallmark of "all relations of the new state." For this
reason, Follett had no patience with class politics, envisioning instead a
rationalized economy based on expertise and collectivism.[16] Thus, while
it might be argued that the Union created its own political machine, jock-
eying with other organizations in Boston to realize its aims, this compari-
son must be qualified by understanding the importance the organization
placed on cooperative relations.[17] Ultimately, the Union was not interested
in the sort of competition that the term "political machine" generally im-
plies; neither was it content to sit on the political sidelines, neutralized by

reliance on the tradition-bound but tired rhetoric of charity. In the early twentieth century, the negotiating table of social reform was located in city hall, and learning the discourse of municipal politics was a precondition for a place at that table. While the alliances the Union made with other organizations were frequently uneasy and while the shift from private to public space was far from linear, the organization became adept at interpreting the "map" of public culture, freeing Union members like Bertha Mahony to consider—and act upon—new employment options. When she was not occupied with school, Mahony made the quick walk to Simmons to attend Union activities.

For Mahony and other young women away from home, organizations like WEIU not only assumed mentoring roles but also represented a surrogate parent. Young women sometimes attached themselves to clubs in support of causes, but they also joined to make valuable social connections. Club membership was frequently a "badge of status" supporting broader class claims and providing social connections essential for young career-minded women. The Union thus served as a vital professional network for such women by helping them to secure these connections.[18] Mahony acknowledged the importance of union credentials by her persistent, lifelong description of WEIU as her "university."[19]

Club life also frequently provided insulation against the traditional claims of family life on women's time as well as against the potential disapproval of society. In addition, club culture provided opportunities for what one historian calls "forays into public activism" by offering members a safe environment to practice public speaking, writing, petitioning, and—increasingly—budget management.[20] In the absence of formal participation in electoral politics, women's clubs created a crucial base of informal but distinct power for women that provided class-crossing possibilities by allowing wider social opportunities with essentially little risk to one's own position.[21]

In 1906, Mahony was positioned to make the kinds of important connections the Union offered, for in that year leaders rewarded her devotion to the organization by making her its assistant secretary; as such, she was the recording secretary for its key committees. This responsibility produced three results in Mahony's life: it taught her organizational savvy, engaged her in the discourse of social issues, and put her in touch with some of Boston's leading and influential citizens. Eventually, her responsibilities expanded to include oversight of Union publications from initial concept to print. These tasks connected her to Thomas Todd, the Boston

printer of the organization's documents who, significantly, taught Mahony the printing business.[22]

In 1915, Mahony read an *Atlantic Monthly* article urging women to consider bookselling a worthwhile and suitable profession. Young female college graduates, it suggested, often faced underemployment if they did not become teachers, librarians, or social workers, but careers as booksellers would provide women with a life useful to the community.[23] Unhappy with the prospect of teaching, Mahony took the advice to heart and decided to set up a bookshop, although doing so made her part of a distinct minority.[24] A young woman's determination to start a business carried the risk of social disapproval compounded by potential financial catastrophe. And the process of establishing a business was slow; even women with solid connections found their goal of self-employment before entering their thirties generally unattainable.[25] Despite such pitfalls, Boston had experienced a distinct increase in female petty entrepreneurs by 1900, although, lacking sufficient financial backing, the majority went into bankruptcy within a few years. Still, bookselling was a "respectable" way for women to make a living for many of the same reasons that made librarianship a "female" profession: bookselling involved culture, part of women's appropriate public domain. This attitude offered women like Mahony a career opportunity that fulfilled their carefully nurtured concept of service.

Women in business, simply because they *were* in business, confronted prevailing gender norms concerning space, but the confrontation could be muted, to some extent, by opening a business that seemed "natural" for a woman.[26] When Mahony decided to open a bookstore especially for children, she might have sidestepped competition from existing Boston bookshops, but she also avoided social criticism. Although she genuinely loved books, her decision represented a combination of risk taking and safety seeking, a variant on the tension between professionalism and domesticity. Like the female grocer whose store was a "kitchen," a shop for children's books seemed to be a "nursery" of bedtime tales with its bookseller resembling "mother."

Mahony sought advice and financial backing from her "university" on Boylston Street, and she had good reason to assume that the Union would provide it. Its reform agenda followed a distinctly pragmatic formula: programs were first incubated in intraorganizational pilot demonstration projects. Then, armed with statistics and demonstrated success, the Union

encouraged government or civic agencies to assume continued responsibility for replicating and administering project operations. But reform was also lucrative for the Union; by sponsoring business endeavors such as the one Mahony proposed, the Union grossed roughly $500,000 annually.[27] The Union therefore agreed to support Mahony's plan, but with contingencies. Excepting a modest salary for Mahony, profits from the shop would funnel back into the Union for other projects. But while financial support was important to Mahony's success, its organizational reputation and credibility were also crucial. As one publisher's salesman later candidly remarked to Mahony, "We didn't think so much of you but you had the Women's Union in back of you."[28]

Mahony's decision to become a bookseller was fateful, placing her immediately in touch with an old profession steeped in traditional perspectives. Book production and bookselling, initially intertwined, had been separated by the end of the eighteenth century, largely due to the growing number of books.[29] That cleavage produced distinct and frequently antagonistic professions. Though their mutual aim of book distribution suggests compatibility, bookselling, once separated from publishing, was forced to defend its legitimate place within the book industry. Among those in the book business, booksellers were sometimes distrusted and sometimes embraced, viewed on a continuum ranging from naked profiteers to "family," from impediments in book distribution to selfless humanitarians. While Herbert Spencer, "champion of the reader," regarded bookselling as an "absurd anachronism" equivalent to "stagecoaches or mounted messengers," *Publishers Weekly* viewed booksellers as "family" who shared common aims with publishers: the "spreading of literature at a living profit." Likewise, the *Dial* argued that booksellers were an "important social influence."[30] A bookstore was, according to the press, "a civilizing agency of the highest importance. . . . It ranks with the public library and the local high school or college."[31] As the proprietor of one of Chicago's most prosperous bookstores, the famous bookseller Adolph Kroch regarded bookselling romantically, as one of the oldest and noblest professions with the power to "mold the mental requirements of the public."[32] William Darling, an English bookseller, declared it "the very kernel of the romance of Commerce."[33] Between these extremes, booksellers were generally regarded with grudging skepticism, acknowledged as important, though hardly indispensable, to the book trade. In the absence of an improved book distribution scheme—more than 50 percent of publisher's sales occurred through bookstores—booksellers maintained significance in the industry.

Those who viewed booksellers positively considered them, like librarians, essential as culture distributors since, as Kroch complained, "there is a vast difference between what the public is interested in and what it should be interested in."[34] Startling evidence of the need for more booksellers, advocates insisted, came from Americans themselves who, relative to Europeans, purchased abysmally few books. According to Earl Barnes, author of the article that had persuaded Mahony to become a bookseller, only one American in 7,300 purchased a book annually, while in Great Britain, the ratio was 1 in 3,800. Even more dramatically, Switzerland, with a ratio of 1 in 872, drastically outdistanced America in book buying.[35]

What accounted for this disturbing fact? Barnes rejected the typical argument that the rapid establishment of public libraries made book purchasing unnecessary, suggesting instead that broad social changes were at the bottom of the problem. By 1919, the small town version of the bookseller was surrendering to the demands of a vigorous marketplace. They had been replaced, Barnes complained, by department store salespersons interested only in a paycheck. Determined that changing markets should not foretell their professional extinction, therefore, booksellers contemplated their role in the expanding network of books. Above all, they were convinced that the American public, largely ignorant of good books, desperately needed the expertise that booksellers offered.

What, many wondered, would secure a place of prominence for booksellers in the eyes of the public? The argument in favor of training, frequently regarded as a means of enhancing professional status, was heightened by the existence of well-established European schools. In Germany, for example, the Leipzig School for Booksellers was founded in 1859, and by 1913 enrolled over four hundred students. In 1916, the year that Mahony opened her bookshop, some American cities took the initiative to create such programs. In Philadelphia the Girls' Evening High School offered a course in bookselling, and Cleveland considered a similar program; in New York, a committee of the Booksellers' League, under the chairmanship of B. W. Huebsch, established a booksellers' school that included lectures on such topics as the psychology of bookselling and offered a course in bookselling at the West Side YMCA.

These opportunities coexisted with continuing concerns about the role of women. In bookselling as in the library, gender became an area of debate as booksellers considered options for the survival of their profession. Approximately eight million women were part of America's workforce in 1916, and roughly seventy thousand women were enrolled in undergraduate

programs in America's colleges and universities. Although a study of nearly eleven hundred Bryn Mawr graduates revealed that somewhat over half had entered marriages or professions (generally teaching), about one quarter nonetheless remained both unmarried and unemployed. What, Barnes asked, should the growing numbers of educated but unemployed young women do?

Women had historically shied away from bookselling and, as in other professions, gained acceptance only after a struggle. Of a total membership of 343 in 1913, the American Booksellers Association (ABA) claimed only about a dozen women, largely because many booksellers, and frequently women themselves, agreed that females possessed little or no business aptitude At an ABA meeting in Philadelphia in 1915, at which not one woman was present, members objected to the recruitment of more women into the field. Critics declared that women had "no financial skill and no interest in commercial life. Their whole tendency is to spend, and they are not only impatient of financial details but incapable of mastering them. . . . The most educated women in the community are probably doing less to create an intelligent public attitude toward property than any other equivalent group of people in our midst. Many of them look down with a kind of contempt upon the money getting which makes their own spending possible."[36] Because of its palpable relationship to business and money exchange relations, therefore, bookselling seemed less service oriented and thus insufficiently "natural" to qualify as an appropriate female occupation. The rapid influx of women experienced by the library was not thus the case with bookselling. Added to "naturalness," the cost of opening a bookshop was prohibitive, especially to young women. The financial costs and risks were substantial, and the necessary financial backing was hard to come by.

On the other hand, women's presumed predilection for culture and art seemed to argue on behalf of their suitability as bookstore owners, and, as with their sister librarians, would-be booksellers appropriated this argument when and where it suited their aims. By the second decade of the twentieth century, many determined women were willing to assume the risk, and had located the backing.

When women did venture into bookselling, however, they often legitimized their decision to do so by reinforcing their claims to traditional qualities. Mary Mowbray-Clarke, co-owner of the Sunwise Turn Bookshop in New York during the progressive years, related that one publisher asked: "'What, you very inexperienced women are going to come into this highly

specialized trade which some people have spent their lives in learning! How are you going to do it?' And we said the reason we were going to try to do it was because it seemed to us as outsiders that books were not being sold as works of art."[37] Conceding that she possessed little knowledge about running a business, Mowbray-Clarke based women's claim to the profession on her belief in books as "spiritual food," meaning the presumed capacity of books to uplift, civilize, and enlighten. Selling books, Mowbray-Clarke suggested, was more a mission than a business.

Not all booksellers accepted the notion that women lacked the intellectual faculties to sell books effectively. "Surely," Barnes concluded, "a college education does not destroy the executive qualities of a capable woman." Clubwomen, often responsible for large budgets, had proven their ability to manage money, and in this way, club culture had helped pave the way for new employment opportunities. Advocates agreed that bookselling was compatible with women's service ideal and, at minimum, would help make "some reasonable return to society for the food they eat and for the clothes they wear." And, if financial security eluded a female bookseller, she would find consolation in knowing she had led "an interesting and useful life."[38]

With the financial and ideological blessing of the WEIU, opening day for the shop was set for October 9, 1916. In preparation, Mahony embarked on a project of self-education about children's literature. On a tour of several American cities, she met leading booksellers and librarians, including Alice Jordan, Caroline Hewins, and Frederic Melcher, who had a particular interest in Boston bookshops, having worked as a bookseller in that city several years earlier.[39] Above all, however, Mahony was impressed with the children's room at the New York Public Library. Like Jordan, she imitated Anne Carroll Moore's use of space in her own shop, giving it the ambiance she felt likely to appeal to children: soft colors, pictures, and mahogany antiques donated by the Union's well-to-do members. Mahony contacted several Massachusetts women's and professional organizations, describing the shop and offering to address interested organizations. Between November 1915 and March 1916, she visited twelve cities where she spread her message, co-opted from the library: "the right book for the right child at the right time."[40] Mahony believed that by getting to know children personally, adults could evaluate their reading levels and interests and divine the precise book they needed at a particular moment. In addition to her arduous travels, Mahony authored "Books for Boys and Girls," the first commercial list of children's publications in America. Containing well over a thousand

titles in its 110 pages, the list identified books by age appropriateness and subject matter. The expense of creating the list prompted criticism from union members and skepticism from others in the book business but, despite such doubts, the list was published in time for the opening day of the Bookshop for Boys and Girls.[41]

When it was time to stock the shop shelves with books, Mahony turned to her friend Alice Jordan for counsel, placing her prominently on the shop's advisory board. Jordan's support was invaluable to the novice bookseller, who valued her self-discipline, discerning mind, and serene demeanor. As director of children's services at the BPL, Jordan also offered substantial expertise on the subject of children's books, and Mahony routinely relied on her.

Unlike Jordan, Moore was not immediately enthusiastic about the shop. She made no secret of her skepticism about the enterprise, fearful that, unlike the library, the Bookshop represented merely one more retail outlet for the purpose of profit, and that it might be "too 'precious,' too 'educational,' too much of the 'cult of the child.'" But on Christmas Eve, two months after the Bookshop opened, she went to Boston with Caroline Hewins. Moore had been particularly impressed with Mahony's purchase list, and had seen to it that all New York's children's rooms had copies. Now, she wanted to see the shop for herself. When Hewins asked Moore what she thought of the shop, she replied it was "a dream come true" and that librarians ought to realize the "animating force" behind it. To the ALA, she announced that the Bookshop was "a piece of idealism which has stood the test of realization in an era of educational experiments."[42] In other words, the homelike atmosphere of the shop resembled that of the children's rooms at NYPL, and Mahony carried books of which Moore approved.

The shop's homelike atmosphere, so impressive to Moore, was also a success with children, but resembled home so much that unexpected consequences frequently occurred during the early months of operation. On several occasions, visitors came to the bookshop not to look for books but to examine the furniture or to ask where Mahony had purchased the drapery fixtures or tapestries. Here too, the distinction between domesticity and profession, private and public, was blurred. These episodes annoyed Mahony, who felt that such visitors trivialized the true missions of the Bookshop: to get children reading and to sell books.[43] Both objectives were, in Mahony's mind, a matter of community outreach and collective action, strategies fully in line with Union politics. Mahony therefore enlisted the aid of allies in the book business—local English teachers, librarians, and

children's book authors—to provide workshops, lectures, and discussion programs at the Bookshop. Saturday mornings were devoted to book conferences, in cooperation with the New England Association of School Librarians. Professionals at these meetings reviewed books and made their book suggestions available to school districts. In addition to a program of more or less continual events at the Bookshop, Mahony lectured to any organization interested in her message.

Among Mahony's ambitions for the shop, significantly, was that it should achieve professional recognition. Specifically, she was determined "to be able to answer a roll call at [the ABA] in the year 1920."[44] As it turned out, she had that opportunity much sooner. By 1917, several women had braved the financial danger and social criticism of becoming booksellers to open shops of their own, and despite its hostility to female entrepreneurs, the ABA invited four of these women to address their next annual convention: Priscilla Guthrie of the Book-Shop in Pittsburgh, Mary Mowbray-Clarke of the Sunwise Turn Book Shop in New York, Catherine Cook of the Open Court Company in Chicago, and Bertha Mahony of the Bookshop for Boys and Girls in Boston. The ABA, which held its seventeenth annual convention at New York's Hotel Astor in May 1917, shortened the usual three-day conference to two, foregoing many of the usual social events so as not to seem frivolous during wartime. In his presidential address, Ward Macauley defined the particular service booksellers might offer to the nation, echoed so often by America's bookmen and -women in response to the war. "Quite aside from the profit involved, every bookseller should place real energy behind the effort to secure general reading for books which teach us to know our country better, to love more ardently the great principle of human liberty and justice toward which America must lead the world, books that inspire to devotion and to sacrifice. . . . Let us place the aims of this Association on the high ground of real service . . . Whether as publisher, jobber or retailer, may we be increasingly united, ready for the glorious future which awaits us if we but deserve it."[45] The afternoon session of the first day, entitled "New Channels in Bookselling," was set aside for the four women booksellers to address the membership. Each in turn spoke about starting her business, and, as they addressed the convention, common themes emerged. All the women minimized their knowledge of business operations, expressed a strong belief in the appropriateness of women as booksellers, and identified three characteristics they regarded as essential to the success of a woman-run bookshop. These characteristics—remaining small but distinctive, providing service, and becoming

experts—embraced both old and new ingredients for success, juxtaposing
nostalgic ideals of the small town local merchant with the cosmopolitan,
well-connected expert. Emboldened by such early business successes as
Mahony and the others had shared with ABA members the previous May,
twenty-one women met in New York on November 13, 1917, hosted by the
Sunwise Turn Book Shop, to organize the Women's National Association
of Booksellers and Publishers.[46]

Despite Moore's initial skepticism, the first two years of the Bookshop
were so successful that Mahony became convinced that children outside
Boston wanted to buy her books, and envisioned a caravan to haul them
throughout rural Massachusetts. The idea of taking books to underserved
areas had a history roughly fifteen years old when Mahony embarked on
her project, but had typically taken the shape of mobile lending libraries.
Unlike such enterprises, however, Mahony's venture was clearly for profit.
The caravan was a bookstore, not a library, and Mahony was clear on this
point: patrons should be prepared to buy, not borrow, her books.

Bookmobiles assumed different shapes, sizes, and routes throughout
America, but their advocates shared one common belief: they regarded
traveling libraries as "sowing seed" toward the goal of permanent libraries.
The idea of sowing such cultural seed was attractive to clubwomen, who
frequently offered both ideological and financial support for such endeav-
ors in many regions.[47] For this reason, Mahony anticipated union back-
ing for the Caravan, but leaders denied support unless arrangements could
be secured to protect the organization from financial loss. Disappointed
but certainly not deterred, Mahony convinced McGregor Jenkins of the
Atlantic Monthly that such an investment would be profitable; Jenkins then
persuaded a group of publishers to underwrite the project. In return for
the group's financial backing, Mahony agreed to carry only books pub-
lished by investors, although she might order books from any publisher
at the request of the customer. In advance of its first journey, Mahony sent
associates like Frances Darling, later a Caravan driver, to speak about the
venture. Her friend Alice Jordan put her on the meeting calendar of the
NERTCL at BPL.[48]

Even while under construction, the Caravan reflected Mahony's per-
sonality and beliefs. It bore not only its own name but "The Bookshop
for Boys and Girls" and "The Women's Educational and Industrial Union"
on two side panels. It had a door on each side and a rear window covered
with orange curtains. The Caravan would be equipped with card tables and
folding chairs that the drivers assembled and placed outside under a large

awning at each stop. The "William Henry," as it was named, was regarded by its drivers as "one of America's finest experiments in bookselling."[49]

While enthusastic about her dream of book caravanning, Mahony had to focus most of her attention on the Bookshop. When it opened in 1916, she had hired two assistants, both graduates of Smith College.[50] She now realized that more help was needed, particularly during the Christmas buying season, traditionally the time when the majority of children's books were sold. In December 1919, at the urging of Alice Jordan, Elinor Whitney stopped by the shop in search of employment. Mahony was impressed with Whitney, a tall, slim woman with the kind of friendly, outgoing personality that she felt would be valuable to the Bookshop, and hired her on the spot.

Whitney shared Mahony's New England heritage and educational background. She had, in fact, also attended Simmons. Born on December 27, 1889, in Dorchester, Massachusetts, Whitney was influenced greatly by her grandmother, A. D. T. Whitney, author of several girls' books. Both of Whitney's grandfathers were connected to the sea, either as merchants or shipowners whose vessels traveled throughout the world. She spent her early life in Milton, Massachusetts, immersed in books and steeped in imagination about other cultures; like other bookwomen, Whitney recalled her childhood fondly. After a year at the library school at Simmons and two years as assistant to the librarian at the Boston Museum of Fine Arts, she returned to Milton where, for four years, she taught English to seven- to twelve-year-olds at Milton Academy, from which she herself had graduated.[51] By the time Mahony hired her as Christmas help in the Bookshop, Whitney was already quite knowledgeable about books and, when the season was over, gladly accepted Mahony's offer of permanent employment.

By 1919, Mahony's career path had already connected her to library leaders like Moore and Jordan, as well as her lifelong collaborator, Elinor Whitney. As a feeder pool for significant reform and career initiatives, the WEIU had provided the sort of crucial psychological and financial support that made these connections possible and made Mahony a typical product of America's changing attitudes about women, work, and reform. While generally respecting—and even co-opting—conventional gender thought, club women viewed the demarcation between public and private as an invitation for confrontation. In other venues, such as publishing, change came at a much slower pace. In some ways the ultimate guardian of print, publishing was the zenith of conventional literary authority, and traditionally more immune, and more resistant, to change.

Making Books

Children's Book Publishing and
Louise Hunting Seaman

O NE MORNING IN THE SPRING of 1919, George Platt Brett, president of the Macmillan Company, summoned a young employee named Louise Seaman to his office. He intended to offer her a promotion by appointing her head of the children's department he had created a few months earlier. The young man originally selected for the position had not lived up to expectations, leaving Brett irritated. Contemplating a replacement, he thought of the bright young woman he had hired a little more than a year earlier to work in the trade advertising department and had later transferred to the educational department to make greater use of her talents. She might, he hoped, do a better job than her predecessor in making the children's department a success.[1]

On the surface, Brett's decision to create such a department at Macmillan appeared innovative since nothing similar existed in any American publishing house. In reality, however, the move reflected motives and beliefs stemming from social responsibility, publishers' most deeply cherished tradition. Historically considered a "gentleman's business," publishing was nonetheless becoming big business, and Brett was vitally concerned that Macmillan should help set the pace of change in the industry without disrupting its commitment to tradition. The creation and early development of the children's department in that firm illustrate the tension between convention and innovation.[2]

Publishing's gentlemanly reputation resulted both from the nature of its relationships and from its products. Brett's quasi-personal relationships with authors—the "writing fraternity," as he termed it—marked him unmistakably as a "gentleman-publisher."[3] But much of the reputation rested

on its material products. Unlike the products of other industries, books represented "culture"; their publishers, by extension, were culture distributors. Publishers therefore polished a public image of themselves as far more than purveyors of the common, profit-driven commodities produced by other industries, claiming that theirs was a high civic calling. The justification for this image resulted from their sense that they were responsible for producing both finely made books and fine literature possessing the power to shape the morals, beliefs, and attitudes of their readers. Regarding book publishing in a democracy as a public service, publishers were devoted to creating literature that would transmit ideas into the cultural mainstream.[4]

Given the spectacular growth of publishing throughout the nineteenth century, their sense of social responsibility must have seemed particularly well placed. The reasons for growth were multifaceted, arising from the rapid and dramatic increase in literacy among Americans, the expansion of mass markets, rapid technological advances (such as the Napier and Hoe cylindrical presses and advances in papermaking), and the increasing preeminence of cultural institutions concerned with literacy, such as libraries and public schools.[5] The heightened importance of print, so critical to the authority of the library, enhanced the publishing industry's claims to authority as well.

While the established houses frequently began as and remained family businesses for several generations, they were rapidly becoming family businesses on a large scale.[6] This occurred in part because, by the 1870s, publishers had to compete against an unremitting tide of what they considered "cheap" paperbacks from the presses of newcomers like Irwin and Erastus Beadle, George Munro, and Ormond Smith, for whom profit was more important than trade courtesy or moral influence.[7] In 1884, shocking established publishers, Munro responded aggressively to the complaints about his books and business practices. "My contemporaries have called me a pirate. Posterity will have a truer word with which to characterize my work—that of reformer. The cheap libraries have broken down the . . . American wall of trade courtesy and privilege. For whose benefit was that erected? for a monopoly of publishers in this country. They dictated terms, and precious low ones too, to the authors, on the basis of non-interference among themselves. From this time forth we shall have a free field and no favor, and the longest finger takes the largest plum."[8]

While unoffended by Munro's desire for profit, established publishers nonetheless believed that the profit motive should be offset by other

attitudes they did not see in the dime novel trade. From a technical point of view, even the best books produced by Munro and others were poorly formatted, printed on cheap newsprint, usually without a cover, and often with three columns of fine print to a page. Illustrations, if included, were selected from house stock with little concern for their relevance to the text. And, in the absence of participation in international copyright law, such publishers felt no obligation to pay royalties to authors. Although piracy was common among all publishers, the older houses strove to differentiate themselves from cheap publishers and create professionalism in the business, gradually offering higher royalty payments to authors. Despite publishers' complaints about dime novels, however, one fact was quite clear to gentleman-publishers: Americans were highly interested in reading them.

Aside from the overlay of civic concern, therefore, all publishers engaged in a fierce scramble for readers throughout the nineteenth century, the consequence of which was the widespread adoption of business practices that tarnished the reputation of the entire industry. Houses turned out badly made books, in terms of both print quality and subject matter. Publishers frequently resorted to creating a book idea themselves and finding authors to accept the assignment. According to editor Edward Bok, publishing houses hired girls and women to scour the nation's newspapers and periodicals for stories that might be quickly and cheaply made into sensational novels. Publishers did not generally care where material was obtained; whatever the source, it should include plenty of murders and dramatic rescue scenes.[9] The stories were then turned over to managers who offered authors between two hundred and seven hundred dollars for a seventy-five-thousand-word story.[10] Even reputable authors, Bok claimed, were eager to supply stories for such boilerplate operations. By the 1890s, publishers were accused of having become little more than manufacturers of common commodities, the very designation they had long dreaded and sought to prevent. Even *Publishers Weekly* reluctantly conceded that the book trade was "far from satisfactory."[11] Blame was placed on the pace of social change, and even on readers themselves. The *Dial* spoke for many when it indignantly declared that the public, "created by the department store and the bargain counter," acquired its books "in delightful ignorance."[12]

As survivors of ferocious competition in the industry and as subjects of intense criticism, publishers were caught between maintaining traditional principles in book publishing, which might mean insolvency, and

responding to the public's demand for inexpensive books, which meant lowering standards. But while anxious to assure the public of Macmillan's careful attention to finely made books and "good" literature, survival dictated that Brett broaden his definition of these things. For realists, survival into the twentieth century meant executing a delicate balancing act that included adapting to broader markets with reading tastes that might very well conflict with their own.[13]

Brett had long recognized children's books as a morally legitimate and economically significant part of the publishing business, and believed that creating a department specifically devoted to juveniles would increase Macmillan's profits and prestige while still allowing him to be a gentleman-publisher. While the majority of Macmillan's receipts came from textbook sales—no small business, since America had produced more textbooks than all European nations combined since the Civil War—the house produced many other kinds of books, including a successful backlist of juveniles.[14] Some twenty years earlier, although no "department" existed as such, a woman named Kate Stephens had served as children's editor under Brett's close supervision. As one might expect of an "editor," her time was spent acquiring and evaluating manuscripts and negotiating contracts with authors and illustrators. But the position had not provided autonomy, forcing Stephens to clear nearly all editorial decisions directly through Brett, who used her more as ambassador than editor in any modern sense. Real authority over what books were printed and when, what topics were appropriate for children, how much was paid, and the size of a print run remained squarely with him.[15]

Yet, several things in publishing—and in America—had changed since Stephens's editorship at the close of the nineteenth century, and Brett understood that the responsibilities and authority of the new children's editor required expansion. Mass markets confronted him with a singular reality: he could no longer afford the luxury of reading all the manuscripts and making all the decisions. The personal oversight of all production aspects, from manuscript acquisition to final printing, became increasingly difficult for publishers to retain even though such involvement had been a defining characteristic of the industry's identity. The rapid proliferation of books throughout the nineteenth century—at Macmillan and elsewhere—denied publishers the ability to preserve such tight control over each and every publication decision and, even if they had time, they no longer personally possessed the expertise needed to make such decisions in widely disparate fields of knowledge. Even editorial assistants like Stephens, who

had helped to sift through incoming manuscripts on a fee-for-service basis, were inadequate to meet demand.[16]

Gradually but persistently, therefore, publishing authority drifted away from the gentleman-publisher toward a new middle layer of professionals: carefully selected editors on whose taste and judgment publishers could rely. By placing children's books in the hands of an expert, Brett hoped his new department would demonstrate to the public an awareness of, and commitment to, improved books for children with minimal disruption to past publishing practices. The qualities of editorial candidates were thus obviously critical. Louise Seaman, he hoped, possessed those qualities.

The public had long wanted quality reading material for children. During the seventeenth century, children's books were generally catechisms and moral teachings aimed at indoctrinating children into the beliefs of their elders. Children were exposed early to adult literature graphically portraying the consequences of godlessness or extolling the advantages of an untimely demise. Such books have been characterized, with understatement, as "gloomy."[17]

As fiction became more acceptable, signaled by the appearance of such books as Defoe's *Robinson Crusoe* and Swift's *Gulliver's Travels,* didacticism in children's literature shifted from moral to social object lessons. The writing of Maria Edgeworth, Samuel Goodrich, Jacob Abbott, and others encouraged children to glean lessons that were more earthbound, tied to social relationships and a "gospel of usefulness." Set in the New World and with characters who articulated American dispositions and social values of thrift, obedience, hard work, and upward mobility, children's books in America became "American" by the 1820s.[18]

Then, at midcentury, children's books entered another new phase, stemming largely from changes in the genre's characters; children's fiction, like adult fiction, became more realistic. To be sure, stories continued to reinforce prevalent social attitudes, but characters were no longer mythic or merely symbolic, less likely to resemble Eva (*Uncle Tom's Cabin*) and more likely to display "normal" childhood traits of mischief or personal ambition. A great many children's "classics" were produced during this so-called first golden age, defined by the work of such authors as Louisa May Alcott, Robert Louis Stevenson, Mark Twain, and Mary Mapes Dodge.[19] Good picture books still had to be obtained from such European illustrators as Kate Greenaway, Randolph Caldecott, Walter Crane, and Leslie Brooke, but by the last decades of the nineteenth century, American illustrators—most

notably, Howard Pyle—achieved prominence and contributed to the over-
all richness of the period.[20]

At the same time, however, American youth patronized the dime novel
trade with the same zest as adults. To the alarm of antitrash campaigners,
dime novel publishers created libraries specifically targeted to a youth
market, beginning with Beadle's Half-Dime Library.[21] Most were about one
hundred pages long, with roughly eighty thousand words or, in the case of
the Half-Dime libraries, about half that. The novels were adventure stories,
sensational accounts of life on the frontier or at sea, some featuring folk
heroes such as Buffalo Bill or Davy Crockett. But after the 1880s, detective
fiction became the principal subject of dime novels, including such famous
characters as Deadwood Dick, Spring-Heeled Jack, and Rob Roy. One such
British novel was the notorious *The Wild Boys* (1866), set in the sewers of
London. The book's adventures included "body-snatching doctors, a bare-
breasted woman flogged by her uncle, ravishings, mutinous convict ships,
and countless corpses." A rerun of the serial was stopped by police since
adults, viewing such "trash" with suspicion, considered these books well
outside the confines of "real" literature.[22] But as children's books flooded
the market, the profit margin for publishers became more slender, encour-
aging further erosion of quality. Selling for anywhere from twenty-five to
sixty cents at dry goods counters, children's books were frequently made on
the cheap by cribbing together what *Publishers Weekly* described as "shreds
and patches of information picked up along the highways and byways of
literature."[23]

Brett was undoubtedly aware of the antitrash campaign, conducted on
many fronts, including children's periodicals. Launched specifically to com-
bat the popularity and bad influence of dime novels and penny dreadfuls
on children, the magazines were run by authors and editors eager to save
and redirect America's youth.[24] Of them all, *St. Nicholas* represented the
high-water mark of what has generally been considered the golden age
of children's periodicals.[25] Conceived in 1870 by Rowell Smith, a founder
of *Scribner's Monthly,* the periodical was distinguished by its high quality
fiction and included in its early issues stories by individuals who later be-
came some of the best-loved juvenile authors. Among them were Rudyard
Kipling, who was so impressed with the magazine that he allowed the first
American printing of the *Jungle Book* stories to appear there in 1893, and
Mark Twain, who authorized the serialization of *Tom Sawyer* beginning
in the same year. In addition to fiction, *St. Nicholas* included poetry, pages
of puzzles and riddles, and a correspondence column. One of the most

popular features of the magazine, started in 1899, was the St. Nicholas League, a department of the magazine to which aspiring authors under the age of eighteen could submit their writing. The early work of a long list of well-known writers was printed as a result of this column.[26]

Much of the magazine's tremendous popularity came from its energetic editor, Mary Mapes Dodge, who "felt the call" to provide literature for children that they could "belong to." The result was a "wholesome" periodical of "sheer fun" designed to "prepare boys and girls for life as it is."[27] Annual volumes, bound in red and gold, were printed in November, in time for holiday giving. Issues were read, cherished, and reread. Alice Jordan declared *St. Nicholas* "a treasure house of riches . . . the very kernel of American books for children"[28]

Thus, the final decades of the nineteenth century witnessed a glut of children's books with wide variations in quality. As the twentieth century opened, children continued reading nineteenth-century classics, but during the 1910s complaints against publishers for failing to stay abreast of changes concerning the attitudes, education, and needs of children gained momentum. Individuals representing a broad range of professions, including psychologists, behaviorists, librarians, and schoolteachers, argued persuasively for the reform of publishing and the special needs of the young. In 1919, Lida Rose McCabe of the New York *Sun* insisted that juvenile authors were "behind the times" and encouraged them to visit children's rooms in public libraries and "awaken to the . . . readers they are up against."[29]

Such challenges, some of it from bookwomen, compelled Brett to respond. The end of World War I convinced him that the peace and prosperity he anticipated for the 1920s would result, among other things, in expanded book sales for Macmillan. Thus it seemed a good time to invest in a children's department. Although publishing for children was at an all-time low in 1919—only 433 new titles appeared that year—Brett recognized that children's books, together with fiction, had accounted for more than 25 percent of the publishing total since 1904.[30] Convinced that more readers and more interest in reading were evident, he and other publishers optimistically viewed their trade as on the "threshold of a new American era."[31] Old-timers like George Haven Putnam, Henry Holt, and Edward P. Dutton were passing from the publishing scene, and new houses continued to emerge.[32] But the "new era" would not flourish without careful cultivation. Some of the old ways of doing business, Brett recognized, required modification.

At Macmillan, in particular, prosperity was already underway. It was, after all, the wealthiest of all American publishing firms, whose story began in 1869, when the British company sent Brett's father, George Edward, to set up an office in New York. Originally located on Bleecker Street in Greenwich Village, the business prospered through its early years and, in 1874, Brett engaged his son as a salesperson for the firm.[33] In 1890 the younger Brett officially took over the management of Macmillan's American concerns when Brett senior became ill and, later in the decade, died. The reorganization of the British Macmillans in 1896 severed the ties between London and New York, leaving Brett junior president of Macmillan. Gradually thereafter, Macmillan became a publishing firm in its own right rather than merely a retail outlet and distributor.[34]

During his tenure, Brett dominated Macmillan, consistently demonstrating sound business judgment and earning the respect and watchful eye of other publishing firms.[35] When he assumed leadership, Macmillan was a fifty-thousand-dollar-a-year business; when he retired in 1931 it was a multi-million dollar enterprise. An optimist, Brett believed that the company's success depended upon obtaining good manuscripts, selling efficiently, and paying sharp attention to business details, a creed he extended to children's books.[36]

Apparently, Brett's only hesitation about appointing Seaman to head the children's department was the fact that she was a woman. By 1919, Macmillan had hired more women than ever before, but not as department heads, as Brett intended to make abundantly clear in his conversation with Seaman. Publishers in general had recently begun hiring more women, partly in response to pressure from the suffrage movement. At the conclusion of the war, in fact, eighty-two of ninety-three houses surveyed actually favored the employment of women, although not necessarily in high-paying or more prestigious jobs. At the moment that Brett prepared to offer Seaman the editorship, roughly two-thirds of the women in publishing continued to be employed in low-paying positions, with slim hope for promotion. Of the 1,406 women reported in the survey, 826 worked in clerical and stenographic jobs, 259 in editorial departments, and 321 in publicity and promotional work. Publishers projected adding 340 women per year to their staffs, 230 of whom would take clerical support positions. The rest were divided between editorial and publicity functions, more or less maintaining the prewar ratio.

Still, publishers expressed a desire to retain specially trained women who could eventually be promoted to managerial positions, including editorship.

For this, they were willing to pay wages of six to fifteen dollars per week at the low end, and twenty-five to one hundred dollars per week at the high. The houses employing the largest number of college-educated women were those, like Macmillan, largely concerned with textbooks. In these houses, college women generally represented 20 to 30 percent of female employees. Among general publishers, however, the proportion of college- to non-college-educated women was much lower. Two New York houses reported that none of their female employees were college graduates; in a third, only 13 of 107 female employees were college educated. Nor was college training reflected in the wage scale; noncollege women frequently received the same salaries as college women.[37] For employers like Brett, in other words, "specially trained" did not necessarily mean college educated. In 1919, therefore, personality and experience remained crucial determinants in job promotions among women in publishing.

In her office that morning, Louise Seaman could not help but wonder—perhaps nervously—why Brett had summoned her. Preparing to meet with him, Seaman recalled her first conversation with Macmillan's president four years earlier when she, newly graduated from Vassar, was in desperate need of a job. At that time, Brett had refused to hire her, claiming that it was beneath her social status to work as a file clerk or a typist, "the only sort of work we have here for women."[38]

The "social status" to which Brett patronizingly referred was not altogether apparent. Like other bookwomen, Louise Hunting Seaman did come from a relatively comfortable background. Born in the Dutch suburb of Flatbush in Brooklyn to a railroad accountant and an artist on June 29, 1894, she was the oldest of four children. She attended both private and public schools, including the Packer Collegiate Institute in Brooklyn, where she received a classical education. At the urging of her English teacher, Seaman's parents allowed their daughter to attend Vassar, a decision she regarded throughout her life as "a great kindness that changed me and my future."[39] She loved Vassar and found that the free elective system in particular introduced her to fields of knowledge she would not otherwise have pursued.[40] She joined the staff of the college's literary magazine; later, the staff selected her to edit the college's weekly newspaper, an opportunity she anticipated would prove important in her life's work and pursued vigorously.[41] While at college, Seaman also developed a close, lifelong friendship with classmate Elizabeth Coatsworth, who not only fueled Seaman's literary interests but also gave shape to her view of the world by sending Seaman long, detailed letters from her extensive travels.[42]

Brett's had been only one of many rejections from publishers as Seaman sought employment after college graduation in the summer of 1915. Her education was adequate, but the only women working in book publishing typically gained entrance either by virtue of kinship with publishers or else in the lowest paid positions. Women between these two extremes were generally absent from publishing, largely because management structures contained few midlevel positions for which educated—but not socially connected—women could compete.

On the surface, more opportunities were available to her than to her late Victorian counterparts twenty years earlier, but it was still quite likely that a woman's college education overqualified her for available professional choices after graduation, or that few professions appropriate for her level of education admitted women.[43] Seaman could not even type, and her round, childlike face did not help matters. In most cases, she did not make it past the employment managers, although occasionally she met with an editor. Despite writing samples and glowing letters from professors, they all turned her down. One frankly advised, "Come back, sister, when you've grown up." Throughout the hot summer, Seaman crossed name after name of potential employers off her list. Discouraged, she envied classmates who, after graduation, had gone to Europe to work in war hospitals or for the Red Cross. Indeed, her job search became sufficiently discouraging to prompt her to enter teaching, one of the few professions that traditionally welcomed women.[44]

For a time, Seaman taught elementary classes in English, history, and music at a private school in New Haven. She remembered her students there fondly and, although she was "scared stiff" and struggled with feelings of inadequacy, discovered that she loved teaching. Occasional incidents reminded her that she had not attended Vassar to teach elementary school. In one case, the wife of a Yale professor proudly presented her with a castle made entirely out of Borax soap cakes to help with classroom instruction on the Middle Ages. Seaman accepted the gift graciously but felt, like Mahony, that her work was trivialized.

But New Haven had another appeal: the possibility of study at Yale, which had only recently opened its graduate programs to women. Eighty women were already enrolled, and Seaman thought she might like to join their ranks. She arranged an interview with the dean about her plan but, once again, her young appearance was problematic. "Graduated rather young, didn't you?" he asked. "Dear, dear! Are you telling the truth about your age?" Seaman quickly asked him to let her prove her "mental age," a

shrewd response that earned her an immediate and long-lasting friendship that sometimes bestowed special favors. In one instance, the dean smuggled Seaman into the Elizabethan Club, where a librarian opened the safe, allowing the thrilled student to hold Yale's folios of Shakespeare. Other professors were less generous, denying her entrance to their classes on the basis of gender. In any case, Yale offered few courses that fit her teaching schedule, and she was unable to complete a master's degree.

After two years, the New Haven school acquired a new principal who quickly informed Seaman that because she had not married, it was time she "tried New York." Seaman, shocked by the "tactless" dismissal, was soothed by the fact that the new director arranged for an interview with Carl Van Doren, then principal of the Brearley School. Turned down, however, for lack of experience teaching older girls, Seaman again found herself jobless in New York. The idea of working with her hands was appealing and she decided she might enjoy book printing. She went to see George Brett again, but this time with a letter from one of Macmillan's top manuscript readers, now married to a former Vassar classmate. With this inside track, Brett hired her at once and assigned her to trade advertising at twenty dollars a week. Seaman, although elated, had mixed feelings. America had entered the war in Europe, causing her brother and several "old beaux" to enter military service. She was envious; "Book work," she claimed, "didn't seem the right way to take a man's place."

Despite her misgivings, Seaman accepted the job more eagerly than her boss, Scudder Middleton, accepted her arrival. Declaring himself "surrounded" by "all these useless women," her new boss grudgingly gave her a desk and a copy of Macmillan's catalog, suggesting that she would be the first person who had ever read it and expressing the hope that it might "touch the heart of the Great White Father [Brett] so he promotes you away from me." After this turbulent introduction, Seaman settled into her new position and became more familiar with Middleton, a "famous figure" of the 1920s who had authored one small volume of poetry. Frequently late to work and hung over, he put his feet up on the desk, sent his secretary for ice water, and told his "harem" his adventures of the night before.

Seaman did as she was told and read the catalog of several hundred double-column pages, but clearly did not regard herself as a member of her boss's "harem." In spare moments, she wrote poetry on the job, and when one of her poems appeared in the New York Times, Middleton was angry. "Well," he said, "get to work. Try a circular on Wells' Joan and Peter, here are the galleys." He also assigned her to write a booklet on the three-volume

Life of Gladstone by Christopher Morley. Her friend and coworker Rebecca Lowrie helped Seaman get through the project, and a grateful Seaman considered her a mentor for many years. This relationship undoubtedly shaped her lifelong commitment to mentoring women in literary careers.

A few months later, Brett moved Seaman to the educational department and raised her pay to twenty-five dollars a week. There she worked under an Irishman named Callahan, assigned the task of "taking the Catholicism out of . . . American History." When the war ended a few months later, Seaman recalled, "we all leaned out of the windows of [Macmillan], cheering or in tears, as decimated regiments marched proudly down Fifth Avenue. My brother came home, shell-shocked from bombing submarines off a converted yacht, and went back to college. We didn't realize it, but we were living in a new world."

Now, a little more than a year after she was first hired, she stood, once again, in front of George Brett. Settling comfortably back into his chair, thumbs in his vest, pince-nez gleaming, neat gray beard thrust out, Brett came directly to the point, proposing to make Seaman the next children's editor. "I suppose that's a subject on which a woman might be supposed to know something!" he commented. Concealing her anger, Seaman suggested instead that her teaching experience "might have prepared me for it." Seaman's irritation with Brett's assumption situates her in sharp contrast to Anne Carroll Moore, Alice Jordan, and Bertha Mahony. Unlike the other women, who were significantly older and accepted "natural" knowledge of children as the legitimate basis for their professional roles, Seaman believed that college and employment, not gender, had prepared her to accept Brett's offer of editorship. Unaware of (or ignoring) Seaman's anger, Brett continued, "You may try it. Bring ideas to me, along with your weekly manuscript list. Children's reading . . . should aim at building their character, shaping their morals. We have a long list of classics, as you know. You will have plenty to do, filling that out and you should unify them. You are a department head, but for the present, we shall not make that public, for only men are the heads of departments. You will be called editor, but you will be responsible, as they are, for your own manufacturing budget, your catalogue, et cetera. Check your sales every day—I will route the blue slips to you. Your salary will be thirty dollars a week. Good morning, Miss Seaman."[45]

This statement contained key points that structured Seaman's role as children's editor. First, although Brett recognized that traditional authority structures were undergoing significant changes, he hesitated to relinquish

control over publication decisions. Second, the statement reinforced his commitment to male privilege. Brett's initial appointment of a male editor to the position and his insistence on having the extent of Seaman's responsibilities remain secret demonstrated that he did not intend to abandon male prerogative. Still, he accepted the possibility that a woman's performance as editor could equal—or in this case, surpass—that of a man. To that extent, his decision was forward looking, relative to his contemporaries, although based on the conservative assumption that women were "supposed to know something" about children. In this way, Seaman's relationship to Macmillan resembled those of Moore and Jordan to their libraries twenty years earlier: new professional space often derived from presumed "natural" knowledge, whether or not the promotee conceded such knowledge. Nonetheless, gains were made. Louise Seaman was now the head of the first commercial children's department in America. She left Brett's office, delighted, and later celebrated with friends at a bistro on Sixth Avenue.

Until the end of her life, Seaman considered her appointment to the children's position the result of "sheer luck," possibly representing an undervaluation of her education and ability to function in the "business world," typical cultural cues that women frequently received about their potential for success in business. Later recalling the appropriateness of Brett's decision to appoint Seaman, Bertha Mahony likewise revealed the extent to which such cueing influenced her own thinking; selecting good books for children, she commented, was "more like dressing a little girl than anything else. One chooses every detail of her wardrobe in harmony with herself. . . . So with a book . . . women . . . bring particular interest and ability."[46]

Some were concerned about Seaman's new role, however. In her autobiography, Seaman recorded that Frances Hackett, a reviewer for the *New Republic,* disapproved of Seaman doing children's books and working for Brett, "an old tyrant."[47] Seaman herself anticipated that new personal opportunities would ensue from her expanded professional role and furnished her small, second-floor apartment on West Tenth Street with the donations of well-wishing friends and family members. Although she did her "cooking in a cupboard," the new apartment established Seaman as "a bachelor business girl."

After the initial excitement subsided, however, Seaman became concerned about her qualifications for the job of children's editor, continuing to resist the idea that her sex automatically prepared her for work with children. "What," she wondered, "did I really know about children? . . . How could one ever decide what books for which children, and help the

books to reach them?" In addition to questioning assumptions about gen-
der, Seaman hesitated to make reading decisions for others, something that
had apparently never troubled Brett. Her personal struggle with profes-
sional qualifications thus blended with less personal concerns about the
nature of editorship itself. And she recognized that her experiences with
children were limited. Aside from teaching middle- and upper-class girls
in New Haven, her exposure to children included only one summer vaca-
tion as a wartime substitute teacher at a large children's convalescent home
in Westchester County. While limited, however, this experience had created
an essential lens through which Seaman viewed children. The students in
Westchester were quite different from those at New Haven, consisting of
boys from city slums who frequently suffered from severe physical handi-
caps but who nevertheless "wanted to learn, not to play." Once a week,
Seaman followed the doctor of the convalescent home on his rounds and
witnessed, perhaps for the first time, the "miracles of modern surgery,"
opening her mind to "the lives of those crippled boys from homes with so
little to lead them to books."[48]

The Westchester episode was a defining moment in the development of
Seaman's ideology of children and books, and their enthusiastic response
to stories and poems left an indelible impression on her attitude about chil-
dren and their need for good books. Central to her reflections about the
events of that summer were images of children impaired and ailing, bereft
of the "right" to childhood through either physical infirmity or social dep-
rivation. Equally prominent was a clear connection between such depriva-
tion and an important remedy: books. The body might be impaired or the
home impoverished, but books, to Seaman, provided an essential ingredi-
ent of a fulfilling life. This could be interpreted as a patronizing, simplistic
solution to complex medical and social dilemmas, spoken from the per-
spective of health and relative prosperity. Whatever the attitudes behind
her conclusions, however, the importance of books to children was, from
that time, solidified in her mind.

By the time Seaman assumed her new position in June, Brett had made
several key administrative decisions about her role. First, her work would
be limited by the amount of time he was willing to allow her to devote to
it; she would continue certain responsibilities of her old job in addition to
those of the new.[49] Brett might have felt that a full-time children's editor
was too expensive or that, possessing "natural" knowledge of children, Sea-
man's workload would not be that demanding. Whatever his reasons, Brett
also initially kept her under the close scrutiny of trade editor Harold Strong

Latham. A 1911 Columbia graduate, Latham was originally hired for the advertising department but moved to the editorial staff within a year. With the exception of titles in the religious books department, Latham was in charge of all trade books, including those for children.[50] An author of several books for boys, Latham's authors saw him as "genial" and "sympathetic," and it appears that Brett wanted him to teach Seaman the role of editorship.[51] She regarded Latham as a "very kind soul" who mentored her "in bits of time" as his own hectic schedule permitted. Struggling "dazedly" with the new responsibilities of her job, which included a large manuscript list, manufacturing orders, and reprint slips, and representing Macmillan at Book Week in November, Seaman settled into the position, discovering immediately that "one must cope with figures, with sales and profit and loss. How could I be any good as a business woman? I would have the backing of the greatest American publishing house of its time. How could I get on with its president? Well, the die was cast." At her desk next to Latham's, privacy was impossible. Phone calls were unavoidably overheard, and private conferences with authors were conducted in the hallway outside the elevators.[52] Sometimes she saw Brett there, "lifting his derby ironically and pulling out his watch, if I were late."[53]

When she was not familiarizing herself with the juvenile list, Seaman continued writing jackets or press releases for adult literature, a task she thoroughly enjoyed. When time allowed, she was thrilled by opportunities to meet authors. On one occasion, the poet Edwin Arlington Robinson came to Macmillan specifically to meet her. "One day an engraved card was brought in to me—Mr. Edwin Arlington Robinson," she recalled. "I pulled over a chair, licked an inky finger, rose to face the tall, dark-eyed, spectacled person who carried a malacca stick and wore spats! He looked about humorously, then spoke very softly so that the busy desks on either side couldn't hear." Robinson complimented her on the jacket copy she had written for his new book and, in the course of the conversation, invited himself to her apartment for tea. A friendship resulted that lasted until the poet's death. She also enjoyed friendships with John Masefield, Vachel Lindsay, Brooks Adams, John Dos Passos, and Katherine Anne Porter. Seaman longed to be part of "the literary turmoil" of the decade, sometimes worrying that becoming the children's editor would eliminate that opportunity from her professional life and fearing the segregation that other bookwomen seemed to welcome.[54]

Although obtaining the editorship at Macmillan was not easy and, for the moment, she had more questions than answers, Seaman's new job was

highly significant. It carried implications for the future of women in the publishing industry by creating a point of entry for women into managerial positions. As her appointment demonstrated, the ability of women to enter the traditionally male world of publishing no longer relied upon kinship as it so often had in the past. Success as a children's editor, therefore, raised the question of whether, perhaps, women might also be successful in a broader range of publishing occupations.

Anne Carroll Moore. Courtesy of the Horn Book Archives at the Simmons College Archives, Boston, MA. Reproduced by permission of the Horn Book, Inc., www.hbook.com.

Alice Jordan. Courtesy of the Horn Book Archives at the Simmons College Archives, Boston, MA. Reproduced by permission of the Horn Book, Inc., www.hbook.com.

Bertha Everett Mahony. Courtesy of the Horn Book Archives at the Simmons College Archives, Boston, MA. Reproduced by permission of the Horn Book, Inc., www.hbook.com.

Louise Seaman Bechtel. Courtesy of the Horn Book Archives at the Simmons College Archives, Boston, MA. Reproduced by permission of the Horn Book, Inc., www.hbook.com.

May Massee. Courtesy of the Horn Book Archives at the Simmons College Archives, Boston, MA. Reproduced by permission of the Horn Book, Inc., www.hbook.com.

Elinor Whitney Field. Courtesy of the Horn Book, Inc.,
www.hbook.com.

Becoming Experts
and Friends

T HROUGHOUT THE 1920S, bookwomen advanced their individual careers by acquiring information necessary to support claims of expertise, improving the output—both in quantity and quality— of the products they supervised, encouraging recognition of achievement, expanding the specialized territory over which they presided, and cultivating relationships that resulted in both professional sustenance and personal friendship. Emerging or deepening friendships constituted networks of mutual reliance that each woman valued in affirming her own expertise.

In addition to the expansion of individual expertise, the beginning of a collective culture among bookwomen was evident by 1924. The creation of the Newbery Medal in 1922, the first professional reward in the field of children's books, lent prestige, encouraged new talent, bred a sense of competition, and heightened interdisciplinary interest. Children's Book Week, rich with the rituals of preparation, selection, anticipation, and celebration, became an important event around which bookwomen gathered as a community. The creation of children's departments in publishing houses provided formal institutional expression of bookwomen's vision of better books for children.

Professional culture, individual expertise, and networks of friendship assumed critical significance, but while bookwomen gained ground in many areas, they were also severely challenged by other child experts during this decade. The language of bookwomen, still heavily steeped in nostalgic metaphors of home and family, remained easily comprehensible, if ill defined, to those outside the book industry, but it put bookwomen at odds with new scientific child experts. The persistent use of "common

sense" language, initially useful for establishing professional claims, was in one sense *too* democratic to qualify as expert language, which typically utilized exclusionary discourse. In another sense, bookwomen's persistence in privileging certain books and certain kinds of knowledge over others was, on the surface, far from democratic.

"A book is . . . a friend and a dream": Anne Carroll Moore and Alice Jordan

In the early 1920s, bookwomen voiced their conception of the model children's book. Alice Jordan claimed that it was "less often found among books of information than among books of any other class." It should, she argued, spark "contagious enthusiasm" and an "animating quality."[1] A fuller definition of the desirable characteristics of children's literature appeared in the writings of Anne Carroll Moore, who, in contrast to many Americans, remained optimistic in the aftermath of World War I. She hoped, in fact, that the war would ultimately produce better living conditions, not so much materially as mentally. She was even grateful for the paper shortages and labor unrest that drove up book production costs, confident that these realities would prompt publishers to become more discriminating in their publication choices.[2] Most of all, she continued to hope for a renaissance in children's literature. The commencement of Children's Book Week had been encouraging, but it was simply not enough, Moore believed, to prime the pump for better children's books. Thus, when Eugene Saxton, editor at George H. Doran, offered to compile her *Bookman* essays for publication, she readily accepted.[3] Published in 1920, *Roads to Childhood* immediately became a key source of literary criticism about children's books while simultaneously establishing her international reputation. After its publication, European publishers viewed Moore as a "major critic" of children's books both in America and "without peer" in England.[4]

Tellingly, the *Library Journal* advertised the book as "human" and "informal," not "theoretical."[5] Far from theoretical, indeed, *Roads* revealed both Moore's love of books and her beliefs about children, which had much to do with her own childhood. "The sense of wonder and mystery . . . the sound of music," she claimed in *Roads*, "are present in my earliest recollections." Her nostalgic personal recollections prompted her to attempt to recreate similar experiences for other children, although she was not insensitive to the fact that many children did not share her New England values or the relative affluence of her own upbringing. On the contrary, her

awareness of some children's lack of financial and social resources made her determined that, regardless of their circumstances, children were entitled to what she considered quality books. In Moore's opinion, two classes of books existed: creative and informative. Of the two, creative literature, she claimed, was more important, "belonging to the very essence of literature, timeless and ageless in its appeal."[6]

When discussing the purpose of books, bookwomen frequently employed metaphors of place and journey. In *Roads*, as the name itself implies, Moore's prevalent metaphor was a pathway. Regarding life as a journey, she insisted that books provided "assured companionship" along the way.[7] Jordan also utilized the metaphor of place and companionship, declaring that books carried the reader "into a world outside his own experience . . . [like] gates opening on far horizons of fact or fancy."[8] Language also frequently alluded to sacred images and texts, a common practice in some literary circles. The publisher Walter Hines Page, for example, once noted, "A good book is a Big Thing, a thing to be thankful to heaven for. . . . Here is the chance for reverence, for something like consecration."[9] The editor Montrose Moses claimed that lost childhood was a "yearning that passeth understanding."[10] As Christine Jenkins and Betsy Hearne have noted, bookwomen included in their writing hefty doses of such words as "joy," "spiritual," "truth," "hope," "excellence," "soul," "richness," "delight."[11] This vocabulary, while vague by contemporary standards, was familiar to many Americans as part of a religious preaching heritage. Resting on assumed common values, that tradition was less interested in precision than in inspiration.

In any case, *Roads* amounted to a call to arms for reversing what Moore saw as the dismal state of literary affairs in children's books. She was particularly annoyed with publishers, whom she accused of indifference to children. Believing that hastily prepared and ill-planned books were the cause of an early distaste for reading, she challenged one publisher to identify children who would be interested in such books. "I really don't know," replied the publisher. "They *are* dull of course, but children must learn a great deal from them unconsciously." The remark infuriated Moore, who saw children's books as "strewn with patronage and propaganda, moralizing self-sufficiency and sham efficiency, mock heroics and cheap optimism."[12]

Moore's overriding complaint was simple: there were not enough good books for children. Her belief was fueled by librarians' repeated complaints about book shortages; fairy tales and books for the youngest children were in particularly short supply. Branch librarians did their best to make use of existing resources, encouraging children to attend story hours and to

read books in the library instead of checking them out, to allow the great-
est number of children to benefit from them.[13] Still, book stock overall
was chronically depleted, leading to "restlessness" among young patrons.[14]
Some publishers took Moore's call for a new golden age in children's books
seriously and began attending a series of evening lectures she offered in the
children's room. There, publishers encountered librarians and solicited
their opinions about publishing for children.[15]

Publishers were not the only recipients of Moore's criticism in *Roads*.
Authors were criticized for their lack of imagination and for their anxiety
about being "juvenile" writers. Believing that writing for children was per-
ceived as requiring less skill than writing for adults, some authors worried
that their professional reputations would be adversely affected, and she
viewed this as an occupational hazard to be overcome. Likewise, she disliked
complacent authors who, she argued, treated children's books as "an old-
age pension." Behind these attitudes, she claimed, were institutions of higher
education that had failed to help develop a robust literature for America's
children and perpetuated in students a resistance to writing for children.
She viewed the situation as a "grave defect in our national education."[16]

Parents, according to Moore, were also remiss in their responsibilities.
Holding up Theodore Roosevelt as a proper role model because he read
aloud to his children, Moore predicted that "if several thousand fathers of
American families would begin to read aloud to their children on a similar
basis . . . we should see great changes in many publications we have recently
reviewed."[17] By more direct involvement with their children's reading lives,
parents might serve dual roles, first as models of book appreciation, and
second as discriminating consumers whose expectations would affect the
market by pressuring publishers to improve book quality.

For Moore, books were clearly much more than what they seemed on
the library shelf. Reading and books, as act and artifact, represented a code
for discussing an entire constellation of behaviors and institutions, the
litmus test of responsibility and intelligence, reliable barometers of both
public *and* private matters. By them, the nation would be prevented from
sinking into selfish materialism, thus preserving family and civic life. In an
environment of brisk change, "classic" books provided mental grounding,
a link with a past perceived to be quickly fading. To a bookman or -woman,
books represented the protective barrier against the turbulence resulting
from those changes, the blueprints for social stabilization and betterment.

Beyond ambivalent authors, indifferent publishers, and recalcitrant par-
ents, Moore identified the lack of sustained literary criticism as the primary

deficiency in the field of children's books. Such a lack promoted "mediocrity, condescension, and lack of humour" instead of the originality, competition, and distinction she desired. Moore urged others to recognize that "children ... are in themselves ... far more interesting than anything which may be written for their benefit or improvement—that writing for their reading is an art ... [that] can be sustained only by vigorous and informed criticism."[18]

Criticism, for Moore, was no mere intellectual exercise. She argued that the best literary criticism should include the opinions of children themselves, whom any credible critic had an obligation to consult.[19] She routinely did so herself, eliciting the thoughts and opinions of patrons of the children's room before issuing comments about any book. Many library colleagues were pleased that Moore had "exposed all the worn-out platitudes and judgments that have grown up around the juvenile."[20] One librarian from Buffalo exclaimed, "I am *so* glad that real criticism of children's books has come in my day."[21]

Technically, Moore's claim to inaugurating literary criticism of children's books was inaccurate. During the nineteenth century, children's books were typically reviewed by literary monthlies, book trade journals, and children's magazines. Depending upon the availability of the book and their own attitudes about children, reviewers' assessments varied from simple two- or three-sentence mentions to more elaborate descriptions, such as those found in *Athenaeum* or those written by thoughtful editors such as William Dean Howells (*Atlantic Monthly*) and Susan Coolidge (*Literary World*). The *Nation*, however, assumed the most watchful eye over children's literature. Reviewing more than six hundred children's books between the end of the Civil War and 1881, the *Nation* represented the largest reviewer of children's books in America.

It seems peculiar, then, that Moore claimed uniqueness for her contribution to children's literature, or that other bookwomen, such as Louise Seaman, supported it. It is tempting to view Moore's claim as plainly fraudulent, or else agree with one historian who argues that Moore's claim represented "an appalling absence of scholarship."[22] But since reviews were simply too prevalent for bookwomen to have been unaware of them, other explanations should be considered. First, for all her fond memories of the past, Moore wanted to separate herself and the new generation of experts from it, desiring that the business of evaluating children's books be left to those with a thorough knowledge of children's literature rather than to editors, for whom children's books represented only a fraction of professional

responsibility. Second, the importance of standard setting, particularly if tied to pioneership, can hardly be overestimated. Whoever set standards wielded tremendous influence over the cultural meaning of books and of knowledge itself.[23] Therefore, Moore's claim to be the first children's book reviewer is significant for two reasons. On one level, it further reinforced her advocacy of the rights of children to good books. On another level, the claim represented an acknowledgement of the fact that in addition to "mere" expertise about children's books, bookwomen sought the authority to define cultural artifacts that could only stem from being recognized as standard setters.

In part, bookwomen based their expertise on a repertoire of beliefs and attitudes that, they postulated, benefited children. In addition to perspectives about service to others, respect for ritual and tradition, and issues of child development, bookwomen were concerned that children view the world as community. Recalling prewar America with more nostalgia than reality warranted, many Americans embraced "100% Americanism" during the 1920s. But the intense nationalism captured by this slogan met with disapproval from some librarians, including Moore.[24] She found available books provincial, and demanded that internationalism take its proper place in American publishing, an attitude that, in fact, became a hallmark of children's publishing in the 1920s. In her opinion, the failure to establish internationalism in children's books rested with publishers who continued to publish "remnants of history and poorly drawn portraits of very dead heroes and heroines, and then have wondered why so few children or grown people seem to be interested in other countries or races." Picture books, she insisted, were central to internationalism, "not lithographs, not geographical readers . . . but pictures that make you want to go there."[25] Moore expressed her support for internationalism, in part, by a strong interest in library work in Europe. She was so concerned with the state of libraries there after the war that she went to see for herself what progress was being made. In France, she had the professional satisfaction of seeing librarians at work that she herself had trained at NYPL.[26]

Others shared Moore's interest in internationalism. Jessie Carson, director of library work for the American Committee for Devastated France, was determined to open children's rooms in that country, viewing this as an exciting and pioneering opportunity for international library work. Consequently, she encouraged her staff to establish a fund for the purchase of a modest collection of books for the Children's Colony at Boullay Thierry and urged other libraries to follow suit.[27] Clara Whitehill Hunt emphasized

the role of children's librarians in promoting international friendships among children and, consequently, world peace. Literature, Hunt exclaimed, should be used as a means of "creating a closer friendship among . . . many races."[28] In Boston, Bertha Mahony observed that books had the ability to provide American children with an international set of "friends" who could recognize the "universality of life, love and art" necessary for a "unified conscience and unified consciousness symbolized in effective world government."[29] Yet more meanings of "book": friendship, unity, world peace.

Authors also frequently espoused international friendship, arguing that with the proper books, children could and should be trained to expand their thinking beyond nationalistic beliefs. Hugh Lofting, for example, declared that internationalism was essential to the very survival of civilization and called for an end to racism and prejudice in children's literature.[30] Notwithstanding the fact that authors, including Lofting, frequently wrote from "an outsider's point of view" that portrayed other cultures in unflattering and stereotypical ways, children's literature was more likely than ever to take up international themes, an idea with limited appeal in America at the time.[31]

Internationalism might be seen as one kind of progressivism, but Moore and Jordan remained equally connected to events much closer to home. America's infatuation with progressive reform might have cooled, but librarians' dedication to progressive attitudes as an effective strategy for achieving meaningful social change had not. In Boston, for example, Alice Jordan informed "her girls" that work at the Boston City Hospital was "a new opportunity for extending library work with children."[32] The children's room at NYPL also remained intimately connected to the community. Month after month, New York's librarians submitted carefully constructed reports to Moore, often handwritten, describing branch activities in elaborate detail. Home, hospital, and settlement house visitation figured prominently as significant and time-consuming activities: the School for Crippled Children on Henry Street urgently called for storytelling; the Chatham Square staff was invited to a party at the settlement at Bowling Green.[33] Cognizant of the multitude of organizations providing active work with children, Josephine White reported to Moore the importance of realizing "how much the library is called upon to do its share."[34] Armed with several books, primarily fairy tales and history, NYPL branch librarians routinely made hospital and school visits to "bring the library to the children's minds."[35] They also visited youth organizations, such as scout headquarters, to obtain pamphlets for circulation in their branches.[36] Librarians

monitored the cultural composition of the surrounding neighborhoods by visiting public schools; when a shift took place in a neighborhood's ethnic composition, such as the increase in Italian registrants at the Chatham branch in 1921, Moore was notified promptly so that "adjustments" might be made in book stock to meet "quite different demands."[37]

Some children, undoubtedly, came to the library seeking information and reading pleasure as many adults intended them to. But, as librarians were fully aware, children came to the library for other reasons as well, some having little or nothing to do with reading. However consciously, they made their own uses for the space and, thus, created their own power within it. The library might offer temporary escape from home life, the opportunity to make or meet with friends, or the chance to win both parental and nonparental adult approval. And while Moore tried to make the children's room "warm" in a metaphoric sense, New York children sometimes utilized the space for literal warmth in the cold winter months. But while children sometimes visited the library simply to stay warm, no urging was necessary to attend certain celebrations. Authors' birthdays were high holy days at NYPL, usually celebrated by exhibits and stories about the authors and encoded with the message of literary privilege. And scores of children attended the elaborate and festive Christmas celebrations. Whether they came in response to the storytelling and candle lighting rituals or whether they were interested in the goodies and presents Moore sent to each branch is difficult to unravel and highly individualistic. Children devised their own relationships with the library, deciding when and under what circumstances that relationship might be beneficial. For their part, librarians were unfazed by the mix of motivations. Whether children were in the library to read, escape chores, or receive presents, the main point was that they were *in* the library and, therefore, in unavoidable contact with its culture.[38] For many librarians, this sense of community was powerful. At the George Bruce branch, Judith Karlson spoke for many librarians, noting with satisfaction that "the children's room has been well used and is an important part of the neighborhood and community. . . . I feel in very close touch with the children."[39]

Storytelling was more than a holiday activity at the library, and Moore continued making much use of it at NYPL. She was also delighted to discover that other bookwomen agreed with her about its importance. Seaman believed that children were "close to the rhythm of long oral cadences in old tongues."[40] The encroachment of modernity, Bertha Mahony declared, created a pressing need for storytelling. More than anything, it was valued

for its ties to tradition, its perceived potential to create community, and its usefulness in modeling for children what Anne Eaton called the "vivid sense of what it means to be able to open the covers of a book and find . . . the wonder and magic of a story."[41] The shared experience of listening to a story enriched it, creating memories and sociability that bookwomen believed were critical to human development. As new forms of entertainment—radio and motion pictures—emerged, they became more adamant that storytelling retain its place in children's lives. Advocacy of storytelling therefore operated on several levels: as a critique of modernity, an instrument of human development, and a means of creating citizens who could transcend "mere" politics. As she was prone to do, Mahony situated her comments in gendered language that privileged male readers: "Never was story-telling more needed than now. Our leaders fill us with doubt and disappointment. Our citizenry, too, seems filled with small spirit; and bent upon small goals; incapable of thinking constructively for the common good. Why is this so? Partly because we have forgotten that men must have heroes. Reading, writing, arithmetic, even the social studies and the best courses in civics do not breed them. . . . The leading of the story-teller is of this kind. The soul of the listener is moved. . . . His perception of what is important becomes clearer. Matters small and mean drop away."[42]

By the 1920s, bookwomen explicitly connected storytelling to expertise. Although Marie Shedlock made it clear that a storyteller was not "the professional elocutionist," she expressed the hope that one day stories would be told "only by experts who have devoted special time and preparation to the art of telling them."[43] Likewise, although they still viewed storytelling as an art, bookwomen did advocate specialized instruction to prepare storytellers for their career. In 1920, Mahony arranged a lecture series, held in the union auditorium, to provide such training, which included the study of Moore's writing.[44]

In their respective institutions, Moore and Jordan continued to personally oversee storytelling because it was, as Moore put it, one of the library's "gifts to youth." She created the position of supervisor of storytelling at NYPL, a position held by such well-known storytellers as Anna Cogswell Tyler and Mary Gould Davis; at BPL, Jordan placed John and Mary Cronan in similar positions.[45] By 1923, the list of permanent and guest storytellers had grown impressively, now including Carl Sandburg, Louis Untermeyer, Stephen Vincent Benet, Anne Thaxter Eaton, Constance Lindsay Skinner, Theodore Seuss Geisel, and others whose stories often kept children in the library until after closing.[46]

Children's Book Week, another aspect of Moore's work, had been so suc-
cessful in 1919 that she was dedicated to its continuation and, almost imme-
diately, viewed New York as headquarters for the event. Posters, stickers,
and a summary of suggestions for booksellers and librarians were mailed
to schools, libraries, and bookstores. The suggestion booklet outlined rec-
ommendations for exhibit development, press releases, and public speaking
engagements to spread the word to civic clubs and social organizations.[47]
Contests for best book reviews, best letters describing how children earned
money to buy a book, best Book Week posters, and best costumes (children
dressed as book characters) were held in a variety of settings to promote
the event. Prizes consisted of books, of course, donated by local book-
stores or clubs. Bookstore windows advertised Book Week, sometimes uti-
lizing books loaned by citizens. Some ministers delivered sermons praising
books and reading.[48] Frederic Melcher—still chair of the Book Week com-
mittee—went on WJZ in Newark to talk about the event, hoping to stimu-
late interest at other radio stations.[49] Moore, too, used the medium in weekly
broadcasts on WEAF, convinced that, if material were thoughtfully selected
and tastefully presented, radio could constitute another avenue of expan-
sion for librarians working with children.[50]

These efforts paid off. In 1920, Book Week drew over one hundred librar-
ians, booksellers, and publishers from the New York region alone. Moore
presided over the day long conference, whose speakers included familiar
figures in the children's book world—Melcher, Hunt, and Caroline Hewins.
In acknowledgment of its success, "Children's Book Week, A National
Movement" was the theme of the ALA's 1921 annual meeting, at Swamp-
scott, Massachusetts. Such recognition no doubt strengthened the repu-
tations of its organizers. But privately, Moore worried that the success of
children's work would prompt the very commercialization she perceived
to threaten traditional ideals. The market, she believed, had no use for val-
ues. The author Cornelia Meigs shared her concern. "It is very difficult,"
Meigs wrote to Moore, "to hold to one's ideals of what constitutes good
writing and what children ought to have. . . . The rewards are not very great
and as a result one is being urged constantly to be more practical and com-
mercial and think more about money and less about children."[51] Melcher,
however, was more optimistic about the market, asserting that "no one can
start out to make better books . . . without realizing that in order for such
books to be published and distributed there must be three thousand other
people interested in the same books. Without a growing market there can
be no real improvement in the variety and quality of the books. With the

increasing of the quantity market the quality grows in proportion to the discussion and interest created."[52]

The Swampscott conference was important for other reasons; it was a moment for the organization to take stock of progress in its work with children. By now, a much larger percentage of librarians identified work with children as an exclusive or substantial part of their work experience, underscoring notable shifts in library service during the previous twenty years.[53]

Also significant to the proceedings was the inclusion of "outsiders" on the speakers' platform. Concerned about librarians' continued resistance to connection with the commercial book markets, ALA leaders invited Melcher and Mahony to address the organization. The plan was for Melcher to discuss books from the publishers' viewpoint, Mahony to offer the perspective of a bookseller, and, to speak for the library, Clara Whitehill Hunt.[54] The ALA's choice of speakers is curious, since none of the three could truly be considered an "outsider." Melcher was well known as a powerful sympathizer with librarians' most deeply held tenets regarding "good" books. Mahony was a bookseller who, as noted, resisted commercialism and regarded books as more than merchandise. Hunt, believing that the library would hasten the return of Christ to the earth by improving the hearts and minds of readers, certainly offered no challenge to librarians' traditional attitudes about "good" books.[55] The ALA pushed its members toward market awareness, but it was a gentle push.

Lastly, the Swampscott meeting was important because Melcher approached Jordan with an idea to improve both children's books and librarians' prestige. He wished to offer, at his own expense, an annual medal for the best new children's title.[56] Moreover, he wanted librarians to select the winner. He hoped his idea would encourage librarians to become more aware of book production and view themselves as more than clerks distributing books. At the same time, he realized that the medal would offer an incentive to authors, thus stimulating the growth of children's literature.[57] He proposed to name the medal after John Newbery (1713–67), the first British publisher of children's books.[58]

Jordan liked the idea at once, and encouraged Melcher to bring it before the general membership. Members enthusiastically passed a resolution acknowledging the influence of the award in "determining a future standard of excellence," although the selection process remained undetermined. Some expressed concern about a "one librarian, one vote" process, fearing that a substandard book might be selected if the rank and file simply voted for the book they believed to be outstanding. Simple majority alone, they

argued, could not be trusted for such an important decision. Enlightened bookmanship prevailed; for the time being, ordinary children's librarians would be allowed to vote, but their opinions would be validated by a final jury of "a few of the people of recognized high standards and experience." That jury consisted of Mary Root from Providence, Effie Power from Cleveland, Alice Jordan, and Anne Carroll Moore. The next year, the jury, invested with final authority, consented to the overwhelming choice of the rank and file; of 212 votes cast by librarians, 168 favored Hendrik Van Loon's *Story of Mankind* to receive the first Newbery at the June ALA meeting in Detroit.[59]

The typical working day of most librarians, however, was less tied to events at ALA conferences than to routinized tasks, and librarians were sensitive to what they considered dismissive attitudes about their profession, even from within their own ranks. Edwin Andersen, Arthur Bostwick's successor as chief of circulation at NYPL, compared the "irksome . . . minutiae of library technique" to "crochet work," while most librarians preferred to view their work as a profession of culture-distributing.[60] Notoriously poor wages did not help the profession's reputation; unable to attract applicants for this reason, some library schools, such as the Children's Library School in Pittsburgh, closed during the early 1920s.

Among those most critical of librarians were teachers who themselves had waged a long campaign for professional recognition. Librarians believed that teachers had easy hours; teachers believed that librarians had easy work. Librarians suspected that teachers regarded them as task-oriented subprofessionals and found evidence of this attitude in school libraries, poorly staffed by those "unqualified to teach any subject in high school, but doing police service over the assembly room [with] the dignified name of librarian."[61] Insulted, librarians insisted that such poorly prepared individuals should not lay claim to the profession. Above all, librarians objected to having their profession denigrated as merely technical. "The greatest services," claimed the *Library Journal*, "are not the menial ones of checking books in and out at the loan desk, and hunting up references on a subject, marking pages with slips; but her greatest functions are to inspire the reading habit, and to teach self-dependence." The *Journal* conceded that librarians were occasionally overbearing toward teachers, but argued that condescending teachers who viewed librarians as task oriented were most at fault. Some libraries followed the *Journal*'s advice for improving the situation by mingling library and school curricula, or by assigning a reference librarian to teachers.[62]

Slowly, teachers responded to librarians' insistence that they play an integral role in public education. Interested in learning about a variety of subjects, teachers brought their classes to visit the public library, often claiming they "received as much help and inspiration as did the children."[63] Even parents occasionally patronized the children's room, most often to settle outstanding debts but also to make sure their children were truly at the library and not "spending their time shooting craps."[64] In Boston, the gap in teacher-librarian relations was bridged at Jordan's Round Table meetings.[65]

The Child's "Rightful Heritage": Louise Seaman and May Massee

The immediate postwar publishing environment complicated publishers' ability to respond to Moore's demand for more and better children's books. The cost of book production was up 100 percent over prewar costs and consequently book prices rose by roughly 50 percent during the first two postwar years. Printers could not meet publishers' demands because pulp was in short supply. Job dissatisfaction and strikes among printers lowered productivity by one-third in some cities, and the resulting labor shortages, particularly in New York and Boston, made it nearly impossible for frustrated publishers to maintain a predictable production schedule. New York and Boston were particularly hard hit.[66] In the papermaking industry, similar disputes carried on throughout 1921, making a national strike in that trade seem likely.[67] By the end of the year, however, most disputes had been settled and publishers once again became optimistic about their production schedules, although printing plants were subsequently located in small cities or rural areas to minimize difficulty with unions.[68]

At Macmillan, therefore, Louise Seaman struggled with multiple contexts that challenged her potential for success. In the midst of those challenges, she continued refining her conception of childhood. To Seaman—and many librarians—it contained powerful strains of poetic sentimentalism that were simultaneously value laden. She described children as "catapults of energy, dynamos of ideas, summer suns of affection, lonesome dark dreamers. Children—flaunting borrowed plumage, desperately flying ancient flags, laboring herculean-wise at nothing. Singing, grimacing, wide-mouthed, informative, earthy, ethereal, combustible, secretive, acrobatic."[69] She defined a "classic" as a book "so widely loved that it lives on long in print and in people's hearts. It doesn't have to be great literature . . . [or] what children like to read the most. . . . The finest and noblest of books intended for

children tell of heroism. They are the inspiration of those who, later in life, sacrifice themselves that they may secure the safety of others."[70] Classics, in short, became part of a "continuous tradition of art, poetry, learning" that will not "have to be outgrown."[71]

While Seaman doubted her ability to select "good" books for children when she accepted the editorship at Macmillan, she quickly developed a sense of legitimate authority to do so. What surfaces in her thought process are beliefs that seem, at very least, paradoxical. On the one hand, she claimed that "the moment when the book order is made . . . one of the greatest acts of a free democracy takes place." Yet, while writers and artists had "a stake in that act," she acknowledged they were "only a part of the whole"; readers, too, had a stake. On the other hand, she perceived readers' opinions as freighted with social and cultural baggage, which she summed up neatly as "the war neuroses, the muddle of tastes, and the thin-spread culture of America."[72] Her sense of fair play in proper democratic process, in other words, compelled her to seek opinions about children's books from members of a culture whose literary taste she did not trust. It is quite reasonable to suggest, however, that Seaman saw no contradiction in any of this. Along with others in the literary establishment weaned on the longstanding republican ideal of enlightened statesmanship, she felt the need to weigh many opinions about books, including those of readers. But just as enlightened statesmanship rejected universal fitness to rule, enlightened bookmanship rejected universal fitness to make decisions about good literature.

George Brett, himself the quintessential enlightened bookman and firm believer that children's books should "influence the course of events in the world" and shape children's character by introducing them to great writing of the past, occasionally reminded Seaman that mere education was secondary to these two tasks.[73] Not generally supportive of segregating children's books from mainstream literature, Seaman regarded segregation as "a phase of an educational mood that will pass and should pass."[74] Still, she recognized that segregating children created and expanded a distinct market crucial to the survival of the publishing industry. For the moment, it was also crucial to her job.

One of her first tasks as editor of the children's department was to create the annual children's book list, a task that did not at first appear difficult, owing to the fact that Macmillan was the largest holder of classics among American publishers. But despite the impressive number of titles, roughly half represented old English imports while the other half came

from the American backlist. As she began her task, she quickly discovered that, consistent with Moore's complaints in *Roads*, there were few new titles to include in the list. Children continued to consume nineteenth-century classics voraciously, but she anticipated that, as the decade wore on, children would want more recent books as well. Sitting at her "overflowing desk, stubbornly sure that my work could be, and should be, as creative as teaching," Seaman therefore recognized that building a truly successful children's department required more than old classics and European imports.[75] New authors and illustrators were desperately needed, and she meant to discover them, but finding time to scout talent and experiment was challenging. In addition to obligations in other departments, she was "The Story Book Lady" every Monday on WJZ radio in Newark.[76] Moreover, Brett wanted his new editor to develop a series of classics for children. For these, Seaman envisioned a series of artistic but affordable books for children and conceived of the Macmillan's Children's Classics Series (1923), the Little Library (1925), and the Happy Hour Series (1927).[77]

Seaman wrote the catalog personally, as she did throughout her career, and was "terribly awfully" proud of it, confident that a child could find something of interest from its 250 titles. It was well received, and when the supply gave out, even after cutting bookshop requests by half, Seaman glimpsed the size of the market for children's books. Above all, the success of the first catalog convinced her that children could be "lured" into reading "great" books sooner if the proper books were available.[78]

She was particularly impressed with brightly colored, high quality illustrations in European books, and interested in producing illustrations their equal.[79] But illustration—especially half-tone plates—was expensive, often costing as much as the text plates themselves. For this reason, publishers had generally eliminated or severely curtailed illustrated fiction before 1920.[80] Illustrations for children's books remained the exception to this general decline, and actually increased during the 1920s, due in part to Seaman's determination to nurture the careers of talented illustrators. Jordan applauded Seaman's efforts, encouraging her to find illustrations to "fit the text . . . a part of the very structure of the book. Everyone knows that the day of the merely pretty picture has gone for the illustration of books."[81]

Seaman's devotion to illustration was best expressed in her consistent support for artists from other cultures as well as America, including Boris Artzybasheff, Wanda Gag, Padraic Colum, James Daugherty, Lynd Ward, and Dorothy Lathrop.[82] Working carefully within budgetary limits set by

Brett, Seaman could frequently be found in her office discussing the details of a book with the illustrator. One observer noted that Seaman, remaining intimately connected to details like cover designs, jackets, and paper type, had "one eye on the book-buying public and the balance sheets which must remorselessly take their part in the scheme of anything." As editor, Seaman possessed or developed qualities of patience, energy, enthusiasm, and "an unlimited belief in the possibility of human beings" that enabled the ideas of her authors and illustrators to survive the arduous process of translating creativity into print.[83] The results were what Virginia Haviland called "living books."[84]

Seaman also encouraged a new individuality among book designers by utilizing both old and new forms of book production to bring specialization to children's publishing.[85] Although photoengraving and photography produced the majority of the changes in illustration later in the period, older illustration techniques, such as etching, wood blocks, linoleum blocks, and lithography, enjoyed a renaissance. By supporting the use of traditional crafts in the context of mass markets, Seaman mirrored Brett's motive mixture, combining the "best" of old techniques with a modern perspective and demonstrating that craft and profit were not necessarily incompatible.[86]

Of all the aspects of bookmaking, Seaman was least informed about selling, though she quickly discovered that it was "the heart of the matter"[87] and therefore actively pursued professional contacts with potential clients like Bertha Mahony and Elinor Whitney.[88] Seaman also asked Brett for a sales route of her own in New York, a request that shocked the publisher. His prediction, that retail clients would resist buying books from a woman, turned out to be accurate. Seaman was most distressed by female book buyers, who often flatly refused to buy anything from her, but male book buyers at retail outlets like Gimbel's were not much better. She observed that "being confronted with a woman made male buyers hyperventilate and get through the ordeal as quickly as possible. . . . The buyer at Scribner's was so nervous when he saw me way down the line of waiting men, with my bulging briefcase, that he would beckon me up to his desk at once, hastily order *one* of everything, and literally push me off. The next day, the regular man on that route would get his usual big re-orders for juveniles."[89]

She encountered other problems in her role as a businesswoman. After persuading Brett to send her on a nationwide working tour and also to Europe to improve her knowledge of the business, Seaman was refused a letter of introduction. "I can't give you a letter to Macmillan in London," Brett explained. "They'd never understand my allowing a—well, a young

woman—to be head of a dept."[90] Seaman, as it turned out, was better at selling the idea of children's literature than at selling actual books.[91] Throughout her tenure at Macmillan, she routinely spoke about children's literature to various groups, including Rotary Clubs, PTAs, and university libraries. Though generally well received, she did encounter resistance from those who resented the part of her professional identity associated with business. Speaking before an ALA conference for the first time, for example, Seaman discovered that a member who disdained her as a "representative of commercialism" had hidden her slide projector.[92]

Seaman remained the only commercial editor for children's books in 1921, although Doubleday, Page and Company created a department for children's books in 1922, selecting May Massee as the head of its new venture. Massee had come to the firm's attention because, in her role as ALA Booklist editor, she had routinely visited Doubleday representatives to discuss their forthcoming titles. Impressed with her enthusiastic attitude toward children's books, the publishing house decided to follow Macmillan's lead and create a department of its own.

Massee, the second of four children, was born on May 1, 1881. Her father, Thomas, was French and English, but Massee's early life was spent in a largely German community near Utica, New York. Born into somewhat less affluent circumstances than other bookwomen, she was nonetheless exposed to many of the same childhood literary experiences. The family subscribed to *Youth's Companion*, and Massee frequently borrowed a neighbor's copies of *St. Nicholas*. Responsible for reading to her two younger siblings, she became particularly fascinated with picture books, "gathering," she later claimed, "a wholesome respect for a nice line and a good pen-and-ink drawing."[93] The child was, in fact, "always reading."[94] While Massee was still young, her family relocated to Milwaukee, where she attended public schools. She graduated from normal school in 1901 and then, after only one year of teaching, attended the library school in Wisconsin. Massee then worked as a librarian at the Armour Institute in Chicago and at Buffalo, where she briefly worked as children's librarian before accepting the editorship of the ALA Booklist, which was intended by the ALA to guide library workers, especially in small public libraries, in their book selections. By 1908, the Booklist was moved to Madison, Wisconsin, in order to take advantage of university faculty expertise in writing book reviews for it.[95] This position offered her prominence by providing her with the opportunity to lecture at the Indiana Summer School of Librarianship at Indianapolis and by connecting her directly to publishers anxious that their books receive her

approval in the list.[96] Unlike her predecessors, Massee visited eastern pub-
lishers to discuss their forthcoming lists, felt comfortable moving among
various traditional book trade territories, and was equally at home with
librarians, booksellers, and publishers. In her role as the ALA editor, Massee
met Seaman, a "new publicity slave," who was instructed to tell Massee
about forthcoming Macmillan titles. Although initially "awfully scared of
her," she quickly found that Massee quickly grasped the implications of
Seaman's "little new side job of editing the Macmillan children's books."
She felt inspired by Massee and respected her high professional standards.
For Massee, work was the center of life, and professional associates were
her closest friends. At the next ALA conference, representatives of Double-
day, then one of the important publishing houses with retail networks
nationwide, invited her to become the children's editor of junior books.[97]

Seaman and Massee, both allies and rivals, pushed boldly forward with
plans to jump-start the children's book industry, quickly surmising that
editorship "is no 'ivory tower' sort of job." Neither woman viewed her role
as passive, and each intended to remain in direct control of the production
of her books from start to finish. They discussed costs and profits, estimates
and processes.[98] Because Doubleday printed onsite, something unusual
for publishing houses, Massee had the opportunity to visit the presses on
Long Island to learn the details of book printing.[99] For the same purpose,
Seaman made frequent trips to Norwood, Massachusetts, where Macmillan
titles generally were printed.[100]

Like Seaman, Massee was required to create an annual catalog. Her first
list contained some books that continue to be well known, including *The
Story about Ping*. Although rivals by definition, Seaman openly admired
Massee's lists for their "cosmopolitanism," noting with satisfaction that she
"combated the banal."[101] Booksellers liked Massee's books as well because,
as one said, "she has been able to produce books that are not only works of
art and of value as literature, but are also 'good merchandise.'" She was, the
bookseller remarked, "peculiarly alert to beauty."[102]

Most of the conversations between Seaman and Massee, however, focused
on acquiring talent for the children's book field since they viewed them-
selves as partners with authors and illustrators, members of a team with the
same ultimate goal: better literature for children. But while Seaman and
Massee encouraged unproven authors and illustrators, they nurtured close
working relationships with librarians, the tried and true voices of authority
in the book world. Moore had made it plain that she held editors account-
able for their products, and she was often drawn into the loop of book

production to consult on a variety of issues.[103] Engaging librarians in the process was good for business, but the editors genuinely regarded librarians as indispensable contributors to the process of making books for children. For this reason, Seaman sent manuscripts to Jordan even before meeting her, considering her comments "clear-eyed," "sane," and "humorous."[104]

In the midst of the excitement of their new positions, pressure to return to a more conventional professional life occasionally surfaced. In 1920, Seaman received a letter from Laura Wylie, one of her professors at Vassar, advising her to give up publishing and return to an academic life. Wylie "suspected the rewards, mental and spiritual, of the commercial life I was leading, and urged me to return to teach English under her. Imagine saying *no* to Miss Wylie! Yet not so long ago I had decided I was not a scholar, and teaching young children well, did not mean one could teach college students well. I had no yearning to live in Poughkeepsie after life in New Haven. Yet, didn't Miss Wylie know best? Well, I wrote *no*, and regretted it for months, during which time I would see the Wylie eyes twinkle sardonically as I read a silly manuscript, or ran to answer Mr. Brett's bell. Once again, I had chosen between scholarship and 'editing.'"[105] Seaman's statement revealed the ambivalence with which bookwomen sometimes viewed their professions, uncertain of reconciling the connection between service and profit. For Seaman, it also raised a question: what *was* a legitimate "literary" career for women?

Bookshopping and Caravaning: Bertha Mahony and Elinor Whitney

Like Seaman and Massee, Bertha Mahony and Elinor Whitney found that enthusiasm and far-reaching goals were only part of professional life. At the Bookshop for Boys and Girls, as at publishing houses, competition was an unrelenting fact of life. For Mahony, that competition increasingly arose from department stores eager to share the profits in the children's book business. Thus, when Filene's in Boston created a book corner in 1919, they advertised stock of the "tried and true" variety, approved by "organizations of authority" and under the supervision of "a trained librarian and college graduate." Its advertising pitch was "Filene's: Parents can safely choose children's books here."[106] But to Mahony's frustration, department store managers frequently treated books as part of seasonal toy stock, packing them away when the holiday buying season was over while she herself regarded books not as merchandise but as "the record of life itself."[107]

Despite worsening competition from other bookshops and department

stores, the bookshop made slow but steady progress. Business had increased at the encouraging rate of about 50 percent each year since it had opened, but the bookshop continued to operate at a loss. The deficit for 1920 was about two hundred dollars, despite the fact that she carried some books on consignment. On the other hand, Mahony's annual booklist enhanced the bookshop's reputation and a steady stream of visitors from around the country bolstered profits. And, fortunately, the Union seemed in no hurry for repayment of the money it had loaned Mahony to get started.

Like Jordan, Mahony found administrative responsibilities bothersome. She did not consider herself a good businesswoman; even the concept of stock turnover had to be explained to her by publishers' salesmen. Consequently, she developed a business credo consistent with her discomfort, keeping organization to a "certain businesslike procedure" that would keep her records in order without consuming too much of her energy. She preferred to spend the bulk of her time creating the pleasant surroundings and developing the "friendliness, helpfulness and sincerity of service" that defined the character of the bookshop and reflected the qualities of her benefactors at the union.[108] Jordan was a steadying influence on her in this regard, consistently reinforcing Mahony's belief that the cultivation of reading was her primary endeavor.[109]

Staffing the bookshop, however, was one chronic administrative problem Mahony could not avoid, although several individuals hired during the early 1920s turned out to be long-term employees who stabilized the shop's high staff turnover rate. Elinor Whitney was, by then, not only a permanent employee but also assistant manager of the shop, and Whitney's sister, Mary, joined the staff in 1922 as assistant director of the children's level and remained for ten years. Frances Darling, another long-term employee, became "the upstairs wizard of finances."[110]

In addition to a nucleus of devoted and long-term employees, the bookshop never lacked a steady supply of willing clerks; young women recently graduated from college, like Edna Humphrey (Wellesley) and Greta Wood Snider (Smith), were eager to work there. For many, it was a powerful experience amounting to a unique internship for later professional endeavors. One employee, Lillian Gillig, wrote that "nothing I had learned in business courses at school prepared me for my first glimpse of the office of the Bookshop for Boys and Girls. . . . I know that I received my real education [there] and I am eternally grateful." The divide separating business and "reality" was, for Gillig, enormous. Moreover, she enthused, the shop "was itself a book, and we were the characters from a story."[111] For all the

enthusiasm of Mahony's employees, however, staff turnover remained significant. Professional opportunity competed with marriage, a fact that, according to Mahony, made "disconcerting inroads in [the bookshop] staff" throughout the decade.[112]

Mahony's trouble with employee retention after marriage was not unusual. While 35 percent of female workers were married in 1900, they represented less than 10 percent of all gainfully employed females during the 1920s.[113] Public debate shifted from the generally well-accepted unmarried "working girl" to the consequences—social and economic—of having married women in the workplace. Indeed, by mid-decade, 96 percent of men surveyed were of the opinion that married women should stay home, at least while children were young.

In response, advocates of women's right to work developed two primary arguments during the 1920s. The first—and more radical—argument attempted to piggyback onto the somewhat fashionable notion that women should lead fulfilling lives (marketed, for example, in sex manuals) by contending specifically that women should be able to pursue careers simply to achieve self-fulfillment. But as general public support for the position of personal development and achievement waned, defenders of women in the workplace retreated to a traditional platform that portrayed woman in helping roles. In this instance, the help women offered was economic. The increasing trend toward heightened consumerism nationwide seemed to justify this argument by depicting wage-earning women as economic allies rather than as threats to male job security. But the high levels of consumerism in the postwar years were new relative to older and significantly more ingrained concepts of family. By the middle of the decade, therefore, careerism came under harsh attack by those who felt that the home was still the proper place for women. By the end of the decade, the public remained tolerant of only certain types of married women in the workplace, primarily working-class women, women with grown children, or, occasionally, women of exceptional ability. Perceived as a threat to men's ambition, married women who worked fell outside the bounds of middle-class respectability, inviting social stigmatization.[114]

While the tension between old and new social attitudes played out, however, some women *did* work, increasingly in new kinds of jobs. Domestic service, by far the largest category of working women in 1890 (42.6 percent), declined to 29.6 percent by 1930, replaced by employment in the growing white-collar sector. Across America, clerical work for women, such as offered by the Bookshop, increased steadily from 5.8 percent of the female working

population in 1890 to 7.3 percent in 1910 and 18.5 percent by 1930. In some cities, like Boston, the figure was even higher, with 25 percent of working women employed in clerical positions by the end of the 1920s[115] Middle-class married women who worked utilized various strategies for improving their success and longevity in the workplace, many of which involved respecting the traditional gender line. Nearly 75 percent hired household help; some deferred motherhood or simply remain unmarried.[116] Career women often attempted to blur the lines between work and home, as if by "blending in" they might draw less attention to themselves as career women. Children's rooms in libraries and in children's bookshops provide clear examples of how work with children, resonating with images of home and traditional female responsibilities, lowered the stakes of career decision making.[117] Bookwomen used many of these strategies. For Moore, Jordan, Mahony, Seaman, Whitney, and Massee, marriage dropped far into the background while they enlarged and consolidated their individual areas of professional expertise and escaped the cultural opprobrium reserved for more uncooperative women.

In addition to staffing problems, Mahony's attention was consumed by the Book Caravan, now ready for the road. She laid out the route carefully, enlisting in advance the cooperation of residents in many of the towns on the Caravan's itinerary and heavily publicizing its departure day. Maurice Day had been enlisted to illustrate a lavish publicity folder, and the National Association of Book Publishers arranged to have the Caravan filmed by Fox, Pathe, Kinegram, and International, the four major motion picture news services, for distribution to movie houses nationwide. This fact is interesting since bookwomen generally viewed motion pictures as a cheap imitator of good stories and therefore not useful to their own aims. Marie Shedlock claimed that the "lurid representations at the cinematograph" inundated children with unhealthy sarcasm, satire, sentimentalism, and sensationalism, and Louise Seaman's disapproval of Disney is well known. Nonetheless, publishers recognized the potential for motion pictures to increase book sales and to assist with the perennial problem of book distribution.[118]

With Genevieve Washburn, a Wellesley graduate, as driver, and Mary Frank, a Pratt graduate on loan from the New York Public Library, as bookseller, the Caravan rolled out of Boston on July 5, 1920, with some twelve hundred books in tow. Throughout July and August, the Caravan made its way as far south as Chatham, then north to Portsmouth. Along the way, stops were scheduled for New Hampshire, Vermont, and Bar Harbor.

Disappointingly, the Caravan showed a financial loss that might have been offset by eliminating one of the women from the payroll, but Mahony insisted that both driver and bookseller were needed. She was anxious to repeat the Book Caravan in 1921, hoping it would produce results more satisfying to its benefactors than the previous year. When the second venture produced no more profit than the first, publisher-backers reluctantly, but firmly, withdrew their support.[119]

Mahony was saddened by the failure of the Caravan, but had other worries. After five years in business, she was anxious to repay the union, but the bookshop had not prospered as quickly or as dramatically as she hoped. She identified two reasons: The store's location above street level kept patrons away, and the stock was limited to children's books. Her new plan, with Jordan's blessing, was to increase the bookshop's visibility by relocating it to street level and to increase patronage by diversifying stock to include adult titles, a decision that both conceded to the market and revealed bookwomen's ambivalence about age segregation.[120]

By fall 1921, Mahony accomplished both pieces of her strategy. At its new location at 270 Boylston Street, the shop now offered books for adults as well as children, quickly improving both patronage and profits. Anxious that the mahogany antiques donated by members of the union not give the bookshop the appearance of clinging to the past, Mahony exhibited the latest art, including the work of such illustrators as Wanda Gag, Elizabeth MacKinstry, Dorothy Lathrop, Pamela Bianco, Maud and Miska Petersham, and others, who became friends as a result of these exhibitions. In 1922, she also inaugurated an art exhibit by children, so successful that she made it an annual event. Children from Boston and environs contributed to the exhibit during the first year, but gradually schools from around the country submitted the work of their students.

Just as Moore and Jordan did not wait for children to come to the library, the two booksellers did not wait for children to come to the Bookshop. In 1922, Mahony approved a new service program under the direction of Mary Whitney. The plan was to ship book exhibits—in wooden crates, hand decorated by Whitney—to schools before summer recess, so that children could make reading selections.[121] The response was immediate and enthusiastic, prompting Mahony and Whitney to enlarge the exhibits, expand the audience to include women's organizations, summer camps, and libraries, and go nationwide in their efforts. The destination for some exhibits, unsurprisingly, was the Children's Room at NYPL, in time for Children's Book Week.[122]

Despite enlarged stock and new quarters, certain features of the Book-
shop remained the same. The "Poetry Afternoons" for young people and
the "Bookshop Special Evenings" for adults, some led by Moore, continued
to be well attended. To cement ties with school librarians, Mahony devoted
Saturday mornings to book conferences in cooperation with the New Eng-
land Association of School Librarians. At other meetings, professionals re-
viewed books and subsequently made book suggestions to school districts.[123]
The lingering influence of the WEIU on Mahony is clear from these activ-
ities. Following the typical organizational formula, she envisioned a proj-
ect, proved its value on a small scale, and expanded. In the process, Mahony,
like the Union, demonstrated initiative and created alliances whenever and
wherever possible.

The principal exception to this strategy was the child guidance move-
ment. Achieving significant national prominence during the 1920s, child
guidance offered little mutual ground for alliance building with book-
women. For the most part, they ignored the movement, as they did many
realities they did not like. Yet, the growth and significance of child guidance
carried serious implications for bookwomen, eventually representing noth-
ing short of the reordering of professional authority over children. Their
relationship to guidance illustrates complex and widely divergent attitudes
surrounding modern childhood, and their response to it reveals the limi-
tation of their endorsement of expertise.

The "Fairy Tale" Wars: Bookwomen and Child Guidance

During the 1920s, it became conventional wisdom to suggest that chil-
dren had become a problem.[124] Products of mass culture—radios, movies,
cars—offered spare money and time, providing a growing number of chil-
dren and adolescents with a level of social and economic freedom previ-
ously unknown. For many adults, such freedom signaled a crisis of youth;
as "problems" as well as consumers, American youth were paradoxically
both celebrated and feared.[125] Added to this fear were the failure of progres-
sive child-saving institutions to produce the hoped-for reduction in delin-
quency, the continued growth of professional culture, and growing respect
for science. All contributed to an unprecedented rise in the number of pro-
fessionals whose primary concern was children.

Prominent among those professionals were psychologists and psychia-
trists who, regarding delinquency as the result of personal emotional dis-
turbances and complexes, urged individual outpatient psychiatric treatment

for troubled children. By 1922, the movement known as child guidance had experienced impressive growth by several means: the popularization of its message, the creation of a professional culture with distinct language and rituals, and the philosophy that all children required psychological intervention. The subsequent "medicalization" of children was sharply at odds with the beliefs of traditional child professionals, like bookwomen, who viewed children more sentimentally.[126] Throughout the 1920s and 1930s, battle lines in the popular press were sharply drawn between scientifically minded guiders and individuals such as librarians and teachers, many of them women, who continued their observance of the gender line vis-à-vis "natural" knowledge of children.

The means by which child guiders achieved authority were plainly evident in the movement's central institution: the outpatient clinic. Each clinic offered the services of an interdisciplinary team, consisting of psychiatrists, psychologists, and social workers. The interdisciplinary nature of guidance teams enhanced their authority by giving the impression of a broad, cooperative professional base upon which conclusions might comfortably rest. The wide range of disciplines and viewpoints appealed to many, and specialized language, eventually comprehensible only to guiders, further augmented the aura of expertise necessary for collecting authority.[127]

Popularization of the guidance philosophy and early efforts at alliance building were also vital to the process. Although clinics remained unavailable to most Americans, guidance literature attuned the public to the "psychiatric perspective." In addition to government literature, via the Children's Bureau, that reinforced guidance principles to parents, the message was routinely disseminated in the popular press.[128] Guiders initially created alliances both with established professions and groups laying claim to expertise in child welfare. Billing themselves as "specialized consultants," they assured such groups that guidance would be useful but nonintrusive. Instead, guiders portrayed themselves as mediators in the generational conflict widely perceived to have infiltrated American culture.[129]

Beyond all these strategies, however, child guidance expanded its authority exponentially by introducing to the public the concept of "predelinquency." Where progressive reformers had maintained that several kinds of children existed within America's many ethnic groups, the general trend of the 1920s was to blur such distinctions. Since all children were potentially maladjusted, they claimed, and since prevention was the obvious solution, guiders undertook the supervision of children not previously understood to be in need of professional help. By the end of the decade,

they declared to a wide and accepting audience that "the normal child is the problem."[130]

Finally, and most relevant to bookwomen, guidance was characterized by its direct and relentless assault on traditional authorities—mothers. So thorough was this assault, in fact, that the assignment of maternal pathology became one of its hallmarks.[131] Guiders confronted motherhood by attempting to show the inadequacy of intuition and "common sense" in child raising, consequently equating instinct with an "antimodern" perspective.[132] Helen Woolley, a Detroit nursery school director, both denigrated parents' ability to raise their children and redefined the ideal environment for children. Mothering, Woolley argued, was a complex task for which women were unprepared in terms of understanding stages of child development. The consequence of unprepared women serving as mothers was that unreasonable demands were made of children. Knowing the capacities of children, she claimed, required experts, and mothers were not experts. The nursery school was not a place for play; it was a "laboratory."[133] If the home was no longer an adequate metaphor for child raising, then parents could no longer remain the presumed authorities. The replacement metaphor, a laboratory, implied that other experts needed to take charge of children. But while mothers were the particular targets of this sustained assault, anyone claiming "natural" knowledge of children, by extension, came under scrutiny.[134] Purposefully or otherwise, guidance called into question the legitimacy of female expertise resting on such knowledge.

The attack on "natural" knowledge and motherhood intersected with bookwomen most obviously in debates about appropriate reading for children. Guiders used the same psychological model to evaluate children's books as to estimate all aspects of the child's environment: their potential to create or exacerbate emotional disturbances in children. They largely approved of what Anne Thaxter Eaton referred to as the "steam-shovel school of literature,"[135] reality-based books such as Lucy Sprague Mitchell's *Here and Now* series, because they grounded children in the exploration of their immediate, tangible surroundings, thus orienting them to "normal" roles in the social order.

By contrast, guiders were not so kindly disposed to imaginative literature. Fairy tales were least favored because, guiders insisted, they resulted in psychological damage by encouraging too much imagination and fostering undesirable traits. Some psychiatrists, such as Felix Adler, recommended the elimination of fairy tales altogether because of their "harmful, superstitious, and immoral elements, such as the success of trickery and

cunning." Montessori likewise crusaded against fairy tales, declaring that they "plunge the child into the supernatural and merely prolong his period of mental confusion" creating a "dread of reality and terror of the actual." One professor at Clark University stated that "fear, imagination, and ignorance make life hard for the child. In fairy tales, his own desires for himself are realized. It is his compensation for being little and helpless."[136] According to Benjamin Gruenberg, president of the Child Study Association of America, fairy tales represented "abnormal gratification," encouraging "primitive and archaic thinking" and hindering proper development. Fairy tales, Gruenberg warned, prolonged "the wishing stage," thereby preventing children from exerting the "real effort" necessary to obtain goals in life. In addition to the possibility of future resistance to social roles, a child overly interested in books of any kind might be failing to socialize here and now. Gruenberg worried that "while it is legitimate to use books . . . as a form of entertainment, the danger suggested lies not in the books themselves, but in other elements of the child's environment—such as the absence of stimulus or opportunity for interesting activities."[137]

Although child guidance gained significant momentum during the 1920s, the notion of viewing children scientifically encountered opposition from, unsurprisingly, those whose authority over children was now perceived to be at risk. Claiming to be "stuffed to the teeth" with scientific theories about children, Clara Whitehill Hunt continued to regard the ability to become a librarian as a "natural gift."[138] Some authors also resisted the "modern" psychological notion of children. Charles Finger, author of *Tales from Silver Lands,* noted in *Publishers Weekly* that if child psychologists wrote children's books, the result would be "a mess."[139] The storyteller Ruth Sawyer added her thoughts:

Like many another I have been stormed with protests about the use of fairy tales. Child psychologists have done their best to create havoc in the field of children's stories and literature; especially would they step in and dilute, remedy, or bar altogether that which has sprung, living, from the spiritual loins of the race or from the creative pen of those who knew the true nature of childhood far better than the psychologist. I have been told that the story of "The Three Bears" conditions a child to fear; that "Red Riding Hood" conditions against grandmothers; that "Jack and the Beanstalk" induced a fixation for stealing. . . . There is no reason to bar from the vigorous and buoyant minds of normal children legitimate folk-experience and fancies.[140]

The coexistence of bookwomen and child guiders, while indirect, was awkward. Bookwomen's public posture on the subject was civil, as long as their professional territory was respected. Least tolerant of guidance, Moore recited the creeds and philosophies upon which literature traditionally rested, making it clear that she had no intention of modifying her literary beliefs to accommodate science. Scientific theories of childhood were fine, she claimed, insofar as they improved books for children and generated standards of intergenerational comparison. But for "intellectual honesty and spiritual clarity," she insisted, one must look to "rare poets and novelists and essayists" who see in children "a world of fresh exploration and discovery."[141] Child guidance claimed psychologists as experts, but bookwomen preferred poets. To whatever extent she spoke for bookwomen, Moore's response to guidance revealed consistent and enthusiastic advocacy of expertise that did not exclude intuition and "natural" knowledge, as it did for guiders. While capitulating to science might have augmented their authority, bookwomen were steadfastly offended by the idea of reducing childhood to scientific formulas and equations.

Despite the steady stream of fairy tales that they created, encouraged, published, and favorably reviewed, bookwomen nonetheless claimed they did not oppose realism in children's books. They made this claim because they expanded the boundaries of their definition of "real" to account for imaginative literature, which they viewed as reflective of the "larger reality of human existence."[142] Still, they had their own ideas about how much and what kind of reality children should experience. During the 1920s, those ideas shaped children's literature by enforcing traditional literary taboos, including divorce, psychological dysfunction, alcohol and drug dependence, suicide, prostitution, and sexual deviance. Other topics, such as racial conflict or sexuality, were either absent or approached with caution, yet these were precisely the issues that guiders sought to uncover.

The consequence of enforcing these taboos was a realism in children's literature marked by what has been called "protective optimism" and created in an atmosphere of "consensus and complacency." Upholding the family as the ultimate social and moral arbiter and headed by adults who could be counted on for wisdom and nurturing, children's books and their creators have been accused of representing an "island in the larger culture."[143] This view, however, fails to account for the complex relationships among bookwomen that confronted the notion of consensus, and their deeply ambivalent feelings about reading segregation. It was, admittedly, expedient for bookwomen to accept, or even endorse, segregation as a

means to distinct professional jurisdiction and culture. But the island meta-phor implies that bookwomen were disconnected from mainstream culture, while their behavior does not support this suggestion. In soliciting outside opinion, they consistently interacted with employers, parents, colleagues, and children themselves and thereby formed often long-lasting alliances that provided them with continual feedback. Fostering children's compre-hension of adults as wise, just, and caring was surely not simply the inven-tion of bookwomen but a reflection of commonly shared cultural beliefs.

While bookwomen defined both their professional roles and their space among child experts, they also developed friendships with each other. In this, bookwomen displayed the sort of "emotional proximity" characteris-tic of other groups of women, quite acceptable in an age when gender lines were starkly drawn. Typically, groups formed networks that functioned well in a broad range of relationships and, as Carol Smith-Rosenberg notes, tended to integrate rather than isolate their members.[144] Seaman and Massee had both a personal friendship and a professional rivalry from the begin-ning of Massee's tenure at Doubleday. Seaman also became close friends with Mahony, Mahony with Jordan, and Mahony with Whitney. Jordan spent winters in Cambridge and summers with her sister at the Knolls, a home they built in Maine in 1922,[145] but was a frequent guest of Mahony at Mount Kisco or Moore in New York. Mahony recalled that time spent with Moore included such activities as "a visit to see the Kate Greenaway books of a private collector; a trip after the theatre to the high roof of her hotel overlooking the river on a wild night of wind and snow; many visits to storytelling in different branches; and meals in one interesting place after another. A jaunt with Miss Moore invariably spells surprises."[146]

But although much evidence of "emotional proximity" exists, this does not equate to relationships unmarked by difference. Moore is, in many ways, illustrative of the relationship difficulties among bookwomen. When obtained, her friendship was treasured—sometimes a badge of accomplish-ment in itself—for its loyalty and honesty. But even Frances Clarke Sayers, Moore's sympathetic biographer, admitted that few who came in contact with Moore "escaped . . . an encounter of great bitterness with her."[147] She remained close to Jordan and, to a lesser extent, Mahony; her relationships with Seaman and Massee were generally respectful, but substantially more distant. On the surface, the editors shared some of Moore's views about what constituted "good" books for children. Beneath the upper layer of vague generalizations, however, differences were clear. They shared broadly similar beliefs about literature, but occupied distinctly different vantage

points from which to view books, creating ongoing tensions that were frequently palpable beneath the surface of apparent consensus. Age played a role as well. Seaman was younger than Moore by more than twenty years. Well into her fifties by the mid-1920s, and with established nationwide authority in children's books, Moore risked less by indulging static, unyielding patterns of thought than a young female editor seeking a successful career in publishing.

Some of Moore's behavior illustrates the dynamic of tension among bookwomen. The folklore surrounding her difficult and eccentric conduct is well known, brought into sharp relief by the infamous wooden doll "Nicholas." As 1920 drew to a close, Moore's staff at NYPL made a basket of holiday treats to send upstairs to room 105. An eight-inch doll, dressed in traditional Dutch clothing, purchased at Bloomingdale's at the last minute by the librarian designated to take care of the details, sat on top of the goodies. Promptly dubbing it "Nicholas Knickerbocker," Moore made the doll a highly visible part of her entourage. Friends noted that the doll, presiding over children's story hours throughout the city, visiting hospitals, and attending dinners at friends' homes, had "developed" a personality of its own.[148] Nicholas "wrote" letters to Moore's friends on his own stationery, and Moore insisted that her friends respond. Invitations of various kinds were sent to "Anne and Nicholas," and Nicholas received gifts—some extravagant—from artists, writers, and friends. Letters to Moore often included regards to the doll as though it was Moore's dearest friend.[149] Initially, this seemed a harmless and amusing eccentricity, and friends cooperated with Moore's bizarre insistence that Nicholas be treated as a human. Mahony cooperated, sometimes referring to Nicholas as "a diplomat *par excellence.*"[150] So well known was Nicholas, in fact, that a young patron at NYPL suggested that Moore write a book about him, and, in 1924, G. P. Putnam published *Nicholas: A Manhattan Christmas Story.*[151]

Gradually, however, Nicholas became an annoyance to Moore's friends and colleagues. Anecdotes about the doll abound among those in the children's book industry, one of the most famous involving Virginia Kirkus, children's editor at Harper. When Kirkus confronted Moore about her disapproval of Harper's publication of the Laura Ingalls Wilder books, Nicholas was perched, as usual, on Moore's desk. Each time Kirkus tried to speak, Moore responded by consulting the doll: "Nicholas, Miss Kirkus wants to know . . ."[152] While, over the years, some individuals forgave such behavior, Anne Thaxter Eaton's claim that "no one ever held it against her" is clearly untrue. Like Eaton, Frances Clarke Sayers ignored those, like Kirkus, who

experienced such behavior from Moore, ascribed it to disrespect rather than eccentricity, and found it infuriating. The author Walter de la Mare discreetly said that Nicholas was Moore's alter ego. Many interpreted Nicholas as exemplary of Moore's increasingly rude and overbearing manner, and there is little reason to doubt that Moore was, to say the least, difficult.

The Nicholas phenomenon might be left at that, except for the fact that Nicholas, for Moore, symbolized all children.[153] Like children, Nicholas had no position or voice except as Moore gave it to him; without her, the doll was mute and opinionless. Moore nevertheless chose to speak through Nicholas, just as she spoke on behalf of children. As their spokeswoman, she paradoxically gave voice to them *and* silenced them since hers was ultimately the opinion that mattered. By consorting with Nicholas the child-doll as a peer, furthermore, her speech could remain safely childlike. Speaking through the doll allowed Moore, however transparently, to evade responsibility for opinions and attitudes whose popularity was waning and to avoid rising to the level of linguistic maturity demanded by expert discourse. As competitors developed new language about, and acquired authority over, children, Moore might have felt anxious about the fate of bookwomen's "spiritual" language among scientific and business experts who refused to base their understanding of children on "foremotherly adages"[154] and anachronistic metaphors.

The first half of the 1920s was an important moment of authority building for bookwomen, producing a potentially wobbly combination of both traditional and "modern" ideas and venues. In distinct ways, bookwomen utilized new technology, such as radio and motion pictures, together with "new" ideas of the professional woman, to secure authority. Simultaneously, they continued basing their authority claims on traditional notions of "instinct" and maternal "common sense." This combination succeeded in pushing bookwomen beyond expertise *about* children's books to positions of authority *over* them while also creating a level of vulnerability particularly susceptible to the growing demand for a neatly packaged, scientific understanding of children. In the second half of the decade, bookwomen turned increasingly to the intraprofessional relationships they had developed for support and affirmation.

Building Professional Culture

T HE PROSPERITY GEORGE BRETT predicted in 1920 was reflected in book sales, boosted overall by 6 percent throughout the decade. Organizations like the ALA enjoyed taking credit for the new burst of publishing activity for children, but a carefully cultivated foundation of interprofessional relationships fostered by bookwomen was an important component of these gains. During the second half of the 1920s, they continued expanding the institutional apparatus of children's book publishing by consolidating their claims to authority, enlarging the scope of their undertakings, and developing consistent and predictable patterns in their working relationships. Although viewing themselves as liaisons between books and readers, bookwomen also became bridges of a different sort, each in her way connecting bookwomen to the past, to those outside their ranks, and to each other. This was especially evident when they mentored new authors and editors, although, in the process, they cultivated discernible levels of privilege among children's book professionals.

Nearly twenty years older than other bookwomen, Anne Carroll Moore and Alice Jordan were generational bridges. While the two women remained associated with the noncommercial library enterprise, they were astutely, if ambivalently, aware that an expanded market was crucial to enhanced quality for children's books. Jordan's persistence in using the NERTCL as a forum to warm Boston's librarians to the concept of the commercial aspects of children's books demonstrated her awareness of this fact. Perceiving themselves as modern and progressive, Moore and Jordan cultivated friendships with bookwomen whose livings derived from the commercial book trade. Moreover, they supported the younger generation as they esteemed

the older. But despite their resistance to being overly identified with the past and their commitment to mentoring young professional women, their sense of the ideal book nonetheless remained firmly anchored in nineteenth-century British and American children's books. Their attachment to such books reinforced hierarchical thought patterns and compounded the obstacles that new authors faced in making their own mark on children's literature by requiring them to reckon with literary figures and books of the past as standards by which their own work was judged.

Moore's own writing, she believed, lived up to that standard. In 1924, with nearly thirty years of professional life behind her, she seemed at the pinnacle of her accomplishments. In the fall of that year, Putnam distributed *Nicholas* to a warm and enthusiastic reception from Moore's friends.[1] Letters of congratulation poured in from colleagues like Della McGregor, chief of the juvenile division at the St. Paul Library in Minnesota, who started a Nicholas diary and invited Moore to visit to receive the keys to the city.[2] Throughout her life, Moore remained particularly proud of *Nicholas*, recalling its success with great fondness and carrying copies wherever she went.[3] Her *Bookman* reviews continued to be widely read as well, and her work in general, one colleague noted, had prompted an interest in children's publishing that "surfaced like a great wave," carrying with it the "authors and artists of enormous gifts" who "rode high on the swing of it."[4]

She continued to be among the core of experts who selected the recipient of the Newbery Medal and, as the acknowledged director of Children's Book Week, her expertise was advertised in the popular as well as professional press. Such magazines as *Good Housekeeping* and *Ladies' Home Journal* routinely printed articles about Book Week and employed children's illustrators such as Jessie Wilcox Smith to design covers.[5] In contrast to the relatively meager and largely local participation characteristic of its early years, Book Week was now a national week-long festival of opportunity for bookwomen to celebrate themselves as much as books. No sooner was one Book Week over, it seemed, than preparations for the next were underway. Women's clubs, civic organizations, and schools promoted bookwomen by their involvement with Book Week; bookshops around the country sponsored plays about the event, performed by youth groups such as the Camp Fire Girls.[6] Requests multiplied for stickers, posters, and assistance with Book Week plans to which Moore happily responded with advice, speakers, and shipments of exhibits.

Financial opportunities for booksellers also attended the event's success; patrons who attended such special exhibits and plays, frequently sponsored

by department stores such as Lord & Taylor and Wanamaker's, were likely to buy books.[7] The result was, according to Frederic Melcher, an event "of national proportions," the momentum behind better children's books, a broadened market, a body of literary criticism, and more children's authors. He noted with gratification that the public had, in response to Book Week activities, developed a "new attitude" that embraced contemporary contributions to children's literature.[8]

It seemed clear to Moore that the renaissance she sought in children's book publishing was indeed underway, a situation that represented nothing less than her "dreams come true."[9] She was so pleased with what she interpreted as considerable progress that by mid-decade she felt inclined to update the nation once more on the state of children's books and began work on *Cross-Roads to Childhood*. But whereas in *Roads to Childhood* she had bewailed a dearth of literary talent for children's literature, she now contentedly reported that children's books had "broken new ground significantly." Further, she argued, "Everybody who is anybody at all is writing a children's book . . . and those who are not writing books are making pictures for them, or are editing the work of their friends."[10] Mahony assured Bookshop patrons that they would "revel" in Moore's new book and feel "urged to take an immediate vacation" to read it.[11] It was true, as Moore noted in *Cross-Roads*, that the quantity of book production was trending upward. By the end of the decade, children's book production was up 25 percent over 1920, despite the high initial investment costs to publishers.[12]

Still another professional opportunity came to Moore during the summer of 1924, when Stuart Sherman, editor of *Books*, the literary supplement for the New York *Herald Tribune*, decided that Moore's reputation would be a weighty asset and offered her the job of editing the children's portion of the weekly supplement.[13] Moore asked for time to consider the offer, and for the next few weeks the "fairy godmother" of children's books compiled a list of contingencies for taking the job, all of which involved control by, or visibility for, Moore.[14] First, no advertising could appear on her page. Second, she would retain control of the book selection process as well as illustrations for the page. Third, she would determine the lead article for each issue. Sherman did not respond immediately, but eventually instructed his assistant editor, Irita Van Doren, to take Moore to lunch and accept her terms. In this instance, the romantic language and traditional metaphors Moore typically utilized to idealize children and their books gave way to the unambiguous language of business negotiation. On the surface a staunch critic of commercialism, Moore demonstrated shrewd business sense when necessary.

Moore called her page "The Three Owls," and, over the next six years, invited Americans and Europeans to contribute to the column, including Geoffrey Parsons, May Lamberton Becker, Esther Averill, and a cadre of editors, critics, and other book professionals. The column, stretching beyond the brief, annotated listings common in book reviews, presented contemplative narratives about children's books. Many authors enjoyed the column and remained faithful readers during the six years Moore reviewed for the *Tribune*.[15]

Under Moore's direction, Boris Artzybasheff designed the column's logo—three owls—to symbolize what she considered the key contributors to children's books: writer, artist, and critic.[16] The logo was significant on at least two levels. The first was its traditional association with wisdom; the second, equally deliberate, represented her conviction that good children's books were the outcome of the efforts of a community engaged in "the rarer art of wise leadership and companionship."[17] The logo connoted not only wisdom, therefore, but an integrated professional community. In much the same way that interdisciplinarity legitimated child guidance, the impression of community enhanced authority for bookwomen. And in a very real sense, the column did enhance professional community by encouraging individuals to "meet" at "The Three Owls" in a figurative sense, as they met at room 105 in a literal one. The column particularly improved Moore's authority by verifying her influence over literary figures, who contributed to the column only at her invitation. While readers might have been "entranced," as Rachel Field claimed, authors paid attention to "The Three Owls" for a practical reason as well: a mention by Moore could be critical to a book's literary prosperity, as in the case of Carl Sandburg, who was absolutely convinced that Moore's positive notice of *Rootabaga Stories* had been instrumental in the series' popularity.[18] The *Nation* also voiced its approval of the owls, asserting that Moore's column "require[s] no comment."[19]

"The Three Owls" was only one example of the increased presence of women in book-related careers. Their presence in bookselling had also increased so dramatically since Mahony addressed the ABA in 1917 that, by mid-decade, women represented nearly half the attendees at the annual conference.[20] This prompted *Publishers Weekly* to remark, in 1928, that the increased presence of women was "one of the most significant developments" in bookselling. Furthermore, women not only were in sales but also occupied executive positions. In New York, for example, women headed all book departments in large department stores. By the end of the decade, about a third of new shops were opened by women, an impressive increase from just ten years earlier.[21]

Mahony and Whitney were also bridges among bookwomen, situated between librarians, clinging to an ostensibly noncommercial vision of books, and editors, concerned with profit. The Bookshop's reputation, consistent with Mahony's vision, extended far beyond the reaches of Boston to a nationwide audience by way of its many activities, one of which was the creation of the *Horn Book,* a watershed event for bookwomen and for children's books. From the stops and starts of its early years, the magazine developed a life of its own, growing, as Melcher put it, from "an oversized bookshop newsletter into the all-but-official journal of 'the new children's book movement.'"[22] It united individually influential bookwomen, whose opinions were not always consensual, around its "masthead,"[23] forcing them to expand their relationships to each other and to the book world. The *Horn Book* became an important part of that collective professional stage from which bookwomen spoke, vital both for affirming their beliefs and for keeping their agenda before the public. While the Newbery award and Book Week augmented interdisciplinary community, the national scope and infrequency of those events diminished the urgency of ongoing, personal connections; the *Horn Book* actually belonged to bookwomen, as no other event or property did. Although activities intrinsic to the *Horn Book*—book reviewing, for example—were not in themselves new to bookwomen, ownership of a collective professional voice was both novel and path breaking, and the magazine's editors heaped consistent and generous praise on each other as "pioneers." But the *Horn Book,* far from being an organ of simple self-congratulation, became a forum for the uncommon task of narrating women's lives.[24]

Its life began early in 1924 when it occurred to Mahony that the small book list published by the Bookshop no longer fit a business with national and international ties and aspirations. An expanded, up-scale publication, she believed, was required to reflect those aspirations, but such an enterprise seemed challenging to two women claiming to have little business sense. Yet they believed that an enlarged publication would increase sales at the shop while strengthening the field of children's books. Since adequate profits from the shop had allowed repayment of the entire debt owed to the WEIU in 1923, Mahony once more approached her "university" for financial backing and, once more, received it.[25]

The fine points of the project, however, were far from clear. In the late spring, therefore, Mahony and Whitney sailed for Europe, during which time most of the details for their new project were settled. Not until they returned in July, however, did they decide upon a name. Evidently the result of a

moment of mutual inspiration, the two women called their new publication the *Horn Book,* a reference to the first books specifically for children beginning in the sixteenth century. To Mahony and Whitney, the name captured the essential qualities of historical tradition and purpose they embraced.

For their logo, Mahony and Whitney selected an adaptation of Randolph Caldecott's nineteenth-century illustration *The Three Jovial Huntsmen.* The huntsmen, in scarlet coats, rode on horseback and blew horns that, as Mahony explained in the first issue, represented the call for better children's books. Like Moore, Mahony selected a symbolic imprint that displayed a community of characters with allied objectives. "Just as [the three huntsmen] are so full of exuberant joy for the hunt that they cannot blow hard enough, so we are full of enthusiasm for the Bookshop as a hunting ground. . . . First of all, however, we are publishing this sheet to blow the horn for fine books for boys and girls—*their authors, their illustrators and their publishers.*"[26]

Printed on ivory stock with Garamond type, the first issue of the *Horn Book* was released from the presses of Mahony's old friend and Union printer, Thomas Todd, on October 1, 1924. But while, thanks to Todd, she understood printing, Mahony knew little about making a magazine. The first issue contained only twenty-five book reviews, an article contributed by Jordan, and a statement from Mahony indicating uncertainty about the future: "Lest this horn-blowing become tiresome to you or to us, we shall publish The Horn Book only when we have something of real interest to say, not oftener than four times a year."[27] It does not seem to have occurred to Mahony that indecision about a regular production schedule might affect subscription numbers. Subscribing to the *Horn Book* would have been difficult in any case, since the editors failed to specify the subscription price of fifty cents per year, or fifteen cents a single issue.

Evidently oblivious to these omissions, Mahony and Whitney promptly sent complimentary copies to individuals they felt would appreciate the *Horn Book,* and the response was enthusiastic. Seaman, offering uncritical acclaim, was "thrilled, entranced, excited, inspired," and immediately sent a four-dollar check for subscriptions for eight "delightful human beings."[28] At NYPL, Moore subscribed immediately but, characteristically, withheld full approval until 1926, when she felt production and policy kinks had been worked out. Melcher's response was somewhat harsher, gently reprimanding the editors for leaving the final three pages of the *Horn Book* absolutely blank and placing on its back cover only one tiny picture of a schoolgirl holding a hornbook. It was, he suggested, "extravagant."[29]

The first few numbers varied widely in content and form, as the editors struggled to establish the magazine's identity and gain proficiency in production techniques. The second number, issued in November, contained reviews of more than one hundred books; the March issue was devoted entirely to authors, and offered no book reviews at all. To entice vacationers to the Bookshop and promote its activities, the summer number was dedicated to "Visitors" and stressed books about New England.[30] Gradually, however, the magazine settled into a routine. With a more dependable format, including regular tributes to authors and illustrators, and predictable features such as "The Booklist," the *Horn Book* assumed a personality as well as the look of a legitimate magazine rather than an expanded newsletter.[31] The editors, too, settled into a routine. Responsibilities pertaining to actual production belonged to Whitney, and several employees vividly remembered her at the Bookshop, hour after hour, with a paste pot. Mahony, regarding the *Horn Book* as a "writer's workshop," was clearly in charge of the magazine's content, responsible for soliciting book reviews and articles, although contributors were expected to write "friendly, honest, able and constructive criticism."[32] Harshness had no place.

Desiring to get the *Horn Book* off to a good start, Mahony and Whitney established a diverse editorial board whose members brought a broad portfolio of skills. After carefully considering potential candidates, they offered associate editorships to Louise Seaman, Anne Carroll Moore, and Alice Jordan, each of whom brought a particular strength to the magazine. Seaman understood the business of production and was accustomed to making hard, practical business decisions, while Moore's name lent authority to the magazine, reassuring readers that experts were on hand to ensure its literary integrity. Jordan was valuable both to the magazine and to Mahony personally, for her insights about children's views of the books that were offered. Her calm personality and easygoing approach to life offset Mahony's tendency toward nervousness and overwork that sometimes left her mentally and physically exhausted.

Rapidly, the magazine became a focal point for the relationships among bookwomen, creating opportunities for them not ordinarily available in the institutions providing their paychecks. Earlier, those relationships were circumscribed either by professional territory, personal friendship, or a combination of both. But accepting obligations to the *Horn Book* meant that bookwomen no longer had the luxury of communicating only with those of like mind, and consequently their relationships deepened, as evidenced by increasing correspondence and visits. Bookwomen spent a great deal of time

together, working independently and collectively in places like Mahony's rented house on Cape Ann, where the strain of continually protecting one's professional turf might be relaxed.[33] The various institutional cultures to which each bookwoman had successfully adapted—or even manipulated—could be temporarily laid aside in the interest of developing a culture relatively free of the formal institutional demands of their jobs. Mahony's increasing dependence upon her editors for advice and support is one evidence of a personalized culture committed, in some ways, to egalitarian ideals.

The rosy warmth of community and the headiness of idealism, however, were never so absolute among bookwomen as to thoroughly dissolve thought patterns and motives typical of the institutions they represented. The magazine's reliance on division of labor, for example, was characteristic of large business. And though dependent on associate editors, Mahony remained firmly in control of virtually all editorial decisions at the *Horn Book*. Likewise, bookwomen reinforced the influence and prestige of their own institutions in their author tributes. Louise Seaman's tribute to Elizabeth Coatsworth, for example, carried a subtle but useful secondary message: Macmillan produced good authors and books. Moreover, while bookwomen used the new magazine to strengthen institutional connections and relationships, they also used their well-established institutional connections to advocate the new magazine. Moore encouraged libraries across America to subscribe, while Jordan invited Mahony to address the Round Table shortly after the magazine was inaugurated and librarians subsequently considered her—and the *Horn Book*—a "source of inspiration and ideals."[34]

Acclaim for the magazine came from other sources as well. Frances Sturges, librarian and bookseller, remarked that librarianship and publishing grew "very close in my day because the *Horn Book* had just started."[35] And although it had been initially skeptical of placing literary criticism on a for-profit basis, the *Christian Science Monitor* praised Mahony and Whitney for refusing to give commercialism precedence. The new magazine was quickly compared to earlier children's magazines, primarily *St. Nicholas;* the *Nation*, in fact, acknowledged that the *Horn Book* had "outclassed its predecessor."[36] Mary Mapes Dodge had developed *St. Nicholas* in accordance with her belief that children's magazines should be a "playground."[37] But while adults reading *St. Nicholas* might be swept back to their own childhood, the *Horn Book* was clearly intended for children. It differed from its predecessor, however, by never drawing the majority of its readership from among children. The magazine was about children but written by,

and frequently for, adults. Children, in a sense, served as grist for book-women's metaphor mill, nostalgically representative of innocence and sim-plicity—qualitites the nation no longer seemed to demonstrate.

The result of such endorsements was substantial growth for the maga-zine during the first two years, inducing the union to seek copyright and a second class mailing permit for the *Horn Book*. Growth was a mixed bless-ing, however, compelling Mahony to make changes at the *Horn Book* she did not welcome. Increasing production costs forced her to double the annual subscription rate in 1926 to one dollar.[38] Even more reluctantly, she offered advertising space in the *Horn Book* for the first time, still preferring to con-sider the magazine a work of art, a service to readers, and a partnership with subscribers. Until the mid-1930s, Mahony longed for alternative means of financing the magazine. "We are always puzzling over ways in which we may support [the *Horn Book*] without having advertisements at all."[39] In this sense, Mahony illustrated naïveté about (or plain resistance to) mar-ket realities, despite ten years as the Bookshop's manager. No doubt, she also resisted advertising because it attached her to the commercialism she claimed to detest. But since the only alternative was a prohibitively priced journal, Mahony issued a cordial statement welcoming advertisers: "The Editors of *The Horn Book* wish to give expression on this page to their en-thusiastic appreciation of book publishers. Whether your joy in books be that of scholar, collector, general reader, or bookseller, you obtain that joy thanks to the vision, faith, enthusiasm, and skill of Publishers. . . . As Book-sellers as well as Editors we extend to Book Publishers our thanks and our support for their fine books and fine book making, cordial co-operation, fair business treatment, courteous, considerate, and honest wholesale calling."[40] Behind the surface pleasantries lay clear ground rules for a relationship with the *Horn Book:* cooperation, fairness, courtesy, consideration, and honesty. Furthermore, she informed publishers that advertising space would be available only in the November issue. Publishers were required to submit advertisements that considered and reflected the character of the *Horn Book*, "build[ing] their pages from the standpoint of excellence and permanence."[41] The magazine, she implied, did not exist for publishers, who should instead consider it a privilege to have advertising space from Mahony. But in spite of her determination to keep control over advertising, it was a two-sided coin. Along with new possibilities for expansion emerged new potential for criticism since the twenty-seven publishers who accepted her terms, now paying customers, had interests in the *Horn Book* that did not necessarily correspond exactly—or even closely—to Mahony's vision of community.

If the *Horn Book* was one consequence of outgrowing the Bookshop's original book list and newsletter, *Realms of Gold in Children's Books* was the other. The reasons motivating Mahony and Whitney to inaugurate the magazine in 1924 also prompted them to begin the monumental task of inventorying five centuries of children's literature in July 1927. The purpose of *Realms*, as envisioned by Mahony, was to trace the development of children's literature by compiling a list of children's books. Such a book was without precedent, particularly since the two editors wanted to compile a grand narrative that described children's books "from the first one . . . to the glorious present day."[42] Much of the book was completed at Mahony's house in Rockport, where Mahony and Whitney agreed to read in its entirety each work to be listed in the book. The proximity of the house to the ocean was alluring, but Mahony noted later that "there was no time to sit on the veranda behind boxes of geraniums and verbena and contemplate the beauty of the wide expanse of ocean and the picturesque town." Instead, the two women worked "harmoniously and with due consideration of each other's opinion and ideas."[43]

In *Realms*, Mahony and Whitney made their philosophy about children's literature and about reading clear. The book's title was a reference to a poem by John Keats, presented in the opening pages. In introductory remarks, Mahony and Whitney expressed their belief that the twentieth century was a literary "golden age"; waxing poetic, they likened it to a "vein of gold . . . threadlike and hidden at first, but gradually . . . widened, opened, and deepened until this present richness is exposed."[44] In plainer terms, the editors viewed the Western literary tradition as "gold" (interesting for its connotation implying both wealth and purity), a kind of buried treasure becoming fully apparent in the modern age. In *Realms*, the reader could expect the treasure to be exposed. Ultimately, the book became a way of attaching the writing of bookwomen to the British literary tradition they esteemed so highly.

Genre by genre, the book offered discussions of the "best" literature. Commentary was uncritical since the editors selected only those titles they deemed "good" literature in the first place. Three of the book's sections reveal worldviews that informed the choices of its editors. The first, entitled "Roads to the Past," invoked Moore's favorite metaphor. Mahony ascribed the inspiration for the title, however, not to Moore but to Geoffrey Parsons's *Stream of History*. That book, a brief and synthetic overview of man from amoebic beginnings to the present, delighted Mahony, who viewed the volume as a "great dramatic poem" expressing a "fair and unopinionated"

view of the past. She liked it particularly because Parsons, she believed, presented "the whole great unwieldy mass of history—as a sculptor might take a huge mass of soft clay—and shap[ed] it with care and skill so that it shall present a certain Rodin-like figure of truth." Parsons, she observed, regarded history as "one unbroken flow . . . always moving onward, not as a series of episodic periods."[45] The editors' unconcealed enthusiasm for Parsons's writing revealed their uncritical acceptance, first, of a progressive historical model and, second, of the ability to satisfactorily capture historical "truth" in one neat volume.

Metaphor continued in another section, entitled "The Great Gates of the Mountain." Containing chapters on literature, literary biography, poetry, and the Bible, and given the editors' love of classic literature, it seems unsurprising that Chaucer, Hardy, Hawthorne, Thackeray, Blake, Wordsworth, Sir Walter Scott, Austen, Shakespeare, and others of similar literary stature occupied this section. Significantly, however, Mahony and Whitney also placed bookwomen here by including books of literary criticism authored by Moore and a few other individuals such as Frances Jenkins Olcott. Positioning bookwomen in this chapter not only implied a connection to literary figures commonly considered "great," but also associated them with gates, presumably passages into the "truth." Anne Thaxter Eaton used the same metaphor when describing the library as a "gateway into a world [children] would not otherwise know."[46] Once again, bookwomen utilized metaphors tied to what Moore referred to as "the spirit of place."[47]

The final section of *Realms*, entitled "This Writing World" (the reference to Untermeyer's *This Singing World* seems obvious), contained an overview of the specific historical preconditions for recent advances in children's literature. Opening with a discussion of the pioneering efforts of the children's library movement, the section then praised the "quiet revolution" among teachers who allied themselves with the library. From there, the editors commented on the influence of bookstores and the foresight of publishers to create distinct departments concerned with children's book publishing. By inserting them into the forefront of the unfolding story, Mahony and Whitney credited bookwomen with recent improvements in children's literature. On the very last of its 727 pages, Mahony and Whitney left readers with three specific images: Anne Carroll Moore, the *Horn Book*, and the Bookshop for Boys and Girls. Benediction-like, the book ended with a fourth image: books, Mahony declared, "will add more trees to the slopes of the sacred mountain." Thus, after celebrating five centuries of the "best" literature, the culminating chapter credited bookwomen with creating the

demand for *Realms* and maintaining the rigorous standards necessary to continue this "rightful heritage." Mahony and Whitney remained silent about women editors in publishing houses outside New York or Boston, acknowledging only the eight children's departments located in those two cities.[48] In a sense, the fact that they privileged New York and Boston mirrored reality, since these cities were indeed the centers of American publishing, but also suggests the degree of narrowness of their particular community of practice.

A year and a half (and several reels of typewriter ribbon) later, Mahony and Whitney presented the ample manuscript to May Massee, who removed almost a quarter of the material but otherwise suggested few editorial changes. The segment Massee removed was placed in a second book, *Contemporary Illustrators of Children's Books*, printed by Thomas Todd and published by the union a year later. *Realms* was an immediate success, receiving high acclaim from bookwomen. Jordan, a manuscript reader, proclaimed *Realms* so highly creative that she regarded Mahony and Whitney as excessively modest in claiming to be "merely compilers."[49] May Lamberton Becker referred to *Realms* as an "affectionate *catalogue raisonee.*"[50] Moore simply advised everyone she knew to purchase a copy.

While Mahony and Whitney compiled *Realms*, they also managed a rigorous schedule of Bookshop activities. Intending to shore up what she considered a dangerous flagging of interest in reading, Mahony dispatched union members to junior and senior high schools as storytellers. School administrators were skeptical, feeling that Mahony exaggerated the problem and that no "help" was indicated, but the results were hard to dispute: book circulation at Boston public libraries grew dramatically, causing Boston's high school English departments to reconsider their response to the program. Mahony, interested in homes as well as in schools, kept parents abreast of new children's books by offering a series at the Bookshop called "A Pleasure Course." Seaman and Massee were called on to address attendees, a double blessing for the speakers since they could advertise their own products while encouraging reading.

By authoring *Realms* and launching the *Horn Book*, Mahony rapidly became an important figure in the field of children's book publishing. As the magazine's managing editor, she became an editor's editor, reviewing articles submitted by children's editors for the *Horn Book*. By 1929, publishing firms such as Scribners sought her advice, asking her to read manuscripts and advise on other publishing matters.[51] She served on the jury of the Beacon Hill Bookshelf, the "great books" series prepared by Little,

Brown, which grew from eight to eighteen volumes by 1927.[52] By the end of the 1920s, Mahony used her unique and authoritative role in the children's book world both to advance her opinions about "good" reading for children and to expand the influence of the other bookwomen with whom she was closely connected. But prominence in the publishing world did not, apparently, detract from her powerful personal identification with her work. She continued to be a daily presence in the Bookshop, meeting with young children and viewing the Bookshop as a personal as well as professional undertaking. This fact was best captured by the title of an article Alice Jordan wrote in June 1929 for the *Atlantic Bookshelf:* "The Bookshop That Is Bertha Mahony."

Seaman and Massee were bridges as well, mediating between a largely male commercial book world and the new generation of women in publishing. The ways they defined their roles at Macmillan and Doubleday established professional standards for women in publishing, paving the way for expanded roles. They became mentors for the rapidly growing number of women editors who, throughout the 1920s, were added to the ranks of commercial editors. Yet, while they created a fresh professional path and mentored newcomers, Seaman and Massee maintained their own images as "the first of their kind" in publishing. By cultivating images of themselves as "pioneers," they contributed to an order of privilege.

The creation of children's departments was attributable, first, to the general prosperity of publishing during the decade, exemplified by Macmillan's relocation to a new, eight-story building on the corner of Fifth Avenue and Twelfth Street in 1923. With branch offices in many major cities, the firm boasted assets of around ten million dollars by 1927. Prosperity was also evidenced by the emergence of new firms with small but impressive backlists and by cooperative working relationships among publishers. Knopf, for example, organized the Book Table, a lunch club designed to mix publishers, booksellers, librarians, authors, and designers. But publishers' generosity also extended to their employees, generally by the implementation of "welfare work," the industry's version of welfare capitalism. Improved working conditions, including a five-day workweek, were initiated in many houses by the middle of the decade.[53]

In addition to general prosperity, however, the proliferation of children's departments also stemmed directly from the successes of Seaman and Massee. While Seaman never saw a balance sheet, she knew that in some years the gross revenue from children's department exceeded a million dollars.[54] By the end of the decade, the number of Macmillan's children's titles

had grown from the two hundred and fifty at Seaman's disposal in 1919 to over six hundred, necessitating an eighty-page annual catalog, nearly three times the size of the original. Moreover, increased prestige for children's authors meant a corresponding increase in the number of manuscripts submitted to Seaman. To handle the workload, she enlarged the children's staff to include Gertrude Blumenthal and Eunice Blake, a student from her New Haven days. Staff members read fifty manuscripts a week, devoting themselves to their work, Seaman said, "beyond any hours or salary or common sense."[55]

The other publishing houses that followed the example of Macmillan and Doubleday by creating children's departments also placed women in charge of them. Helen Dean Fish, who began her book career as a manuscript reader for Stokes in 1917, became the first children's editor at that firm in 1922. Marian Fiery was put in charge of E. P. Dutton's department in 1925; in the same year, Bertha Gunterman joined Longmans, Green. In 1926, Virginia Kirkus was appointed to head Harper's children's department, followed by Lucile Gulliver at Little, Brown in Boston in 1927 and Katharine Ulrich at Coward-McCann in 1928. As these women editors assumed their new roles, they looked to "pioneers" for guidance. In the *Horn Book,* Mahony quoted one anonymous editor who gratefully acknowledged Seaman's "pioneer work" as of "infinite help" and who doubted that she could have successfully navigated the process of creating her department without it.[56] Many of these newcomers published some of the most dearly loved (and best-selling) titles of the interwar years, and the *Nation* was liberal with praise for them. Departments like those at Macmillan and Doubleday represented the "aristocrats of the children's book world" and could be "trusted" to cultivate a reading taste for children and uphold traditional standards.[57]

Notwithstanding the fact that children's editors in general sometimes received praise, Seaman and Massee continued receiving acclaim as "pioneers" and "aristocrats" of children's editing. In a 1928 *Horn Book* article, Mahony did mention the newer children's departments, but expressed her hope that all children's departments would eventually live up to Macmillan and Doubleday in both quantity and quality of children's books.[58] While other editors had talent, she declared, "the truth of the matter is that [Seaman and Massee] have made a new world of children's book publishing. They have set up such standards as will keep publishers running hard for a long time to equal them."[59] The explicit class discourse of aristocratic taste, in which bookwomen unhesitatingly participated, was more uneasily

situated against the discourse of the "reading democracy" than book-women seem to have comprehended.

Bookwomen not only mentored new editors but also nurtured new authors. Elizabeth Coatsworth and Rachel Field, two Macmillan authors, were particularly close to Seaman, and her relationships with these women exemplified her editorial attributes. Her friendship with Coatsworth was the older of the two, dating back to their college days at Vassar. When Seaman assumed her position in the children's department, her usual long talks with Coatsworth turned toward considering books "from a new angle." Coatsworth offered "inspiring advice and suggestions" to Seaman about titles on the list, including discussions of "an Oriental point of view" par-ticularly interesting to both women.[60] These discussions prompted Coats-worth to try her own hand at writing for children, and in 1929 she produced a book about a cat and the Buddha in what became her most famous work, *The Cat Who Went to Heaven.* Edited by Seaman, it required reprinting within one month and received the Newbery Medal in 1931. Seaman nur-tured the writing development of Coatsworth from "impressionistic, occa-sionally precious or studious" to her position as a major contributor to American children's literature.[61] Eventually, Macmillan published over fifty Coatsworth titles; those books were commonly used by various storytellers like John Cronan at Boston Public Library.[62] Much later, when Seaman's speeches and essays were collected for publication, she dedicated the book to Coatsworth, for "the special friendship that has brightened every year since college."

In Seaman's professional relationship to Rachel Lyman Field, however, her "guiding hand"—and indeed that of all bookwomen—in promoting children's books can most clearly be seen. Field was one of Seaman's first authors and she possessed, it seemed to Seaman, a greater sense of pub-lishing than the children's editor herself. Field was born to a prominent New York family in 1894 but grew up in Massachusetts, entering Radcliffe in 1914 on the basis of her writing skill. While there, she wrote plays, some successfully produced between 1917 and 1920. After graduation, she worked for five years in the editorial department of the Players-Lasky silent film company in New York before becoming a freelance writer. She submitted her work to several publishers and received several rejections but, in 1924, Yale University Press published *The Pointed People: Verses and Silhouettes,* a volume of poetry for children. Unfortunately, the book was overshadowed by the publication of A. A. Milne's *When We Were Very Young,* stalling her authorial debut even though children wrote to her that they enjoyed it.

Seaman had met Field shortly after becoming Macmillan's editor and was immediately impressed with her abundant ideas for stories or poems and her consistently accurate self-evaluations about which of those stories she had the ability to write. On rare occasions, when Field strayed from her literary "range," Seaman gently encouraged her to return to areas best suited to her.[63] When the author was at a loss about some aspect of her work, she came to Seaman's office for advice, although she recalled that the author generally worked through problems herself simply by describing them. Normally, in fact, she edited Field's work only for mechanics. In the latter half of the decade, Seaman accepted two books from Field: *Eliza and the Elves* (1926) and *Little Dog Toby* (1928). During the same period, Field also found May Massee a powerful ally, both as a friend and as the editor at Doubleday. Massee, in fact, also published some of Field's first books, including *An Alphabet for Boys and Girls* (1926), *Taxis and Toadstools: Verses and Decorations* (1926), *A Little Book of Days* (1927), and *Polly Patchwork* (1928). But shortly thereafter, Field embarked on writing the book upon which much of her reputation is based.

Although Seaman preferred to designate the illustrator for most of the books she published, Field was allowed to find her own illustrators. As a result, Field brought Dorothy Lathrop to her editor's attention. Inspired by a doll they saw in the window of an antique shop on Eighth Street in New York, author and illustrator decided to collaborate on a book. When the two women brought to Seaman their idea of writing a book about the doll and its hundred years of journeys, she responded only, perhaps thinking of Nicholas, that the idea was "interesting."[64] Nonetheless, the two women began work on *Hitty: Her First Hundred Years*. Field predicted that the book would win the Newbery and, in 1930, she indeed became the first woman to receive the prestigious award.[65]

The book is the autobiography of a wooden doll named Mehitable, shortened to Hitty, carved by a New Englander sometime around 1820. As she changed owners, the doll experienced a variety of adventures. Owned by missionaries, farmers, slave owners, and sea-faring families, Hitty (and the book she "writes") made her way through the nineteenth century, frequently pausing to appreciate America through comparison to other cultures. The storyline, privileging Yankee tradition, no doubt explains bookwomen's intense and prolonged attraction to the book, an attraction that ultimately contributed significantly to its success.

With a price of $2.50, the book made its debut in October 1929 with Hitty as "the debutante of the year." Moore announced the book's publication on

November 3, 1929, in the "Three Owls" page of the *Herald Tribune,* uncharacteristically devoting the entire column to a discussion of the book. In so doing, she signaled not only approval for the book but also her feeling that Hitty "must be given her own distinctive place among books embodying the American tradition."[66] She not only reviewed the book favorably, but also invited Field and the doll to the children's room as guests at Children's Book Week.[67] *Time* thereafter described Field as "the Louisa May Alcott of Contemporary Writers," insisting that the book was the "only true juvenile classic written in America in a generation."[68]

Field, who regarded Seaman as pivotal to her writing career, frequently wrote to her editor. Her letters (and those of Field's mother, also a correspondent) consistently revealed a firm conviction that Seaman was responsible for launching her career. Blurring the usual distinction between personal and professional influence, she told Seaman that she was "a grand *person* as well as a publisher."[69] Allowing the author and illustrator to decide "every detail," Seaman later said that she had "little to do" and that the book was only "just slightly" to her credit because she stood in Brett's "good graces."[70]

In reality, Seaman was much more connected to the book's enormous success than she admitted. Indeed, she kept *Hitty* before the book-buying public for three years by devoting the cover of her annual catalogs for the years 1929, 1930, and 1931 to the doll. The 1929 catalog displayed a color illustration from the book as the frontispiece. Although the theme of the catalog was doll stories, Seaman carefully reminded readers that *Hitty* was a pioneer, the "first story of an American doll done with authentic American backgrounds." The next year, Seaman again made *Hitty* the cover feature in celebration of the book being awarded the Newbery. This time, Seaman portrayed Hitty in an airplane which, she explained, was how the doll (and Field) traveled to Los Angeles to receive the award. As one *Horn Book* contributor noted, the doll had become a "Public Person."[71]

Hitty shared the 1931 catalog with Field's next book, *Calico Bush,* another Newbery winner. But Seaman continued to endorse *Hitty,* featuring in the catalog a letter written by the doll to Anne Carroll Moore at the *Tribune.* In the letter, Hitty related her latest adventure to Moore: she was now owned by the poets Stephen Vincent Benet and Rosemary Carr Benet, who read the book to their young daughter. *Hitty,* it seemed, was adored by the "best" literary people, another reason to purchase a copy.

Field's success continued after *Hitty* and *Calico Bush,* in no small part the result of both Massee's and Seaman's efforts to turn her into a successful author. Just as Bertha Mahony "was" the Bookshop, Louise Seaman and

May Massee "were" the children's departments at Macmillan and Double-day. They mediated between new authors and the public by mingling an entrepreneurial attitude with maternal qualities. Seaman once disclosed the depth of these relationships: "I don't think other book editors can understand the way a children's book-maker feels about her list. Each title means so much more than just an editor's OK on a manuscript. More frequently than on other lists, it means the actual conception of the book by the editor and the difficult pursuit of the right author and artist. . . . How often it means a happy friendship . . . and thereby a deep concern for their welfare."[72] In addition to three Newbery winners and four honor books between 1925 and 1931, Seaman also published the writing of two bookwomen: Elinor Whitney's *Tyke-y: His Book and His Mark*, her first children's book, and her *Tod of the Fens* (Newbery honor book, 1929) and Moore's *The Three Owls* (1925), a book of literary criticism.[73] Two books by Moore's old mentor, Caroline Hewins (*A Traveler's Letters to Boys and Girls* and *A Mid-Century Child*), became Macmillan titles as a result of Moore's intervention.[74] Seaman also published Arna Bontemps and Langston Hughes's *Popo and Fifina*, the first children's book, excepting poetry, writ-ten and illustrated by African Americans and published by a major house; *Men at Work*, the first juvenile photo documentary, by Lewis Hine, and the first wordless book, *What Whiskers Did*, by Ruth Carroll. Considering "the here-and-now no less vital than the once-upon-a-time," she published books for children about science, such as Wilfrid Bronson's *Fingerfins and Paddlewings;* Edith Patch's *Holiday* series, and "real-world" books such as Louise Lamprey's *All the Ways of Building.*[75] At Doubleday, likewise, Massee experienced much success. Like Seaman, she was responsible for several award-winning books, including *Tales from Silver Lands* (1925) by Charles Finger, *Downright Dencey* (1928) by Caroline Snedeker, and *The Runaway Papoose* (1929) by Grace Moon.

Seaman and Massee also steered their houses into the field of picture books in response to widespread demand among librarians and literary critics. By the end of the 1920s, full-color picture books were available in unprecedented quantity because of new processes in color lithography and bigger edition runs. School textbooks also changed as a direct result of books produced by bookwomen in publishing houses; publishers produced attractive books for use in classrooms and utilized the talents of the new authors and artists discovered by children's book publishers.[76]

Mahony decided to honor Seaman's efforts by dedicating the August 1928 issue of the *Horn Book* to the editor's achievements. To her mind, they

were cause for community celebration, and she anticipated that other children's editors would agree. But her assumption that other editors shared her warm-hearted admiration for Seaman proved naïve Having included, in addition to tributes, substantial excerpts from Macmillan's annual catalog, Mahony was shocked to discover that other editors, far from viewing the issue as a celebration of community achievement, regarded it as little more than unpaid advertising. The immediate context for this incident was competition for market share, heightened by the advent and growing popularity of other media and, more indirectly, a nationwide sensitivity to censorship issues.[77] Accusations of payment by Macmillan to the *Horn Book* stunned and deeply hurt Mahony, who felt that her personal integrity had been called into question. Eventually, she used the *Horn Book* to issue a formal response.

> One of the most memorable blows which the *Horn Book Editor* has received . . . was when a prominent figure in the library world turned to her one day and asked "What did the Macmillan Company pay you for the *Horn Book* of August 1928?" . . . We had said, "Let us . . . present the work of those Juvenile Editors who have been making such fine history and let us begin with Miss Seaman because she is the first." We had expected to follow with similar numbers for May Massee, Bertha Gunterman, Lucile Gulliver, and others. . . . So we asked Mr. Brett if he would write an article about the department. . . . If we were making a similar number of the magazine today, we should do it differently, having learned something as Editors. But we did think that we had made the aims and purposes of the magazine so clear that such a question would never occur to any one. . . . We . . . say once more that in the *Horn Book* we are attempting to build a genuinely critical, constructively appreciative and inventively active journal on books and reading. . . . The *Horn Book* is made without any consideration of its advertisers.[78]

Mahony was so shaken by this assault on her editorial judgment that she did not print another tribute to an editor for eight years. It was only the first of several episodes questioning the *Horn Book*'s editorial policy and the privilege its editors consistently extended to certain individuals.

In addition to the tribute debacle, Seaman was at the forefront of bookwomen's attention for another reason. In 1929, the thirty-five-year-old editor married Edwin de Turck Bechtel, a graduate of Harvard law school and an attorney for American Express. Her marriage to Bechtel placed Seaman

in a social world that included such individuals as Franklin Roosevelt, Bechtel's old classmate and coworker. Bechtel shared Seaman's love of literature, and the couple also enjoyed horseback riding, print collecting, and rose gardening—for which they became particularly well known—at their thirty-acre farm in Bedford Four Corners, New York. Bookwomen, although pleased by Seaman's happiness, wondered about the implications of marriage for the new Mrs. Bechtel, and for bookwomen. Cornelia Meigs, a Macmillan author, informed Seaman that everyone was involved in "the great question" of whether she would give up her career.[79]

For reasons already noted, Meigs and other bookwomen had good reason to wonder. Potent national ambivalence about married working women, stemming from the much-discussed sexual revolution and the absence of an organized feminist movement, fueled the context for the continued marriage-versus-career debate. The relationship between the sexual revolution and female career aspirations was complex, as were the relationships among women themselves, who frequently disagreed about the appropriateness of women's professional aspirations.[80] Reformers, for example, did not automatically defend a woman's right to a position in the workplace if she wanted one. To some, the declining birth rate among white, middle-class Americans symbolized the disintegration of family, including notions of "race suicide."[81] But at thirty-five, although childbearing was certainly still a possibility for Seaman, delaying marriage might have diminished social pressure to do so. In the end, Louise Bechtel continued her professional life; it appears that Edwin Bechtel made no request that his new wife leave her career.

Shortly after their marriage, however, national economic events took a turn for the worse. Throughout the first half of 1929, sales and optimism in the publishing industry remained high and Brett predicted a continuation of prosperity.[82] But the economy's long, downward spiral commencing in the fall of that year posed distinct hazards to bookwomen and the fragile "empire" of children's books they had helped to construct. Institutional mechanisms for the production of children's books were well defined and fully operational, and bookwomen had helped to launch the careers of some important literary figures as well as forums for professional exchange, including the *Horn Book*. The Great Depression, however, quickly fashioned a set of national priorities that was not necessarily favorable to children or their books. As prosperity receded, elegant children's books became superfluous, a painful, if not obnoxious, reminder of better days.

CHAPTER 7

Triumph and Transition

THE UNITED STATES CENSUS FOR 1930 revealed that nearly eleven million women were in the workforce, representing about one quarter of all gainfully employed Americans. Of these, the government recognized slightly over 14 percent, or about a million and a half, as professionals, but during the first half of the decade, nearly one third of them became unemployed.[1] Under the catastrophic financial circumstances of the decade, public opinion polls indicated that Americans continued their overwhelming opposition to the employment of women, especially those who were married.[2]

The effect of the Depression on bookwomen corresponded to its impact on the institutions employing them. In varying degrees, bookwomen were required to adjust to harsh economic realities, but none suffered the sort of hardship frequently associated with the decade.[3] Despite cutbacks, adjustments, and shifts in employment among members of the "inner circle," bookwomen, collectively, reached their zenith during this decade, largely as a result of their connection to the *Horn Book*. While the Depression gave little cause for celebration, they refused to allow those circumstances to rob them of their idealism, professional commitments, or sense of community. Networks and alliances, Children's Book Week, Newbery award celebrations, and the *Horn Book* all dramatically expanded during the Depression.

The professional lives of most bookwomen also changed dramatically during the 1930s: May Massee left Doubleday; Louise Seaman Bechtel retired from Macmillan; Elinor Whitney and Bertha Mahony each married; the Bookshop for Boys and Girls was sold; Mahony both acquired ownership

of the *Horn Book* and stepped down as its managing editor. Some of these changes were directly attributable to the financial and cultural tensions of the decade, while the relationship of other changes to the Depression was more ambiguous.

The Depression, Libraries, and a Silver Jubilee

Like most institutions in Depression America, libraries experienced budget cutbacks, thus making the prosperity of the previous decade seem remote. Many libraries, in fact, cut their book purchasing budgets dramatically, often by 25 percent.[4] Paradoxically, as fewer books were purchased, book circulation in many cities rose by as much as 40 percent, partly because, unlike other activities, reading could be free.[5] On a deeper level, books were familiar and comforting artifacts, signifying stability in the midst of profound national turbulence. Books connected readers to the past, somehow reassuring them of a future and reminding them that they would survive the worst of calamities. On a more pragmatic level, books continued to represent important currency, influential reminders that with the right attitude and education, getting ahead was still possible, whatever the present circumstances. And never was belief in success potential more important than in Depression-era America.

Librarians, including Anne Carroll Moore and Alice Jordan, typically responded to budget restrictions with a no-frills, back-to-basics approach in book selection, relying on titles with proven track records for circulation.[6] In addition to slashed book budgets, wage reductions were a common means of fiscal control. Librarians, on average, suffered pay cuts ranging from 20 to 30 percent, although the figure approached 60 percent in some cases. Federal resources allocated to the public library system allowed roughly fifteen thousand librarians to be shifted to the Works Progress Administration (WPA) payroll, but where WPA funds were not available, many libraries simply could not afford to retain staff.[7] Consistent with national social attitudes and employment trends, library women who lost their jobs found little recourse or sympathy for their plight.[8]

Despite the library's grim financial picture, 1931 marked Moore's silver anniversary as supervisor of children's work at the library. This event served as a catalyst, drawing together a diverse community of bookwomen, publishing people, and librarians who were determined to acknowledge Moore's substantive contribution and vision with an event befitting their "commander-in-chief."[9] Throughout the summer, therefore, preparations

were underway at NYPL for a surprise party in her honor. In addition to honoring Moore, the event symbolized collective achievement, provided a unique opportunity for reflection, and brought the interdependence of varied professionals in the literacy enterprise into sharp relief. Invitations for the September event went out to friends and colleagues nationwide and the response was impressive. Moore's biographer, Frances Clarke Sayers, described the event:

> The scene was the Central Children's Room. . . . [Moore] came with [cousin and publisher] Storer Lunt, to find the place brilliant with candlelight and flowers, and men and women of the literary world, old friends and out of town guests waiting to greet her. She was escorted to the center of the room and there she was seated in a high, curved rocking chair that had belonged to Washington Irving. Frederic Melcher was master of ceremonies. He announced The Procession of Branches. Winding through the length of the children's room they came, the children's librarians. . . . A great portfolio of original drawings made for Anne by artists of the time was put into her hands, and at one point Mr. Melcher poured from a large cornucopia a shower of letters, telegrams, messages from everywhere, into her lap.[10]

The acclaim she received at the party was typical of tributes elsewhere. Eleanor Roosevelt cabled congratulations. Sara Teasdale declared that Moore's work would "live in mankind to the end of our civilization . . . planted where it can not die," bringing forth "fruit that our country needs more than any other thing."[11] Even Benjamin Adams, Arthur Bostwick's successor at NYPL with whom Moore frequently disagreed and over whom she nearly resigned her job, acknowledged Moore's "zeal and energy" and her "never failing loyalty and complete devotion to the cause."[12] May Lamberton Becker, a literary editor for *St. Nicholas* at the time, claimed that there was "not a department . . . in our country . . . that has not been strongly influenced . . . by her noble idealism."[13] Moore's old friend Montrose Moses acknowledged her critical role in the "Great Transformation" that had "educated [publishers] in the faith that young people should rub elbows with the Great Books."[14] Financial prosperity had diminished, but books, perceived to be an important stamp of civilization, remained reliable touchstones of cultural vitality.

Hundreds of letters expressed a similar sentiment: Moore had redefined the field of children's books. Writing the introduction for Moore's third and latest, *The Three Owls,* Bertha Mahony claimed that "no person living

in America today has exerted the same constructive influence in making the children's books what they are today. . . . There are three great names in the history of American children's books—Horace Scudder, Mary Mapes Dodge and–Anne Carroll Moore."[15] In recognition of her "commanding influence and authority in the choice of children's literature within and without the library profession," Pratt Institute bestowed a Diploma of Honor upon Moore shortly after the silver jubilee.[16]

Publishing and the Depression

Like the library, publishing revealed signs of financial strain, although only two small houses went bankrupt during the Depression, further evidence of their remarkable durability. The industry survived by minimizing overhead costs, lowering profit expectations, cutting wages, reducing the number of titles published, and keeping prices low. Books, in fact, were commonly available for prices ranging from fifty cents to a dollar, the result of price wars to retain customers. By 1934, NRA coding stabilized the book market by forbidding price alterations within six months of publication, but after the codes were declared unconstitutional in May 1935 the price wars resumed. As the decade wore on and publishers' faith in the market was partially restored, the number of titles and sales gradually increased so that by 1937, more than six million books a month sold—some for ten cents— at various retail outlets around the country.[17] Publishers, attentive to cost control, cut children's book production despite the fact that children's books had expanded more than any other category during the prosperity of the previous decade.[18] As a result, Bechtel and Massee focused on reprinting popular stories, but ultimately both editors left their positions during the first half of the decade. Bechtel's position was never jeopardized because of the Depression; with nearly twenty thousand titles on backlist, Macmillan retained its prestige as the largest and wealthiest firm in America, and its sales were higher than ever.[19] Her departure, instead, was the result of a horseback riding accident in 1933, in which she fractured her hip. Authors, illustrators, and editors she had mentored found standing room only when they visited her in the hospital; the outpouring of concern for their editor and friend was enormous. Bechtel's recuperation was protracted and, in light of her long absence, she considered leaving Macmillan but worried about the consequences of such a decision. She had published over six hundred books at an average rate of sixty titles a year.[20] Her intimate connection with the printing process, as well as with her authors and

illustrators, caused Bechtel, like Mahony, to become personally identified
with her job. "To leave a list in the hands of others," she mused, "is a com-
plicatedly bitter experience. Who will see that the next printing of WYZ
is done on the right paper? Who will watch the binding of PQ? Who will
follow up in those special letters to schools about AB? Will somebody be
kind when CD simply must have his royalty check a week ahead of its due
time?"[21] What would happen, in other words, when market relations in
America no longer rested on personal relationships?

During her convalescence, George Brett continued paying Bechtel's salary,
even offering to put her on "advisory salary," but she thought this would
be unfair to her successor.[22] After an agonizing decision-making process,
Bechtel left Macmillan in 1934 and returned to Bedford Four Corners.
Although she remained an important advisor to Mahony at the *Horn Book*,
thus maintaining a sturdy connection to children's books, many were trou-
bled about the void Bechtel's departure represented in publishing.[23] Rachel
Field lamented that "a very real force has gone out of literature for chil-
dren," and even Moore, with whom Bechtel had a relatively distant rela-
tionship, wrote to Brett, warning him that he had "a good deal to live up
to" in finding an adequate replacement for the editor.[24]

May Massee's departure from Doubleday, by contrast, appears to have
borne a more direct relationship to the national financial predicament.
The firm's cutbacks in children's book production caused one of Massee's
assistants to leave the company in 1930 and Massee herself to do so the next
year.[25] Unlike many other working women, however, the editor found work
quickly; in January 1932, she became the first children's editor for Viking.
The firm, willing to give Massee "absolute control" in creating the depart-
ment, was more to her liking. Viking had, Massee claimed, "the ability in
these times to outline a policy and stick to it."[26] For Massee, this meant a
budget allowing her to publish the elaborate children's books she could not
produce at Doubleday.

While publishers temporarily cut children's book production, their in-
terest in creating children's departments did not diminish. Several firms
added juvenile editors to their staffs during the Depression years, includ-
ing Laura Harris (Grossett and Dunlop), Rose Dobbs (Coward-McCann),
Elizabeth Gilman (Farrar and Rinehart), Alice Dalgliesh (Scribners), Louise
Bonino (Random House), Dorothy Waugh and Lillian Bragdon (Knopf),
Helen Hoke (Julian Messner), Grace Allen Hogarth (Oxford University
Press), and Marion Dittman (Rand McNally). Whether appointed during
the 1930s or later, editors in many cases began their professional lives under

the direction of bookwomen. Alice Dalgliesh had gotten her professional start as an author and manuscript reader for Bechtel, while Edith Patterson Meyer, who had studied storytelling at Columbia under Marie Shedlock, had assisted Massee in work on the ALA Booklist and eventually became the children's editor at Abingdon-Cokesbury Press. Mary Silva Cosgrave (Houghton Mifflin) and Margaret McElderry (Harcourt Brace) began work at NYPL under Moore in 1936 and 1939 respectively. At least six of Bechtel's and Massee's assistants became children's editors: Eunice Blake, Doris Patee, and Gertrude Blumenthal at Macmillan, Dorothy Bryan and Margaret Lesser at Doubleday, and Annis Duff at Viking.

During the early 1930s, bookwomen also expanded rituals connected with the field of children's literature, deepening relationships among themselves and strengthening alliances with teachers. The important annual Newbery decision, now resting in the hands of a fifteen-member award committee consisting of ALA committee officers and chairs, had traditionally been a simple luncheon affair.[27] Despite the Depression, bookwomen decided to enhance the award ceremony by making it a dinner function and by expanding the guest list beyond members of the Children's Section of the ALA to include school librarians and prominent individuals, including Eleanor Roosevelt, who addressed one annual gathering during the 1930s. When Mahony began printing the text of Newbery acceptance speeches in the *Horn Book*, a dimension of permanence and prestige accrued to both the award and the magazine.[28] By doing so, Mahony connected the *Horn Book* explicitly to the Newbery, by now the "symbolic center" of jurisdiction over children's services.[29]

The expansion of concern over children's books was also evident in the growth of the Children's Section of the ALA, whose membership, by 1937, rose to nearly eight hundred members, approximately four times more than in 1921. Likewise, most children's editors now attended the annual ALA conference, hoping to change librarians' notion that commercial interests in book production contaminated the field. One such instance occurred at the 1934 ALA meeting in Montreal, when Massee confronted children's librarians about the need to trust others in the book business.[30] Bechtel was more blunt: children's librarians, she claimed, had "remained childish too long."[31] Librarians' attitudes about this issue persisted but, with Whitney, Massee, and Mahony as NERTCL guests, Jordan continued creating opportunities for interaction with publishers.[32]

In addition to deepening alliances with those actively involved with children's book production, bookwomen continued reaching out to educators

and adolescents. Moore and Mahony, for example, collected a steady stream of information from G. S. Leland, superintendent of the New York public school system, who sent them monthly school bulletins.[33] At the Bookshop, Mahony strengthened ties between school age adolescents and books through the Amy Lowell Memorial Poetry Series, named in honor of an early Bookshop patron, by offering an impressive lineup of guest presenters, including Carl Sandburg, T. S. Eliot, Archibald MacLeish, and Robert Frost.[34] Beginning in 1934, she sent collections of children's books to state teachers' colleges nationwide to keep them abreast of children's literature.[35]

The *Horn Book* and its managing editor underwent significant changes during the 1930s, altering both Mahony's relationship to the magazine and the magazine's relationship to the book industry. In her attempts to maintain the original vision of the magazine, ironically, Mahony was forced to intensify her relationship with publishers. As a result, the *Horn Book* was more firmly situated in commercial book trade territory, a process that she continued to resist. Likewise, it became clear that the *Horn Book* faced more than intrusion from profit-driven "outsiders." Further charges of censorship, and criticism of the magazine's editorial policy, came from insiders: bookwomen themselves. Attempts at combining service with business had taken its toll, resulting in the sale of the Bookshop in 1936 and, ultimately, the resignation of Mahony as managing editor in 1939.

For Bertha Mahony, significant change began long before her resignation when, in 1932, she married William Davis Miller, a wealthy furniture manufacturer whose home was Ashburnham, a large estate in central Massachusetts. She first met Miller and his wife, Celena, in 1918, and the three became friends. Both Millers were well educated, Celena at Wellesley and William at the Sorbonne. Instead of teaching French at Annapolis as he was invited to do, however, William Miller joined his father-in-law's furniture company and eventually became its owner. After meeting Mahony, and while her health permitted it, Celena served on the advisory board of the Bookshop as a book reviewer, but a heart condition made her involvement increasingly difficult. Celena died in July 1931 and on September 7 of the following year, Mahony and Miller were married in Weston, Massachusetts.

After her marriage, Bertha Mahony Miller moved to Ashburnham and, significantly, left her predecessor's belongings—including sentimental memorabilia—virtually undisturbed.[36] Two other behaviors after her marriage revealed that her desire to "blend in" was personal as well as professional and that she was uncomfortable with confrontation. First, she assumed

Celena's social obligations by joining the same organizations and com-
mittees to which her husband's first wife belonged. More bizarre, however,
was her continuation of Celena's diary, whose last entry was dated July 25,
1931, just five days before her death. The very next entry, dated August 1933,
is in Bertha's handwriting.[37]

At the same time, she created a distinct identity of her own at Ashburn-
ham. She had no intention of abandoning her professional life, but the
one-hundred-year-old farmhouse was simply located too far for a daily
commute to Boston. Miller selected for herself a second-floor room, over-
looking gardens and woods, for professional work. Known henceforth as
the Study, much *Horn Book* work took place in this room. Neither did she
abandon the friendships so important to her; marriage, in fact, accommo-
dated friendships rather than the reverse.

Like Edwin Bechtel, William Miller supported his new wife's profes-
sional life. On more than one occasion, he provided personal funds for
a *Horn Book* publication to which his wife had committed herself, with the
understanding that he would be repaid as the book made money. Just as
she had insisted on timely repayment of her debt to the WEIU so many
years ago, she insisted on repaying her husband as quickly as possible. In
this sense, her marriage to Miller resembled her relationship to the union,
since both provided financial stability for new or expanding career aspira-
tions. Unlike the public library and the publishing industry, whose ability
to survive the Great Depression could hardly be doubted, the survival of
the *Horn Book,* despite its connection to the customary machinery of book
production and distribution, could not be assumed. Miller nonetheless re-
fused to view her husband's generosity as a substitute for the sound fiscal
management that would bring the magazine economic independence.

While neither the magazine nor the Bookshop operated at a loss dur-
ing the 1930s, business records divulge the financial worries of bookwomen
and the precarious financial situation in which it sometimes operated.[38]
Well-worn and carefully handwritten on pieces of cardboard held together
with pieces of string, records represented the intensely personal nature
of the editor's investment in the magazine's success. Stars were drawn or
applied to the record in celebration of days when new subscriptions were
added to the *Horn Book* mailing list. In the context of meager resources,
every subscription was significant. The sense of both worry and victory evi-
denced by the records, however, was undoubtedly for nonfinancial reasons
as well, since Miller knew that, if necessary, she could rely on her husband's
financial resources. More important than the money they represented, the

growing number of subscriptions confirmed to the editors that, in the midst of what seemed to be profound change, an audience existed for their magazine and its abiding hope that the America of their childhood recollections continued to exist.

Miller devised a multidimensional strategy to assure the *Horn Book*'s fiscal health and to minimize dependence on outside sources. Initially, the plan included conventional promotional schemes to enhance circulation. But by 1932, Miller believed that increasing production to a bimonthly rather than quarterly schedule was the best way to improve the magazine's financial circumstances. The advisability of this decision seemed doubtful, given the fact that the total income of the *Horn Book* for that year stood at $3,936.58, while the total cost for the same period was $4,640.06. On a quarterly publication schedule, the magazine ran a $175 deficit for each issue, or an average of two dollars a page based on an average of fifty-eight pages of text per issue.[39] Miller and Whitney were nonetheless determined to carry out their plan, believing that expanded visibility meant expanded profit. Increasing publication frequency, however, meant higher production costs, and doubling the magazine's price in March 1934 proved inadequate to offset their expenditures.[40] Reluctantly, Miller again faced the undeniable usefulness of more advertising, although advertising in the *Horn Book* meant targeting parents, not children, as the actual consumers of children's books.[41] Recognizing that, under the old quarterly schedule, each page of advertising generated $47.43 of income, Miller calculated that, under the new schedule, the proper ratio of text to advertising was three to one. Her formula, thus, was thirty-nine pages of text for every thirteen pages of advertising.[42]

Promotional schemes, increased advertising, and more frequent issues were designed to stimulate circulation, but Miller was convinced that establishing the reader's sense of personal belonging to the magazine was a cardinal element of success. Consequently, she invited subscribers into a partnership with the *Horn Book* by announcing that memberships to the new Horn Book Guild for Children's Books were now available. A membership form was included in the August 1933 issue, and subscribers were urged to join; membership was free, and annual renewal was merely $2.50. Miller informed readers that "when the arts and crafts were threatened, the various trades and professions organized . . . to save their industries." It was not clear precisely what direct benefit subscribers received as a result of membership, but Miller's appeal resonated with middle-class joiners who valued her attempt to "form . . . an alliance [with subscribers] because as a

group they bear a closer relation to the aims and purposes of the Horn Book than magazine subscribers have ordinarily to the journal purchased. The Editors . . . have thought that to unite in a society . . . those who have a special interest in children's books might result in some dynamic influence upon the vitality of those books which combine the creative arts."[43] Elsewhere, Miller stated that the guild was intended to create "a family feeling."[44] Secondarily, no doubt, she also hoped that guild membership dues, during the lean Depression years, would provide a critical cash reserve that potentially represented the difference between operating at a loss and operating in the black.

The announcement of the guild would not have surprised *Horn Book* subscribers, since children's magazines like *St. Nicholas* had an established tradition of creating such partnerships. Activities such as art and writing contests encouraged subscribers to engage with the *Horn Book* on a more personal level by creating a sense of group ownership. Similar to the act of signing pledge cards in the library, joining the guild constituted a commitment to the *Horn Book,* a sign of support and loyalty for the magazine and its editors. The guild intensified the investment of the subscribers beyond the impersonal act of sending a yearly check, exemplifying one of bookwomen's central beliefs: good business practices should be based on relationships that were, if not face-to-face, at least personal, involving mutual vows of integrity and goodwill. Additionally, bringing subscribers into a personal relationship promoted children's awareness of market relations and encouraged advertisers to view children as a potential market.[45]

In the eyes of the editors, therefore, guild membership represented a momentous commitment between themselves and their readers. For their part, readers promised that format changes, including substantial advertising increases, would not diminish their support for the magazine. In return, editors promised that the noncommercial nature of the magazine would remain intact and that subscribers could continue to rely on all that was familiar about the *Horn Book,* including its tributes, its booklist, and, not least, the integrity and expertise of its contributors.

Miller also ensured the survival of the *Horn Book* by keeping a close watch on salaries. To accomplish this, she hired a new editor, a particularly urgent need since she and Whitney refused to consider themselves businesswomen, despite ten successful years of magazine production and eighteen years of bookstore management. In January 1934, therefore, Beulah Folmsbee was hired to build up the mail order department and handle the publicity aspects of both the *Horn Book* and the Bookshop.[46] Folmsbee was

a graduate of Emerson College in Boston and had been employed by the Atlantic Monthly Company in various capacities for fifteen years, including work on *Youth's Companion.*

Miller set Folmsbee's annual salary at $1,300, making her by far the magazine's highest paid employee. By contrast, Miller allowed salaries of only $600 a year for herself and Whitney, hardly reflective of the amount of work performed by either editor. Miller's economic status allowed her the luxury of making herself, virtually, a volunteer in service of the *Horn Book.* At the same time, her token salary allowed her the satisfaction of laying claim to a symbol of "modern" womanhood, the paycheck. In this sense, Miller was possibly able to reconcile her deeply felt beliefs about financial independence and service to others.[47]

Once in full swing, the Depression made it nearly impossible for bookwomen to sidestep the issue of money, and it became a palpable issue of concern for those connected to the *Horn Book.* Economically comfortable marriages enabled Miller and Bechtel to scrupulously retain the service ideal, so deeply rooted in their upbringing and training, as the warp and woof of their professional behavior. Without fail, Bechtel refused payment for her contributions, and Miller persisted in her conviction that there was nothing she felt "less interested in than money."[48] Others, like Jordan, did receive payment for contributions, while Moore steered a somewhat unpredictable middle course, sometimes accepting and sometimes declining pay. Two obvious questions arose: how much should women be paid for doing what was only "natural," and how possible was it for a nationally acclaimed magazine to avoid interacting with the market? The answer to the second question seemed clearer than ever: it was not.

In any case, bookwomen voiced generous support for the "new" *Horn Book.* Bechtel offered praise for "clever" and "wonderful" editorials that "ought to be quoted widely" and acclaimed Miller as "*the* most wonderful planner and dreamer for every side of the book world."[49] Others expressed satisfaction with the new format. Teachers and librarians around the country routinely used the magazine as a resource in their classes or research, partly the result of Folmsbee's efforts to convince library schools to adopt the *Horn Book* as a textbook in their children's literature classes.[50] Helen Smith, for example, an assistant professor of library work with children at Case Western Reserve and a researcher of the effect of book illustration on children, requested the *Horn Book* as research material, and Edith A. Lathrop at the Department of Education in Washington recommended the *Horn Book* in her guide for rural schools.[51]

Despite retaining the final right to "pass judgment on everything printed in the Horn Book," Miller continued to rely heavily on senior bookwomen for support.[52] Despite Folmsbee's capable management of the *Horn Book,* Miller frequently turned to Bechtel, now at Bedford, for advice about fiscal and personnel matters.[53] Folmsbee might be an able business manager but, as later events demonstrated, she remained a "junior" bookwoman. Entrance into the inner circle was selective, open to "pioneers" and to those who spoke the language of Yankee cultural values.

In any case, Miller had particular need of Bechtel's counsel by the beginning of 1935 when the issue of censorship once again arose, this time from among the ranks of bookwomen. Writing to Miller, May Massee demanded to know if the *Horn Book* was suppressing *Trigger John,* a book she had recently published. Noting that the book was not available at the Bookshop and had not been reviewed by the magazine, Massee threatened to withhold Viking advertising in the magazine if she felt that Miller denied a book to the public simply because she did not personally like it.[54]

Viking had published *Trigger John,* written by Thomas Pendleton Robinson, in 1934. Reminiscent of Mark Twain in both style and subject, the book itself was about the mischievous behavior of a group of young boys. The book received praise from several reviewers, including children's author Margery Bianco, who acclaimed it as "the best thing of its kind since *Tom Sawyer.*" May Lamberton Becker, likewise, gave the book a good review, saying that some men might find within it a "lost paradise."[55] Given the publication date, the book represented one of Massee's early projects at Viking. For this reason, it was especially important to her that the book receive favorable reviews, and few reviews were more important at the time than those in the *Horn Book.* Recognizing her dependence on publishers who purchased advertising space in the magazine, Miller anxiously reassured Massee by denying that censorship was practiced, either in book reviewing or in advertisement policy. Assuming a more defensive tone, she remarked that she "would not hesitate" to print comments with which she did not agree. Insisting that the *Horn Book* meticulously followed a policy of tolerance, she acknowledged that her editorial judgment was "no more important than that of someone else equally equipped to judge."[56]

The question was, who else was "equipped," in the minds of bookwomen, to judge? Those individuals expressing differing viewpoints, like Becker and Bianco, might be respected but were given ancillary status in the children's book world. Still, confiding her thoughts to Bechtel, Miller revealed the extent of self-doubt that arose from Massee's complaints. Massee,

in fact, had not only complained about censorship, but told Miller that no children's magazine was presenting "attitudes that needed to be expressed." The statement is vague, but likely a reference to Massee's frustration with the magazine's reticence to take on difficult or controversial subjects. As a result, Miller told Bechtel that the magazine was "not good enough," stating that if she had enough money to endow the magazine, she would make Moore the editor.[57]

Bechtel responded reassuringly, asserting that the growth of the *Horn Book* proved its value and expressed Miller "in a rare way." Encouraging Miller to stick with her current editorial policies, Bechtel insinuated that Massee's comments sprang from jealousy, and reminded her that the *Horn Book* was not intended to be a popular magazine. By maintaining a small, select subscriber list, she suggested, the editorial staff could take certain things for granted among its readers, whereas a more widely based magazine would be obligated to take a variety of viewpoints into consideration.[58] Still, the *Trigger John* issue left Miller upset; despite budgetary constraints and overextended commitments, she valued her relationship with Massee even in times of confrontation. Eventually, she decided that while Massee had "idiosyncrasies," her friendship was too important to lose.[59]

She nonetheless made a point of crafting an institutional response designed to address the censorship issue in a revised editorial policy for the *Horn Book*. Acknowledging that the former policy had been to "give space . . . only to those books we wished to recommend," the *Horn Book* now welcomed other opinions. While her intention was to offer book reviews "honestly and sincerely," she denied that hers was "the only opinion worth having."[60] It is difficult to ascertain the degree to which Miller's announcement lined up with her personal feelings. On the one hand, there is little evidence to support the idea that bookwomen ever significantly altered their sense of what constituted a "good" children's book. On the other hand, the shift from "protector" to "advocate"of children's reading had intensified throughout the early twentieth century. While bookwomen typically claimed to reject only badly written books, their definition of that had sometimes included books with controversial themes. Bookwomen were now pressured to comprehend and respect the difference between the two.[61] But there was more to respecting the opinions of others than becoming broadminded; for bookwomen, doing so carried a potentially significant price. In the "reading democracy," it was necessary to acknowledge variety, but acknowledging other standards risked professional authority.

Amid the turbulence of the censorship debate, the *Horn Book* did well

on its new publication schedule. In 1935, the magazine reviewed 267 books (58 percent of all new juveniles published), nine biographical sketches of authors and illustrators, three articles on bookmaking and publishing, and fourteen articles on either writing for or reading by children.[62] At this point, 60 percent of the magazine's sales derived from schools and libraries with the remainder from bookstores, writers, artists, teachers, parents, and children.[63] In fact, by the middle of the decade the magazine was doing so well that Miller was increasingly torn between her responsibilities at the Bookshop and those at the *Horn Book*.

Not only did she bear enormous responsibilities for both enterprises, but she and Whitney were also now at work on *Five Years of Children's Books*, the sequel to *Realms of Gold*, due to come out early in 1935. Whitney spent several weeks in New York completing research and soliciting reactions from bookwomen, and at completion *Five Years* turned out to be as large a text as its predecessor.[64] In it, the authors asked why better books for children could now be found. Metaphorically, they responded to their own question: a "crystal-clear mountain brook," they insisted, now existed in children's rooms in public libraries and among editors with "fine intelligence and sensitive perception . . . [who believed in] books as a source of joy."

The "brook" was broader, in some ways, evidenced by the fact that while *Realms* covered five centuries of children's literature, its sequel dealt only with five years. But although bookwomen were quick to point to the rapid expansion of children's literature as proof of their influence, they themselves had not generally broadened their own definitions of good books, leaving them as only one, albeit distinctive, current in the brook of children's literature. In any case, *Five Years in Children's Books* was shepherded through Doubleday by Massee's successor, Margaret Lesser, in 1936, and was dedicated to Moore, Jordan, Bechtel, Massee, and Melcher.[65]

The adjustment to a recent marriage, management of the Bookshop, editorship of the magazine, and a strenuous writing schedule took a toll on Miller. At the urging of the union, she tried to continue her responsibilities at the Bookshop on a part-time basis in addition to managing the *Horn Book* but, unable to devote the kind of time to the Bookshop it required, began feeling that a younger woman would be more suited to carry on its responsibilities. She had run the Bookshop for the union for eighteen years and resisted the thought of giving up the enterprise she had nurtured to prosperity, evidenced by $101,000 in sales receipts in 1934.[66] But Miller's heart lay with the magazine. The *Horn Book* required the constant efforts

of its editorial staff to manage its fragile finances and tentative growth. Moreover, the idea of reaching a national—or even international—audience had long defined her vision for her professional life. Friends and associates, recognizing her struggle over the possibility of leaving the Bookshop, offered advice and comfort.[67] Assuming an optimistic stance, Bechtel wrote to Miller that "your personal influence through [the *Horn Book*] . . . speaks to the book world—which is . . . important. When I think of your vision, so long before Mr. Brett thought of a department, in starting that shop, your ideals for it, your enlargement of bookselling to be a creative force in the community—well, it makes publishing look puny!" At the same time, she encouraged Miller to set limits on how much she did for the shop. At all cost, Bechtel advised, she should not become a "stopgap for [the union]." While she was "generous hearted and really interested to have [the Bookshop] go on well,"[68] she reminded Miller that her strength had limits.

Miller considered various schemes that would allow her to continue working in both places or, at least, find a suitable replacement, but she became increasingly nervous and tired, confiding to Melcher that she did not want the Bookshop to become "just another Boston book shop."[69] She and Whitney considered Folmsbee, but dismissed the idea. Failing to find what they considered a suitable replacement, they resigned their responsibilities at the Bookshop in 1934. After two years and a nearly "disastrous experience" under another director, on June 1, 1936, the union sold the Bookshop to the Old Corner Book Store in Boston.[70]

Attendant on the sale of the Bookshop, the proprietary rights to the *Horn Book* were transferred to Miller, who subsequently incorporated the magazine. Its ties to the union were dissolved on friendly terms, but she remained distraught about the sale of the shop. Especially devastated by the union's decision to sell to outsiders, since the shop had been a union-supported activity for twenty years, she turned, as usual, to bookwomen. In uncharacteristically harsh language, Jordan derided the decision, declaring the union "dumb," "stupid," and "short-sighted."[71] Miller confided to her old friend Clara Whitehill Hunt that she wished she could have done more to prevent the sale of the Bookshop, but consoled herself with the notion that the sale actually imbued the *Horn Book* with an increased sense of mission; in the absence of the Bookshop, it became all the more important that the magazine "carry on."[72] She also recognized that Whitney's marriage to William Field on April 29, 1936, and subsequent move to Alstead Centre, New Hampshire, made it even more imperative that the two women confine their efforts to the magazine.

The sale had consequences for other Bookshop associates. Several staff members, including Lillian Gillig, Pauline Langley, Frances Darling, and Genevieve Washburn, opened bookstores elsewhere. Many of these women had been with the Bookshop for nearly as long as Miller and Field, devoting their time and creative energy to its success. They wrote about the experience with fondness, emotion, and faithfulness to metaphors that, by their vagueness, encouraged uncritical acceptance of bookwomen and their ideology of books. Although no longer formally connected to the *Horn Book,* the union continued providing space for the magazine at its offices on Boylston Street, in the heart of Boston's business district.[73] Despite continued physical proximity to the organization, the *Horn Book,* as Miller always dreamed, was now freed from its regional connection to Boston. As such, it became the critical intersection where relationships and professional authority were cultivated, nurtured, sustained, and consolidated in the ordinary and routine business affairs of the magazine. Miller continued meeting with publishers anxious for *Horn Book* attention and soliciting contributions from various children's authors and editors.[74] She also met increasingly with other bookwomen, either in person or in correspondence, to discuss future issues of the *Horn Book.*

When Miller assumed ownership of the *Horn Book,* Moore offered the now famous "Three Owls" to her as an expression of confidence in the future of the magazine. She was willing to do the column for one year without payment in order to strengthen the subscription list but told Miller that when "[the column] really does pay it will not need to be a free contribution."[75] Unlike Miller, Moore nowhere claimed that money was unimportant to her. Her offer demonstrated a belief both in the ideal of service and an assumption that financial remuneration could and should become part of women's professional rewards. Moore looked forward to rejuvenating the column and informed Miller that the owls were "preening their feathers for the flight." Her speculation about the resulting growth of subscriptions was accurate: circulation, which had grown steadily but slowly during the Depression, increased by nearly a third in one year with Moore on board as a regular contributor.[76]

In the midst of support and generosity, significant differences of opinion still surfaced among bookwomen, the result of an editorial staff consisting of experienced, honest professionals who offered Miller unyielding advice.[77] In one instance, she proposed raising funds to provide storytelling in communities throughout the country in honor of Marie Shedlock. She intended to collect dues from *Horn Book* subscribers. Moore forthrightly

objected for several reasons: dues would be hard to collect; people gener-
ally disagreed about what constituted good storytelling; few remembered
Shedlock in the first place; children's librarians would not necessarily sup-
port the venture. Instead, Moore advised Miller to stay focused. "'This one
thing I do' is as good a line today as it was for St. Paul," she admonished.
"[Limit yourself to what you can] do practically to the community you can
reach at first hand."[78]

With ties to the Union cut and those to bookwomen strengthened, the
Horn Book entered a decisive developmental phase in 1936. In terms of cir-
culation figures, production quality, and time investment from the com-
munity of bookwomen, the magazine reached a high point in its history.
Miller resumed her tributes to editors, beginning with one to Massee in
1936. Bechtel was now free of obligations to Macmillan, and Moore and
Jordan, approaching retirement, dedicated significant amounts of time to
the magazine. With such help, the *Horn Book* became a distinct current in
the "crystal-clear brook" of children's book culture, evident in aesthetically
appealing and well-written, if generally nonconfrontational, issues.

Beneath apparent consensus enhancing the richness of the *Horn Book,*
however, deep and still unresolved questions about the magazine's over-
all editorial policy continued to punctuate bookwomen's relationships. In
1937, Moore confronted Miller about her editorial policy, challenging the
magazine's very nature. NYPL children's librarians, she said, "found the
Definition of a poet 'dull,' 'patronizing,' and various other derogatory
things. . . . They also came down heavily on the lack of critical . . . notes for
the lists. . . . [Certain books] are being 'boosted' rather than 'described.' . . .
[The librarian's] criticism in general is that [the contributors have] no
unified format of criticism." Deeply committed to literary criticism, Moore
took her staff's charges of a weak editorial policy at the *Horn Book* seri-
ously, recognizing that such accusations had the power to undermine the
success of the magazine and children's books in general. The magazine
needed librarians' support and she therefore urged Miller to "face the real-
ity . . . and get a detached and objective view."[79] Moore's criticism, however
well intended, caused Miller to consider resigning as managing editor. She
wrote to Moore that the *Horn Book* needed a "fresh current of vitality," sug-
gesting that she had "not been doing a good job" and wondering whether
she should put herself "out to pasture for a while."[80]

Moore's was not the only criticism. In 1938, Helen Dean Fish, editor at
Frederick A. Stokes Company, also inquired into Miller's editorial deci-
sion making. This time, the issue was *Susan Beware,* a Stokes title that, like

Trigger John, had been ignored by the *Horn Book.* Fish avoided the level of direct confrontation that Moore and Massee had used, but echoed a similar concern: why were some books noticed and not others?[81]

Regardless of criticism and self-doubt about her fitness to continue as managing editor, Miller put aside thoughts of relinquishing her role for another year. And, for all their private questions, bookwomen continued to exhibit a public face of thoroughgoing support for each other and for the magazine.[82] But the following year, Miller indeed began preparing to resign. As with the Bookshop, she contemplated her replacement carefully. This time, however, because she owned the *Horn Book,* no financial backer held the power to contravene her decisions. Field was not a possibility; although remaining strongly connected to the magazine from New Hampshire, she had removed herself from its day-to-day operations in 1936. Eventually selecting Folmsbee, Miller informed the bookwomen of her decision.[83] They expressed unanimous concern both for Miller and for the future of the magazine and braced for change. Jordan wrote to Miller, saying that the proposed change gave her a "pang," but acknowledged that the burden of the editorship was heavy. "It is better," she concluded, "for you to make the decision yourself rather than have it forced upon you." The last phrase, "have it forced upon you," implied that Moore was not alone in desiring a change in editorial style for the *Horn Book.* Further, while Miller owned the magazine, others were clearly empowered to enforce that desire. Jordan reassured Miller that Folmsbee was an able replacement, likely to carry on "the tradition" Miller had established, but that she would nonetheless be missed "dearly."[84]

Moore's opinion was significantly more matter-of-fact, less concerned with Miller than with creating a plan that would allow for a smooth transition by establishing ground rules, philosophical and practical, for Folmsbee to follow. In the first place, she wanted it made clear to Folmsbee that Miller's withdrawl from the *Horn Book* would leave an authority vacuum best filled by herself and Jordan. Jordan should prepare annotated lists to "represent the Horn Book's claim to authoritative criticism of children's books." That, Moore insisted, meant that Jordan should be placed on the payroll because the prestige of Jordan's name would have "immediate promotional value."

Further, Moore made it clear that she wanted her own name to appear as associate editor along with Miller and Field. The associate editors should meet at least annually to provide "stimulating fresh ideas and a constructive plan for the Horn Book of the future." Although Folmsbee would carry

the title of managing editor, her job, as Moore envisioned it, would be manuscript acquisition and correspondence. "Put any part of this [letter] as your own rather than mine," she advised, "only do be definite. Don't try to explain. . . . You are not 'retiring.' Merely . . . releasing certain responsibilities." She concluded the letter by reminding Miller that "you still *own* the [*Horn Book*]."[85]

As she had so often, Moore put her own words in the mouths of others. Before increasing Folmsbee's authority, Miller should take a firm hand with her, ensuring that "senior" rather than "junior" bookwomen remained in control of the magazine. This plan worked, for a time. In 1939, Jordan indeed became book editor, a position she held until 1949. Moore retained control over the Owls column, a prime feature of the *Horn Book* until 1960. Bechtel joined the board of directors. Miller temporarily relinquished her role as managing editor, trading it for the more vague and less market-related title of editor. She did this partly because she did not wish to change her editorial style and partly because she wanted, once again, to enlarge the boundaries of her professional life. During the 1940s, she turned to publishing books under the Horn Book imprint that subsequently formed the canon of thought about children's literature for many years. Between 1939 and her final retirement in 1950, Miller's movements within the Horn Book structure thus became distinctly fluid, allowing her to delegate more responsibility and devote herself to other publishing projects, of which the bimonthly magazine now represented only one. The relationship of other bookwomen to children's books also changed. Jordan and Moore retired from their library positions in 1940 and 1941 respectively, but while their institutional affiliations changed, bookwomen remained vitally connected to children's literature—and to each other—for the rest of their remarkably long lives.

Commenting in 1950 on the mission and dilemmas of early children's librarians, Louise Bechtel astutely described the bookwomen in this study as well: "At first it seemed clear what [they] were after: simply to have more children read more good books. But soon they were involved in as many battles as the wars they were living through. The book battles were waged but never were wholly won. . . . These literate book-lovers, embattled, were taking on new foes, trying to be, all at once, booksellers, nurses, . . . actresses, critics . . . and good business women. As custodians of the public taste, their challenge was terrific. For they were living in a new world."[86] Of all the metaphors bookwomen used, battle was perhaps the most consistent. Perceiving themselves in dramatic conflict with "the public taste"

while considering themselves friends of that same public, bookwomen simultaneously trusted and distrusted the public, both defending a public that did not necessarily ask to be defended and fighting a public that did not necessarily have a quarrel with them. Having drawn such ambiguous battle lines, what initially seemed so "clear" quickly became unclear. Bookwomen achieved authority on ground that was continually shifting, and this ambiguity was the real "foe." By wanting to join the "new world" they saw without losing the old world they remembered, bookwomen inhabited a cultural "no man's land" between the two and struggled with their own private paradox of uncertain certainty.

Epilogue

ISPUTES ABOUT CENSORSHIP AND EDITORIAL POLICY, changes in
employment status, and even Bertha Mahony Miller's dramatic, if
temporary, delegation of responsibilities to Beulah Folmsbee did
not signal the dissolution of bookwoman culture. From New Hampshire,
Elinor Whitney Field continued her collaboration with Miller and remained
connected to the *Horn Book* as an associate editor until 1957. She died on
November 24, 1980. Not content to remain away from the everyday opera-
tions of the *Horn Book*, Miller returned as its managing editor in 1941. She
did not fully relinquish editorship until 1950. In later years, she edited and
compiled several books, including *Newbery Medal Books* (1955) and *Calde-
cott Medal Books* (1957), with Elinor Whitney Field; *Illustrators of Children's
Books, 1744–1945* (1945) with Beulah Folmsbee and Louise Latimer; and
Illustrators of Children's Books, 1946–1956 (1958), with Ruth Hill Viguers
and Marcia Dalphin. She also undertook, on behalf of the Horn Book, Inc.,
the publication of eighteen volumes of the history of children's literature.
Miller contributed to several journals, including the *Saturday Review of
Literature, Publishers Weekly, American Review of Books, Book Review, Child
Life,* and *Parents Magazine.* She received the Regina Medal of the Catholic
Library Association in 1967 and remained chairman of the board of Horn
Book, Inc., into her eighties. On May 14, 1969, at eighty-seven years of age,
she died at Ashburnham. To honor their founder and recognize her lifelong
friendship with Miller, the New England Round Table of Children's Librar-
ians established the Jordan-Miller course in children's literature in 1969. The
School of Library Science at the University of Southern California estab-
lished the Bertha Mahony Miller Seminar Room in 1973.[1]

After forty years, Alice Jordan retired from Boston Public Library in 1940. In retirement, she continued as book editor for the *Horn Book* until 1949. At the age of eighty-nine, she died on March 9, 1960. In honor of her friend, Miller—then seventy-nine—ran a *Horn Book* memorial issue in November 1961. She also established a fund in Jordan's memory to support a lecture series at the Boston Public Library beginning in 1962. Today, the Boston Public Library houses one of the world's largest collections of children's literature, named in Jordan's honor.

Anne Carroll Moore was awarded an honorary degree of doctor of letters by the University of Maine in 1940. The following year, she became the first recipient of the Constance Lindsay Skinner Award in recognition of her pioneering work in the field of children's literature.[2] After retiring from NYPL in 1941 at the age of seventy, she agreed to teach at the University of California Graduate School of Librarianship. She was awarded an honorary doctor of letters degree by Pratt Institute in 1955 and the Regina Medal in 1960. Between 1903 and 1955, Moore authored or edited twenty-one books, frequently focused on commemorating the work of authors and illustrators. On January 20, 1961, the day of John Kennedy's inauguration and ten months after the death of Jordan, Moore died in New York City.

May Massee continued working at Viking until 1960. She received the Constance Lindsay Skinner Medal in 1950 and was the first woman member of the American Institute of Graphic Arts. In total, she published four Caldecott and nine Newbery winners. She died on December 24, 1966. By contrast, after her retirement from Macmillan in the 1930s, Louise Seaman Bechtel never again worked, formally, in publishing. From 1949 until 1957, she wrote for the *Herald Tribune Book Review* and, additionally, wrote for the *Saturday Review,* the *New York Times,* and the *Bookman.* With the help of Virginia Haviland, she compiled her speeches and essays into a volume, *Books in Search of Children,* published by Macmillan in 1969 and dedicated to Elizabeth Coatsworth Beston. Between 1933 and 1957, she served at various times on the juries of the American Institute of Graphic Arts and remained a trustee of the local library at her home at Mt. Kisco until 1962. She continued to contribute to the *Horn Book* and to serve as an associate editor until 1957. She wrote two children's books, *Brave Bantam* (1946) and *Mr. Peck's Pets* (1947), as well as a privately published memoir about her life with Edwin ("Ned") deTurck Bechtel, *The Boy with the Star Lantern* (1960). She served on the Library of Congress committee concerned with children's books and the publication of the *United States Quarterly Book List.*

She routinely spoke on behalf of children's literature for the remainder of her life, and served as advisor to Susan Hirschman, children's editor at Macmillan, during the 1960s. In 1960, speaking on "Books on the Ladder of Time"—a metaphor characteristic of bookwomen's writing—at the fiftieth anniversary celebration of NYPL's annual children's holiday exhibit, she praised the work of authors and illustrators and expressed the hope that "whatever happens to the commercialization of publishing, there will always be new, experimental, individualistic publishing done." Bechtel died in 1985 at ninety-one. Throughout her long career, she insisted that the personal touch was essential: "Perhaps we shall see the Miss Moores . . . of the future broadcast books to half a continent from a space station. Whatever the un-dreamed-of changes in book promotion, one special skill of theirs surely will continue and prevail. That is, the seemingly simple matter of personal introduction of the child to the book."[3]

Thus, the end of the 1930s is best understood as a transitory moment for bookwomen, some of whom continued work on behalf of children's books for another three decades. Still, the transition was significant: within a few years, a generation of younger, non–New Englander bookwomen made their way into literary careers, seeking, and in some cases gaining, entry into the "closed world."

This study has shown that the children's book industry changed sub-stantially between 1919 and 1939, in part because of the accomplishments of these women. Individually, their lives reflect significant and palpable achieve-ment; collectively, they constitute an extraordinarily complex group of literary women. During the twenty years under discussion, the number of books available to children nearly tripled. The U.S. Census of Manufac-tures figure for children's books in 1919 was 24,435,000, including 433 new juvenile titles; by 1939, the total reached 60,232,000, with 1,041 new titles in the peak year of 1938.[4] That bookwomen participated in creating this situation is clear; the strategies by which they inserted themselves into the process, and the attitudes supporting them, are more complex. In some ways, they became casualties of their own success.

Bookwomen brought attitudes to their professional lives that revealed the depth of their liberal faith. Their confidence in expertise, in the possi-bility of reform through education, and in children's right to childhood formed the substructure upon which their goals, decisions, and activities rested. No problem, they believed, defied the power of education and col-lective action, and their vital attachments to social and professional orga-nizations reflected their endorsement of this concept. Associating expertise

with college attendance, job experience, institutional affiliations, and intimate knowledge of the processes they oversaw, bookwomen entered new careers or redefined old ones.

In varying degrees, they complicated their definition of expertise by accepting the notion that children were the proper jurisdiction of women. Packaging this traditional belief in the modern language of expertise, they proclaimed a "new" day for children's books. But while insisting that their professional authority derived partly from their "natural" knowledge of children, bookwomen had no early impulses to devote their working lives to children. Whether they were perceptive enough to recognize that tying themselves to children would provide social approval and security for their careers, or whether they were compelled by their society into child-centered roles is difficult to untangle. Either way, the inclusion of "natural" knowledge in their definition of expertise carried one primary consequence: bookwomen were simultaneously confined and liberated by the children's book field they created.

Their authority derived from carefully nurtured alliances that at once reinforced their belief in collective action and affirmed the importance of individual contributions. During the early stages of their careers, they "borrowed" authority from the libraries, publishing firms, or social organizations with which they were affiliated. As they became acknowledged as experts in their own right, however, their reputations lent prestige to the institutions that employed them.

Ranging from personal friendships to more impersonal business relations, alliances were also cultivated with authors, illustrators, and other recognized authorities in the book field. Alliance building also included mentoring young women new to the field of children's literature, and bookwomen did so consistently. In the 1920s, this was especially important because, in the absence of consolidated and meaningful feminist leadership, there were few precedents for aspiring young female professionals. In the 1930s, when layoffs among women approximated national trends, female role models were especially important, and even harder to come by than in the previous decade. The dwindling potential pool of mentors made bookwomen's mentoring roles throughout the period all the more critical.[5]

While a major goal of creating space was alliance building, bookwomen's embrace of newcomers was tinged with exclusionary professional practices. Editors outside New York or Boston did not receive the same sort of acknowledgment as "insiders." This fact exemplifies a dichotomy peculiar

to bookwomen: the public "face" exuded a solidarity not always reinforced in private attitudes. This public/private split was evident in moments of personal disclosure as well; outwardly, bookwomen showed enormous optimism about their work, but privately displayed ambivalence and fragility. Under fire, bookwomen required, and generally received, reassurance from each other, due to the powerful sense of personal identification each woman made with her career, "becoming" the profession she practiced: a bookshop, a magazine, a children's department. The contemporary attitude of "just doing my job" was unknown to bookwomen; they were their jobs. Identified by their professions, they also lost identity to them, making outside criticism seem exceptionally difficult to endure.

The development of space, both figuratively and literally, proved an essential ingredient in alliance building, signaling specialized spheres of influence and establishing meeting places for colleagues. Space was cultivated in such places as children's rooms in libraries, room 105 at NYPL, the Bookshop for Boys and Girls; figurative space was created in book columns such as Moore's "Three Owls." The Book Caravan in particular suggested the broad and fluid concept of space bookwomen envisioned for their work. The importance of space to bookwomen, and how they utilized it, in fact, is perhaps the characteristic that best reveals the extent of their bourgeois beliefs. Bookwomen brought qualities of private space into the public sphere and, in so doing, enhanced the relevance and legitimacy of "private." They did so not because they hoped a familiar environment would make them more comfortable or recognizable, but because they believed in the power of "public" as an essential principle of a just society. The "public" common good, however defined, ultimately rested on the "private" individual good, and should be deliberately acknowledged and purposely intertwined. At the same time, public space never really became private space, nor was it intended to. Cozy, homelike décor aside, public space required the observance of certain behaviors and rituals that distinguished it absolutely from private space. So, while cooperating with the gender line was generally useful because it allowed bookwomen into certain public spaces, the public/private line, by contrast, disallowed their presence. Unsurprisingly, this was the line they most often blurred by their use of space and language. By challenging the customary and arbitrary line dividing public and private, bookwomen helped to remodel both.

Initially, bookwomen regarded the rapid expansion of the children's book market as evidence of their influence. Once past the initial exhilaration of presumed success, however, bookwomen developed a complex relationship

to the market frequently marked by suspicion, ambivalence, and resignation. The complexities of that relationship reflected much about the tenacious cultural perceptions they developed as children. The relatively affluent childhood circumstances of most bookwomen, situated in the last quarter of the nineteenth century, allowed them a nostalgic, if not always accurate, memory of a "simpler" America. Such nostalgia was at odds with a society in the process of rapid change. Carrying images of small communities into large cities, bookwomen were dismayed by a marketplace in which service and social intimacy had little purchase. Miller's Horn Book Guild is only one example of the ways they sought to reconcile small town neighborliness with their desire for national and international expansion of the market for children's books. The balancing act between the personal touch and the impersonal market, in fact, proved one of the greatest challenges bookwomen faced.

Moreover, by 1939, the market had grown too large for the personal oversight bookwomen thought optimal. In 1919, it had been reasonable for them to read and evaluate all or most of the roughly four hundred children's titles published each year. Twenty years later, it was much less realistic to be thoroughly knowledgeable about the one thousand children's books published annually, pressing bookwomen to redefine their claims to authority. Various strategies might have been utilized, but bookwomen ultimately decided to forgo the language, research methods, and measurable outcomes characteristic of "scientific" child experts.

Still, language became a defining feature of bookwoman culture, situated at the problematical intersection of gender and class discourse. The boldness with which bookwomen expanded their careers was circumscribed by their lack of willingness to take risks; by retaining "rosy" language, the *Horn Book* provides the most obvious example. James Daugherty implied that the magazine's editors used language that excused them from mainstream literary criticism. But the saccharine language Daugherty criticized can alternatively be regarded as bookwomen's determination to establish voice. If that determination made them appear exceptionally agreeable to each other, that is precisely what gave the *Horn Book* its special significance in that historical moment. Although the *Horn Book* editors can be accused of unwillingness to risk precious financial support with critical reviews, the magazine's dedication to celebrating the careers of literary women was the very thing that identified its importance in the trek toward those careers. Bookwomen's language, therefore, represented more than mutual admiration. The magazine's gender composition was an essential

component of establishing voice and, hence, power. The tradeoff seems clear: bookwomen accepted the obvious safety resulting from compliance with social expectations that women innately understood children and, in exchange, retained the ability to exclude male voices. In the sense that the *Horn Book* eventually acquired male financial backers, the fiscal structure of the magazine resembled the union. But while such backers offered needed capital, they had little if any voice in the routine operation of the magazine.

Bookwomen, contrarily, were powerfully woman-identified. With only a fragile foothold in nontraditional literary careers, mutual support was essential to continued success. Daugherty's view failed to discern this imperative, as well as the many shades of subtle disagreement, territorialism, rivalries, and ambivalence among bookwomen that mitigate his interpretation. From a contemporary vantage point, it is clear that the vague, romantic language bookwomen preferred has remained crucial to our vocabulary about childhood, frequently and prominently employed by adults who interact with children. Wrapped in the "rosy" language of bookwomen, children are still connected, by adults from day care workers to movie producers, to "joy," "wonder," and "beauty." The subjective nature of these terms makes them no less important today than when bookwomen utilized them to describe an essential component of, and hope for, the next generation. With adolescent suicide rates tripled in the past twenty-five years and over three million American children victims of violence each year, creating safe environments and positive opportunities for youth continues to press the nation.

Language is only one example of bookwomen's unwillingness to take risks. Although they competed with men in a general sense, bookwomen's attention to children largely absented them from immediate competition with males. Posing no economic threat to the publishing industry, the *Horn Book* functioned, in view of its dependence on advertising, as the "handmaiden" of publishing. Moreover, the magazine's early racial homogeneity suggests that the *Horn Book* reinforced the notion that certain jobs were suitable for women, but only white women. At the same time, the *Horn Book* exerted great influence over the houses by determining what books were reviewed, ultimately resulting in a relationship of mutual, if not always harmonious, respect. Having consolidated their authority, bookwomen gradually ventured further out into the literary marketplace, better able to weather the criticism they received. In retrospect, the longevity of the magazine suggests that its editors possessed more than rose-colored glasses,

and that they eventually found their way in a world of changing markets driven by shifting and sometimes unpredictable reading audiences.

Bookwomen created new opportunities for women in literary careers. As the ill-defined and arbitrary gentleman's publishing tradition of the nineteenth century gave way to the rise of editorship, bookwomen were among the early decision makers in that reconfigured industry. Their focus on expertise and autonomy, utilization of new technology, intimate association with the book production process, and sharp understanding of market demands placed them squarely at the advent of modern children's book publishing in the twentieth century. By 1939, about thirty publishing houses had added children's editors to their staffs, almost all of them women.

This achievement was remarkable, given the complicated, and often hostile, social response to working women. Women found the highest degree of career success when citizens felt that the family structure—and bank accounts—were secure. Where social problems were perceived, working women were likely culprits. Throughout the twentieth century, working women were blamed for a variety of perceived social ills, including race suicide, demoralized males, unruly children, and even the Depression itself. In 1924, indeed, social researcher Lorine Pruette concluded in her book *Women and Leisure* that, in part, American women failed professionally because society had fewer expectations for their career success than for men. By extension, fewer social expectations for women's careers meant fewer consequences for failing. Because less prestige was tied to a woman's career, it was easier to live without one. The growing tendency to identify women as consumers also defined new, largely semiprofessional, working slots into which young women could or should be steered.[6] During the Depression, sex segregation in the workforce became more prominent than ever, often resulting in lower prestige and pay for women. The women in this study turned sex segregation to their advantage, using it to create autonomous professional space.

Bookwomen not only created new career opportunities for women but also helped to shape American literary practice. As critical bridges between nineteenth- and twentieth-century publishing, their attitudes about children's literature were reminiscent of the past, yet dynamic in their vision for the future. Many of the institutions that bookwomen created around the turn of the twentieth century, such as children's reading rooms and storytelling, remain central features of modern literary practice concerning children. Professional awards, beginning with the Newbery, also shaped

the future of the field by acknowledging the importance of good books for children. Bookwomen did not inaugurate the awards but responded to them vigorously and energetically.

By acquiring authority, crossing and expanding boundaries, engaging in diplomacy, and developing a "concurrence of spirit," bookwomen created an empire in children's book publishing.[7] Relations among bookwomen, sometimes strained over differences of opinion, personal eccentricities, or professional rivalries, were characterized overall by generosity, coopera-tion, and even, at times, simple forbearance. In 1973, Miller's biographer claimed that bookwomen "willed a literature for the young into being by creating it, publishing it, evaluating it, and spreading the glad tidings of its existence far and wide."[8] More to the point, they willed new opportunities for women into being by creating them, evaluating them, and relentlessly advocating them. Those efforts helped to bring women into new literary professions, and children and their books to a prominent and permanent place in American culture.

NOTES
BIBLIOGRAPHY
INDEX

NOTES

Abbreviations

ACMP Anne Carroll Moore Papers, Manuscripts and Archives Division, New York Public Library

AMJC Alice M. Jordan Collection (one box), Special Collections, Boston Public Library

HBR Horn Book Records, MS 78, College Archives, Simmons College, Boston

LBP Louise Seaman Bechtel Papers, Archives and Special Collections, Vassar College Libraries

LBUA Louise Seaman Bechtel, unpublished autobiography, box 3, Manuscript Collections, Baldwin Library of Historical Children's Literature, Department of Special Collections, University of Florida George A. Smathers Libraries

NERTCL New England Round Table of Children's Librarians (one box), Special Collections, Boston Public Library

Introduction

1. Periodicals ran articles with such urgent titles as "Equality of Woman with Man: A Myth"; "Career or Maternity: The Dilemma of a College Girl"; "Spinster Factories: Why I Would Not Send a Daughter to College." But personal testimonies of women who had made the "proper" choice also ran: "I Gave Up My Law Books for a Cook Book"; "I Quit My Job"; "You May Have My Job: A Feminist Discovers Her Home."

2. See, for example, Jessie Bernard's study, *Academic Women;* William O'Neill, *Everyone Was Brave: The Rise and Fall of Feminism in America;* William Chafe, *The American Woman: Her Changing Social, Economic, and Political Roles, 1920–1970;* Mary Ryan, *Womanhood in America: From Colonial Times to the Present;* Rosalind Rosenberg, *Beyond Separate Spheres: Intellectual Roots of Modern Feminism;* Barbara Solomon, *In the Company of Educated Women: A History of Women's Higher Education in America;* Dee Garrison, *Apostles of Culture: The Public Librarian and American Society;* Penina

Migdal Glazer and Miriam Slater, *Unequal Colleagues: The Entrance of Woman into the Professions, 1890–1940;* Joyce Antler, "The Educated Woman and Professionalization: The Struggle for a New Feminine Identity, 1890–1920."

3. Hearne and Jenkins, "Sacred Texts," 536–47. Hearne and Jenkins include Moore and Miller in their article and identify a canon that includes texts by three bookwomen in this study: *My Roads to Childhood: Views and Reviews of Children's Books* by Anne Carroll Moore and *Realms of Gold* compiled by Bertha Mahony and Elinor Whitney.

4. Muncy, *Creating a Female Dominion in American Reform, 1890–1935,* xii.

5. Bush, "New England Women," 719–35.

6. R. Smith, "Just Who Are These Women?" 161–70.

7. Vandergrift, "Female Advocacy and Harmonious Voices," 718; Hannigan, "A Feminist Analysis," 851–74.

8. James Daugherty to Bertha Mahony Miller, May 18, 1946, box 5, folder 1, HBR. Daugherty suggested that "a more analytical note might be sounded occasionally, without spoiling the atmosphere of rosy enthusiasm appropriate to this particular field. . . . I wonder if we haven't come to the point when [literary criticism] can be given more serious attention."

9. [Bertha Everett Mahony], "New Books," *Horn Book* 2 (November 1925): 11.

10. J. Brown, *Definition of a Profession,* 13–14, 33.

11. Hearne and Jenkins, "Sacred Texts," 537.

12. MacLeod, *American Childhood,* 179.

13. Children's books during these years have been frequently criticized. In *Thursday's Child,* Sheila A. Egoff, for example, argues that "any examination of children's books of this period will show barely one-tenth of one percent to be of any enduring value" (9).

14. The editor was Laura Harris at Grossett and Dunlap.

15. Heilbrun, *Writing a Woman's Life,* 46, 72. Heilbrun argues that women "have been seen to support one another in the crises of their lives, particularly in those family crises so central to a woman's experience of marriage, birth, death, illness, isolation," but friendship and "colleagueship" among women have seldom been recounted (98).

Chapter 1. Troublesome Womanhood and New Childhood

1. Bledstein, *Culture of Professionalism,* 70.

2. Pawley, *Reading on the Middle Border,* 7. In *Free to All,* Abigail Van Slyck notes that Carnegie's gifts complicated the library's role by creating decision-making dynamics that embraced both philanthropy and paternalism (79).

3. Carson, "Children's Share," 254.

4. Winston Churchill, "The Mission of the Public Library," *Library Journal* 28 (March 1903): 115–16.

5. Kliebard, *Struggle for the American Curriculum,* 7.

6. Ditzion, *Arsenals of Democratic Culture,* 6.

7. Van Slyck, *Free to All,* 220.

8. Bledstein, *Culture of Professionalism,* 56.

9. Ibid., 57, 79.

10. See Wiegand, "Structure of Librarianship," 18–21.

11. For a discussion of Dewey, see Wiegand, *Irrepressible Reformer.*

12. Wiegand, "Structure of Librarianship," 31.

13. The term "separate spheres" cannot be used uncritically, and its meaning has been debated by historians for several decades. For a historiographical essay on the subject, see Linda Kerber's "Separate Spheres, Female Worlds, Woman's Place: The Rhetoric of Women's History" in *Toward an Intellectual History of Women*.

14. Hawes, *Children between the Wars*, 2.

15. Lears, *No Place of Grace*, 16.

16. Bledstein, *Culture of Professionalism*, 56, 61–64.

17. Lears, *No Place of Grace*, 303.

18. An example of this concept can be found in Sanborn, "Books for Men," 165. See also Lears, *No Place of Grace*, 50, and Douglas, *Feminization of American Culture*.

19. "The English Conference, Official Report of Proceedings," *Library Journal* 2 (1878). By 1910, the percentage had risen to 78.5; by 1920, fully 90 percent of America's librarians were women (Garrison, *Apostles of Culture*, 173).

20. Rubin, *Making of Middlebrow Culture*, 17. Rubin identified a genteel "ideology of culture," which throughout the nineteenth century increasingly linked culture to character and moral stature rather than financial means or social status. The "democratization of gentility" had as its goal the greatest exposure of individuals to culture, "spreading the 'best' throughout society," often by creating standards. In the library, this translated into what has been called "the library faith," that is, getting the "best" books to the greatest number of people.

21. Moses, *Children's Books*, 5.

22. Garrison, *Apostles of Culture*, 174.

23. Sanborn, "Books for Men," 166–69. Christine Pawley's study of library records of the Sage Library in Osage, Iowa, during the late nineteenth century revealed that fiction reading was much more equally distributed between men and women than librarians and publishers assumed. Publishers took it as a matter of course that reading taste was driven by gender. The lack of factual data to support this assumption did not deter publishers from targeting markets by gender as early as the mid-nineteenth century (*Reading on the Middle Border*, 106).

24. During the late seventeenth century, fiction and romance accounted for a mere 3 percent of print material available (Douglas, *Feminization of American Culture*, 108).

25. Gail Schmunk Murray, "Virtues for the New Republic, 1790–1850," in *American Children's Literature*. The perceived urgency for literate citizens resulted in a vigorous Sunday school movement beginning in the 1790s. But unlike the British version, the American movement evolved beyond literacy training and began offering literature primarily aimed at moral object lessons. Murray observed that Sunday school libraries were often the only source of reading material in many American towns.

26. Hundreds of books fell into this category. Examples include the Rollo series and the "Lucy" books by Jacob Abbott and the Peter Parley books by Samuel Goodrich. Sedgwick wrote domestic novels (*Morals of Manners; or, Hints for Our Young People*) that, according to Gail Schmunk Murray, reflected middle-class advice about "work habits, cleanliness, demeanor, and virtue" (*American Children's Literature*, 34).

27. Tebbel, *History of Book Publishing*, 2:24–26.

28. Lears, *No Place of Grace*, 104. As Alison Parker demonstrated in *Purifying America*, the library was not alone in its concern over America's literary choices. Other

organizations, such as the Women's Christian Temperance Union (WTCU), were highly invested in guiding Americans' reading material.

29. Beginning with the list compiled by Hartford librarian Caroline Hewins, enough were added so that by 1909 the H. W. Wilson Company published a volume consisting of twenty-four lists (Hearne and Jenkins, "Sacred Texts," 548).

30. Dain, *New York Public Library,* 286. While rank-and-file librarians were often treated to antifiction rhetoric, they continued to place book orders for their libraries that included a significant amount of fiction. According to Dain, roughly one-third of NYPL's total circulating stock consisted of fiction titles by 1900. Librarians who actually did the book ordering in towns and cities across the nation responded to patrons by stocking books they knew would draw readers to the library. Pawley's findings reinforced the idea that librarians, often ignoring ALA recommendations, continued to stock fiction in large numbers, frequently to facilitate the absorption of middle-class values by immigrant and working-class populations. In *Reading the Romance,* Janice Radway suggested that fiction reading might be construed as oppositional or as a "female ritual" by which women "explore the consequences of their common social conditions" (212, 220). She contended that the explanation for increases in fiction consumption were technological as well as sociological; advances in print technology made mass book production possible (19–20).

31. Whitehill, *Boston Public Library,* 184–85.

32. Hawes, *Children between the Wars,* 21, although the phrase is Viviana Zelizer's in *Pricing the Priceless Child: The Changing Social Value of Children* (New York: Basic Books, 1985).

33. Ronald D. Cohen, "Child-Saving and Progressivism, 1885–1915," in *American Childhood,* ed. Hawes and Hiner, 274.

34. Hamilton Cravens, "Child Saving in the Age of Professionalism," in *American Childhood,* ed. Hawes and Hiner, 415–16.

35. Cravens, "Child Saving," 416.

36. Kliebard, *Struggle,* 37.

37. Ibid., 11, 12. See Dorothy Ross, *G. Stanley Hall: The Psychologist as Prophet* (Chicago: University of Chicago Press, 1972). Moore referred to Hall as "the great explorer of adolescence" in *Cross-Roads to Childhood,* 213.

38. Kliebard, *Struggle,* 36, 43–45. Hall's theories constituted only one of four major viewpoints in educational reform of the late nineteenth century. The other streams of thought he identifies include humanists, efficiency educators, and social meliorists. For further discussion, see chapters 1 and 2 in *Struggle.*

39. K. Jones, *Taming the Troublesome Child,* 17. Jones argued that because doctors did not generally believe in the possibility of childhood insanity, they remained indifferent to children. She also noted that concern about middle-class children was readily available in advice manuals (36).

40. Cravens, "Child Saving," 421.

41. Lasch, *Haven in a Heartless World,* 15.

42. Hawes, *Children between the Wars,* 22.

43. Ibid., 18.

44. K. Jones, *Taming the Troublesome Child,* 23, 38–43; also Horn, *Before It's Too Late,* 13.

45. K. Jones, *Taming the Troublesome Child,* 4.

46. Horn, *Before It's Too Late,* 15.

47. Carson, "Child's Share," 252.

48. Murray, *American Children's Literature,* 83.

49. In 1851, Charles C. Jewett, librarian of the Smithsonian Institute, included this information in an appendix to a report entitled "Notices of Public Libraries in the United States of America" (Whitehill, *Boston Public Library,* 1–2, 55–59).

50. Even in cramped quarters, BPL was one of the ten largest libraries in the nation. In 1885, BPL moved to Copley Square. Its branches, at the turn of the twentieth century, consisted of sixty-one outlying structures, including five reading rooms, thirteen delivery stations, twenty-two engine houses, a post office, five public schools, and various other public institutions. Together with ten official, but dilapidated, branches, these agencies struggled to supply books to the citizens of Boston. But by 1905, BPL had expanded dramatically to 201 branches, in part from patronage by children. See Whitehill, *Boston Public Library,* 55–59, 69, 73, 76–77, 103, 109, 164–65, 187–188, 195–96, 200.

51. Ibid., 195–96.

52. Diane Farrell, notes, lecture delivered on May 24, 1889, p. 1, AMJC.

53. Whitehill, *Boston Public Library,* 164, 182.

54. Dain, *New York Public Library,* 335.

55. Ibid., 24.

56. Ibid., 21–23, 270–73, 288.

57. Frederick C. Hicks to R. R. Bowker, August 27, 1912, box 46, R. R. Bowker Papers, Manuscripts and Archives Division, NYPL.

58. Dain, *New York Public Library,* 270–72.

59. For the most part, departmental supervisors served in advisory capacities as Bostwick envisioned. Supervisors of children's services, however, developed an early reputation for maintaining strong personal control over their own departments (Dain, *New York Public Library,* 277).

Chapter 2. Protecting Books

1. Franklin K. Mathiews, "Blowing Out the Boy's Brains," *Outlook* (November 1914): 652–54.

2. Henry Beston to Moore, November 24, 1924, box 1, ACMP; Gertrude Andrews to Moore, October 11, 1931, box 1, ACMP; Frederic Melcher to Moore, December 27, 1939, box 2, ACMP; Sayers, *Anne Carroll Moore,* 32.

3. Miscellaneous documents, box 5, ACMP.

4. Sayers, *Anne Carroll Moore,* 139, 208. Moore was a member of the American Booksellers Association committee charged with organizing Book Week. Melcher chaired the committee; Mathiews served as vice chair (Tebbel, *History of Book Publishing,* 3:267).

5. Carson, "Children's Share," 256.

6. Sayers, *Anne Carroll Moore,* 152, 154, 208, 215.

7. Moore, *My Roads,* 8–57.

8. Sayers, *Anne Carroll Moore,* 58.

9. Mahony, "Alice M. Jordan," 7 (originally printed, January–February 1941).

10. Ibid., 7–8.

11. Barbara Holbrook, manuscript, "Alice Mabel Jordan," AMJC.

12. Sayers, *Anne Carroll Moore*, 41.

13. Hearne and Jenkins, "Sacred Texts," 547–57. Other librarians who played critical roles in the early library movement were Minerva Saunders, Lutie Stearns, Alice Hazeltine, Elva Smith, and Mary Root. These women influenced the development of children's services by establishing children's reading corners in their libraries and also by addressing the ALA about the need for children's library services. Hewins, a particularly important figure, pressed the issue before the ALA in a report she delivered to the organization in 1882, insisting that librarians had a responsibility to encourage children's reading, which, she claimed, was not being taken seriously by the organization. At about the same time, Stearns, a librarian at Milwaukee Public Library, delivered a paper to the ALA sufficiently persuasive to convince the organization that age limitations for public libraries should be abolished. See also Hearne and Jenkins, "Sacred Texts," for further discussion of the way language was utilized by Moore, Frances Clarke Sayers, Annis Duff, Ruth Hill Viguers, Bertha Mahony, and other bookwomen who consistently spoke of library work in religious terms.

14. Bostwick, *American Public Library*, 101. As one of those activities, reading ought to be preparatory for reality. In 1870, the editor Horace Scudder rejected literary age segregation and also voiced the prevalent assumption that "classic English literature" provided both desirable reading and a tool by which other books might be measured.

15. Ibid., 90.

16. Wiegand, *Politics of an Emerging Profession*, 118.

17. Carson, "Children's Share," 253.

18. Jenkins, "Strength of the Inconspicuous," 31.

19. Bostwick, *American Public Library*, 93.

20. Moore, "Reading Rooms for Children," 130.

21. Ibid.

22. Hearne and Jenkins, "Sacred Texts," 548. Organizing itself on the principles of a confederation of interest groups caused the ALA to resemble other organizations of the time, like the public school (Kliebard, *Struggle*, 7).

23. Sturges, "Pattern and Ideal," 38.

24. The room opened on June 1, 1896. Within one year, Moore reported that eleven thousand children had visited the room ("Reading Rooms for Children," 126). Although the children's room at Pratt was not the first, Moore nonetheless later cast it in a pioneering role, declaring that it was "the first . . . to be included in an architect's plan . . . the first to be furnished with chairs and tables of varying height, the first to consider the right little children to enjoy books . . . the first library to make circulation of books subordinate to familiar acquaintance with books and pictures in a free library" (*Cross-Roads*, 127).

25. Moore, *Cross-Roads*, 127.

26. Sayers, *Anne Carroll Moore*, 256.

27. Shedlock, *Art of the Story-Teller*, xvi, xvii.

28. Sawyer, *Way of the Storyteller*, 96.

29. Carson, "Children's Share," 256.

30. Sayers, *Anne Carroll Moore*, 121; Tyler, "Library Reading Clubs," 548. The reference to Yeats is found in Moore's *Roads to Childhood*, 121.

31. Sayers, *Anne Carroll Moore*, 122–23. The value of pictures in children's rooms was widely, but not universally, acknowledged. At the 1900 ALA conference in Montreal, a Newark librarian noted that "mounted scraps of paper are out of place as a decorative feature in a large and noble room." Objections centered on issues of excessive cost and time to create such displays ("Picture Work in Children's Libraries," Report of Montreal Proceedings, *Library Journal* 24 [August], 281).

32. Sayers, *Anne Carroll Moore*, 117.

33. Melanie A. Kimball, "Youth Services," 62.

34. Dain, *New York Public Library*, 296, 301, 303–4.

35. Long, *Book Clubs*, 10, 67–68.

36. Monthly report to Moore from Judith Karlson, librarian at George Bruce Branch, 1924, box 2, ACMP.

37. Moore segregated the clubs by sex, claiming that it was difficult to find stories suitable for mixed groups.

38. Carson, "Children's Share," 254.

39. Tyler, "Reading Clubs," 547–50; Carson, "Children's Share," 254. Scholars have sometimes interpreted children's rooms only as places of solitude. Sybille Jagusch claimed that children's librarians "frowned upon too much entertainment" and encouraged literature that "brought moral direction," but activities at NYPL suggest that Moore's attitude toward the uses of the library was complex ("First among Equals," 33).

40. Moore, "Reading Rooms," 126.

41. Pawley, "Hegemony's Handmaid?" 127–28.

42. Long, *Book Clubs*, 18.

43. Moore, *Cross-Roads*, 133.

44. Sayers, *Anne Carroll Moore*, 67.

45. Gladys B. Hastings, meeting notes, December 1920, NERTCL.

46. Mahony, "Her Quiet Fame and Influence on the Future," Alice Jordan Memorial Issue, *Horn Book* 37 (November 1961): 15.

47. Vandergrift, "Female Advocacy," 711; Lundin, "Pedagogical Context," 844.

48. Long, *Book Clubs*, 9–10.

49. Sturges, "Alice M. Jordan." The organization later became a section of the Massachusetts Library Association and the New England Library Association.

50. Ibid.

51. Gladys B. Hastings, meeting minutes, September 1920, NERTCL.

52. Jennings, "Sticking to Our Last," 614. For a discussion of attitudes about the entrance of large numbers of women in the library, see Jacalyn Eddy, "'We Have Become Too Tender-Hearted': Gender and the Language of Negotiation in the Public Library, 1880–1920," in *Libraries as Agencies of Culture*, ed. Augst and Wiegand.

53. Walkley, "All in the Day's Work," 161.

54. Van Slyck, *Free to All*, 66.

55. Moore, *Cross-Roads*, 50.

56. Moore, *Roads to Childhood*, 37.

57. Ibid., 37–39.

58. Dain, *New York Public Library*, 301; Sayers, *Anne Carroll Moore*, 122.

59. Elizabeth Shumway to Moore, October 10, 1931, box 3, ACMP.

60. Sayers, *Anne Carroll Moore*, 120.

61. Ibid., 120–28, 143. One of Moore's successors at NYPL was Augusta Baker, an African American hired by Moore.

62. Dain, *New York Public Library,* 302. Several distinguished bookwomen who began their professional lives as NYPL librarians believed that Moore had provided them with a strong professional foundation, e.g., Margaret McElderry, Ruth Hill Viguers, Anna Cogswell Tyler, Mary Gould Davis, Marian Fiery, Eleanor Estes, Helen Forbes.

63. Sayers, *Anne Carroll Moore,* 144.

64. Deutsch, *Women and the City,* 105, 110.

65. Whitehill, *Boston Public Library,* 191. On the other hand, all branch custodians were women with salaries fixed at $1,000 per year (215).

66. Dain, *New York Public Library,* 316; Whitehill, *Boston Public Library,* 201. Initiating pensions was also difficult. Repeated calls for retirement benefits at BPL met with persistent inaction on the part of the city. Civil War veterans with ten years of service could retire on half pay, but otherwise no retirement plan existed for employees of the library as for other municipal employees. BPL employees did not receive pensions until the Massachusetts legislature passed the pension bill in 1922 (210). Libraries typically granted liberal vacation time, however, ranging from three to six weeks' paid leave.

67. Dain, *New York Public Library,* 315.

68. "Hearing on Salary Question in New York," *Library Journal* 42 (October 1917): 812. This percentage represented fifty-two individuals. The highest paid staff librarian was the branch librarian with a salary range of $1,020–1,500 (average paid was $1,283). Second highest was the children's librarian with a salary range of $780–1,200 (average paid $926), followed by first assistant librarians, senior assistant librarians, and junior assistant librarians. See additional discussion, "New York Librarians Ask for More Pay," *Library Journal* 42 (April 1917): 302–3.

69. *Library Journal* 42 (March 1917): 191.

70. "New York Librarians Ask for More Pay," 302–3.

71. James W. Milden, "Women, Public Libraries, and Library Unions: The Formative Years," *Journal of Library History* 12 (Spring 1977):151–53.

72. Professional Training Section, *Library Journal* 43 (August 1918): 606.

73. Milden, "Women, Public Libraries," 152–55.

74. *Library Journal* 43 (June 1918): 411.

75. Milden, "Women, Public Libraries," 155–56. The vote before the ALA was 121-1. By the early 1920s, all public library unions had died. Unions reemerged in the 1930s, but these were male dominated and did not take up sex discrimination issues.

76. Between its inception in 1895 and Doran's assumption of the periodical in 1918, the *Bookman* had been published by Dodd, Mead. Moore's early essays were signed "Annie Carroll Moore," but this was changed to avoid confusion with another woman of the same name, who taught at Teachers College.

77. R. R. Bowker to Moore, February 13, 1912, box 42, R. R. Bowker Papers, NYPL.

78. Sayers, *Anne Carroll Moore,* 211, 215.

79. Annie Carroll Moore, "Some Recent Books for Children," *Bookman* 48 (November 1918): 329, 345–49. In this particular review, Moore uses Poe, Kipling, and Bret Harte as measurements of "good" books.

80. Moore, *Roads to Childhood,* 77.

81. Wiegand, "Structure of Librarianship," 27.

Chapter 3. Selling Books

1. Mahony's personal recollection (1927), box 24, folder 9, 7, HBR. See also Frances Darling, "The Book Caravan—Chapters from Horn Book History," *Horn Book* 39 (April 1963): 208.

2. Mahony was not the only individual to conceive of the caravan as a bookselling venture, though she may have been the first. J. W. Hiltman, president of D. Appleton and Company, sent out a similar vehicle, with an eight-hundred-book capacity, to the Long Island area in the summer of 1921. See Tebbel, *Between Covers*, 209.

3. Ross, *Spirited Life*, 8–23.

4. Deutsch, *Women and the City*, 6. The composition of most, though not all, helping agencies was Anglo Saxon and Protestant. Ethnic agencies existed as well, like the League of Catholic Women, the United Hebrew Benevolent Association, and Federation of Jewish Charities. As Deutsch points out, ethnic agencies were often more likely to offer cash assistance than their Protestant counterparts (39–40).

5. By 1890, several other women's organizations took up this issue. The Women's Christian Temperance Union (WCTU) worked with the Knights of Labor. In Chicago, some twenty independent women's organizations, including the Woman's Club and the Trades and Labor Assembly, allied to address working conditions for women in sweatshops. In surveys conducted by the General Federation of Women's Clubs at the end of the nineteenth century, club women overwhelmingly identified economics as the root of their problems.

6. The Women's Trade Union League (WTUL), founded in 1903, provides a good example. Operating under the auspices of the American Federation of Labor, the WTUL brought together women active in the trade union movement as well as women from middle-class voluntary organizations. Their combined efforts contributed to early protective legislation on behalf of women and children.

7. Addams, *Spirit of Youth*, 67–68.

8. Peiss, *Cheap Amusements*, 165.

9. Addams, *Spirit of Youth*, 14.

10. Peiss, *Cheap Amusements*, 165.

11. Typical leisure activities included lectures about natural history and travel, musical performances, games, singing or painting lessons, and flower making. Union facilities often contained small libraries for member use.

12. This was the description of union facilities opened in Auburn, New York, in 1907. The building contained parlors, bedrooms, and spaces for communal eating (*Auburn Daily Advertiser*, May 7, 1907).

13. Deutsch, *Women and the City*, 145–46.

14. In *Women and the City*, Deutsch discusses the spectrum of women's organizations in Boston at this time, including the Fragment Society, Denison House, and the WEIU. Of the three, Deutsch claims, the union exhibited the most aggressive political style.

15. Deutsch, *Women and the City*, 397.

16. Quandt, *From the Small Town*. Quotes are from chapter 10, "Politics and the Small-Town Fetish."

17. Deutsch, *Women and the City*, 147.

18. Ibid., 119–20, 286–87. Mahony was far from the only college woman in the organization. Many Wellesley students were WEIU members (104). See especially "Moral Geography" in *Women and the City*.

19. Bertha Mahony, manuscript, box 24, folder 9, p. G-3, HBR.

20. Scott, *Natural Allies*, 37.

21. Antler, "Educated Woman," 204; Scott, *Natural Allies*, 25.

22. Ross, *Spirited Life*, 36–37.

23. Barnes, "New Profession"; Ross, *Spirited Life*, 39.

24. Tebbel, *History of Book Publishing*, 3:277. Of 396 bookshops nationwide studied by *Publishers Weekly*, only 3 percent were opened by women before 1919. The number of woman-owned businesses rose dramatically thereafter to roughly 40 percent by the late 1920s.

25. Deutsch, *Women and the City*, 115, 117, 130. Businesses run by men survived at roughly twice the rate of women-run businesses.

26. Ibid., 133. Women who sold groceries, Deutsch points out, reminded the public of women in a kitchen. Milliners and dressmakers, likewise, offered services that would not necessarily alarm the public. See "Business of Women" in *Women and the City*.

27. Bertha Mahony, manuscript, H-2, box 24, folder 9, p. G-4, HBR.

28. Bertha Mahony, manuscript, H-2, box 24, folder 9, HBR.

29. Kroch, *Great Bookstore*, 7–8.

30. *Publishers Weekly* 53 (March 19, 1898): 553–54.

31. Reprinted in *Publishers Weekly* 53 (March 19, 1898): 555.

32. Kroch, *Great Bookstore*, 2, 14.

33. W. Darling, *Private Papers*, 40.

34. Kroch, *Great Bookstore*, 9, 19.

35. Barnes, "New Profession," 225.

36. Ibid., 228–33.

37. Mary Mowbray-Clarke, "The Sunwise Turn Bookshop," *Publishers Weekly* 91 (May 26, 1917): 1704.

38. Barnes, "New Profession," 223–34.

39. *Horn Book* 38 (April 1962): 192–93.

40. Bertha Mahony, "The Bookshop for Boys and Girls—Boston," *Publishers Weekly* 91 (May 26, 1917): 1702; Ross, *Spirited Life*, 49–56.

41. Ross, *Spirited Life*, 49–56.

42. Anne Carroll Moore, "The Bookshop for Boys and Girls," *ALA Bulletin* 11 (June 1917): 168–69.

43. Mahony, "Bookshop for Boys and Girls—Boston," 1701.

44. Ibid., 1703.

45. Ward Macauley, presidential address to the ABA, *Publishers Weekly* 91 (May 26, 1917): 1679–81.

46. Tebbel, *History of Book Publishing*, 2:176–77.

47. Passet, *Cultural Crusaders*, 84, 89. Bookmobile history has received relatively little attention. In 1961 *Library Trends* devoted its entire January issue to "Current Trends in Bookmobiles." More recently, Passet's *Cultural Crusaders* provides information about transportation of books throughout the West during the nineteenth century (see especially chapter 5, "Bringing Books and People Together"). See also Deanna B. Marcum,

"The Rural Public Library in America at the Turn of the Century," *Libraries and Culture* 26, no. 1 (Winter 1991): 87–99. There is also a brief but informative background of traveling libraries in Marcum's *Good Books*.

48. Gladys B. Hastings, meeting minutes, February 1922, NERTCL.

49. Frances Darling, "The Book Caravan," *Horn Book* 39 (April 1963): 208–10.

50. Mahony, "Bookshop for Boys and Girls—Boston," 1702.

51. Ross, *Spirited Life*, 66–67.

Chapter 4. Making Books

1. Bechtel, "The Cold World Turns Kind," 6, LBUA. Brett transferred Seaman after reading some of Seaman's poetry, which circulated at Macmillan.

2. Sheehan, *This Was Publishing*, 36. Sheehan describes Macmillan as a "halfway" house in this regard.

3. Macmillan, *Author's Book*, preface and dedication. Many examples of the importance of personal relationships between publisher and author exist, frequently in publishers' memoirs. See, for example, Doubleday, *Memoirs of a Publisher*.

4. Tebbel, *History of Book Publishing*, 2:4, 11, 13.

5. Ibid., 2:5, 6. Despite a chronic shortage of capital, publishing growth during the nineteenth century was dramatic. The total value of American books in 1820 was $2.5 million; by 1840, $5.5 million; and on the eve of the Civil War, an astonishing $16 million, with New York alone claiming nearly a third of the total. The increase in book production was correspondingly impressive. In 1840, approximately 100 book titles issued from American publishers; by 1853 the number had risen to 879; by 1855, the total was 1,092; by 1860, 1,350 new titles. See Hall, *Cultures of Print*, 43–44; Tebbel, *History of Book Publishing*, 1:219–22.

6. Tebbel, *Between Covers*, 80. Two hundred American publishing firms established before the Civil War continued into the twentieth century. According to Tebbel, in 1950 fifty-three (27 percent) of these firms continued to be controlled by their founding families.

7. A wide variety of "cheap" books were produced during the nineteenth century, including inexpensively produced editions of "classics," typically costing from twenty-five cents to two dollars. Munro's inexpensive editions sold well and were important because they provided Americans with the possibility of private ownership of classic literature by making it affordable. The notorious dime novels, descendants of story sheets earlier in the century, were another form of cheap books available during the second half of the nineteenth century, and it was to this genre in particular that established publishing houses objected. Dime novels covered such topics as detectives, the circus, mystery, sports, westerns, get-rich-quick schemes on Wall Street, sea adventures, and science fiction. A third genre of cheap books was sentimental fiction. Emma Dorothy Eliza Nevitte (E.D.E.N.) Southworth was only one of the authors—though perhaps the most obvious—who represent this genre.

8. Madison, *Book Publishing*, 53.

9. Tebbel, *History of Book Publishing*, 2:8.

10. Madison, *Book Publishing*, 51; Tebbel, *History of Book Publishing*, 2:8.

11. *Publishers Weekly* 53 (June 18, 1898): 960.

12. Reprinted in *Publishers Weekly* 53 (March 19, 1898): 554.

13. It is a mistake to regard publishers as "Victorian prudes masquerading as publishers" (Sheehan, *This Was Publishing*, 110) or to view them as hampering the evolution of literature in America. While publishers like Brett tried to hold the line against merely sensational writing or writing that, to their minds, amounted to religious heresy, room existed for free thought, particularly if tied to artistic expression. Publishers produced and even defended work they did not personally support. For example, Macmillan published Veblen's *Theory of the Leisure Class* and Beard's *Economic Interpretation of the Constitution of the United States*. Harper published Henry Demarest Lloyd's *Wealth against Commonwealth*; Scribner, *Das Kapital*; D. Appleton, the work of Charles Darwin.

14. Tebbel, *Between Covers*, 217, 222; Bechtel, WNBA speech notes, LBP. Among Macmillan's adult British authors were Rudyard Kipling, C. S. Lewis, W. B. Yeats, H. G. Wells, Thomas Hardy, and George William Russell. Its American authors included Henry James, Hamlin Garland, Sara Teasdale, Zona Gale, Edgar Lee Masters, Ida Tarbell, Owen Wister, Jack London, Conrad Aiken, and Rachel Field.

15. Kate Stephens's title was children's editor at Macmillan, but her letter book of 1898 (located at NYPL) suggests that her role was limited.

16. Sheehan, *This Was Publishing*, 126. The specialization required to support claims of expertise was already evident at Macmillan. Brett had created an education department in 1894, followed by a college division department, the first in the nation, in 1906, and a medical department in 1913. Brett allowed these departments, together with three trade departments, to function with a high degree of autonomy, so long as his employees were generally successful in surpassing competitors. Shortly before he created the children's department, Brett had added a department of religious books.

17. Arbuthnot, *Children and Books*, 41; Tebbel, *History of Book Publishing*, 1:47. In America, the most popular children's book of the seventeenth century, for example, was James Janeway's *A Token for Children*, in which no fewer than thirteen children died. First printed in 1671, the book remained in print until the early nineteenth century.

18. Avery, *Behold the Child*, 2.

19. The conceptual model of golden ages dominates the history of publishing and of children's literature, including periodical literature. For example, see Ellis, *History of Children's Reading*, Egoff, *Thursday's Child*, and Townsend, *Written for Children*. Townsend claimed that the first golden age extended from 1860 until 1914; the second commenced in 1965. Gail Schmunck Murray, in *American Children's Literature*, considered the demise of the first golden age the result of such things as the influence of Stratemeyer, the existence of self-appointed individuals who assumed dictatorial power over children's publishing, or the inability of authors to escape the Victorian ethos. More recently, Anne Scott MacLeod has written about the demise of the golden age in *American Childhood*.

20. Tebbel, *History of Book Publishing*, 3:266.

21. Edward T. Le Blanc, "A Brief History of Dime Novels: Formats and Contents, 1860–1933," in *Pioneers, Passionate Ladies, and Private Eyes*, ed. Sullivan and Schurman, 16. Characters like Deadwood Dick, Buffalo Bill, Nick Carter, and Jesse James became stock for such novels, published (in addition to Beadle) by Frank Tousey, George Munro, Norman Munro, and the firm of Street and Smith. Another useful book is Diedre Johnson's *Edward Stratemeyer and the Stratemeyer Syndicate*.

22. *The Oxford Companion to Children's Literature* (New York: Oxford University Press, 1984).

23. *Publishers Weekly* 36 (December 21, 1889): 959–60.

24. Tebbel, *American Magazine*, 64, 105. Among these were *Parley's Magazine* (1831), *Merry's Museum for Boys and Girls* (1841), *The Youth's Companion* (1827), *Our Young Folks* (1865), *Oliver Optic's Magazine* (1867), and *The Riverside Magazine for Young People* (1867). Between 1870 and 1900, over one hundred new periodicals made their debut, including *Harper's Young People* in 1879. Securing contributions from well-known authors, some of these periodicals represented a trend toward more imaginative writing. The largest audience for such periodicals came from a self-defined genteel class eager to expose their children to the messages of these magazines. L. Feliz Ranlett, "The Youth's Companion" (1951 Hewins Lecture), in *The Hewins Lectures, 1947–1962*, ed. Andrews, 89; Murray, *American Children's Literature*, 76, 78; Madison, *Book Publishing*, 67.

25. Murray, *American Children's Literature*, 78.

26. *St. Nicholas* authors included such notables as William Dean Howells, George Washington Cable, Joel Chandler Harris, Thomas Bailey Aldrich, Sarah Orne Jewett, Hamlin Garland, Laura Richards, Louisa May Alcott, Kate Douglas Wiggin, Ringgold Lardner, Babette Deutsch, Bret Harte, William Cullen Bryant, James Baldwin, John Townsend Trowbridge, Eudora Welty, Henry Steele Commager, Howard Pyle, Abby Morton Diaz, and Edna St. Vincent Millay. It should be noted that many women who later became authors/editors during the time under investigation in this study won prizes for contributions to *St. Nicholas*, including Rachel Field, Anne Parrish, Helen Dean Fish, Helen Sewell, Mary Gould Davis, Babette Deutsch, and Dorothy Canfield Fisher.

27. Florence Stanley Sturges, "St. Nicholas" (1959 Hewins Lecture), in *The Hewins Lectures*, ed. Andrews, 267–70.

28. *Oxford Companion to Children's Literature*, 466–67.

29. Reprinted in *Publishers Weekly* 95 (June 21, 1919): 1670.

30. Tebbel, *History of Book Publishing*, 2:28, 3:681 (appendix A, "An Economic Review of Book Publishing, 1915–1945").

31. Tebbel, *Between Covers*, 272.

32. Examples are Knopf, Simon and Schuster, Viking, and Harcourt, Brace.

33. Tebbel, *Between Covers*, 151, 216. Macmillan also established an office in Australia (1904) and Canada (1905). Morgan, *House of Macmillan*, 165–66.

34. Morgan, *House of Macmillan*, 163.

35. Recalling her early years at Macmillan, Bechtel stated that "everyone who learned publishing from [Brett] knew that he considered it a great profession as well as a business; that he cared greatly about publishing *great* books; that he obviously believed books could influence the course of events in the world. As to children's books, they should above all shape character, and introduce [children] to great writing of the past, aside from educating them." (WNBA speech notes, LBP).

36. Tebbel, *Between Covers*, 152, 216–17.

37. Tebbel, *History of Book Publishing*, 2:176–77. Between 1914 and 1920, wages rose overall for both men and women. Men's wages in publishing increased from 64 to 87.5 percent during this period while women's wages increased from 86 to 110 percent, depending on the job. Workers in binderies, for example, received pay increases at the

low end of the scale, while workers in composing rooms received greater increases. See Tebbel, *History of Book Publishing*, 3:675.

38. Bechtel, "Cold World," 5.

39. R. Smith, "Just Who Are These Women?" 162; Bechtel, "At the Turn of the Century," 7, LBUA.

40. Bechtel, "Scholar or Editor," 4, LBUA.

41. Ibid.

42. This correspondence can be found in LBP. Seaman clearly cherished Coatsworth's letters about her worldwide travel experiences, which often included hand-drawn figures of individuals Coatsworth encountered.

43. Wright, "Women in Publishing," 318. See also Solomon, *In the Company of Educated Women*, especially chapter 8, "After College, What?" Solomon discussed the complex attitudes toward college-educated women during the years 1870–1920. Since life was no longer "predetermined as a simple transition from daughter to wife to mother," Solomon observed, many women, like Seaman, seemed to "drift while deferring long-range decisions." Seaman and several other bookwomen accepted temporary professional situations, often representing a "significant interval," before settling into a "permanent pattern." Undergraduate education had augmented a sense of independence among young women while long-term cultural expectations had not changed. Seaman's three years of teaching and desire to become a printer before settling into editorship supports Solomon's conclusions.

44. Bechtel, "Cold World," 1, LBUA.

45. Quotes taken from Bechtel, "Cold World," 2–12.

46. Bertha Mahony, "The First Children's Department in Book Publishing," *Horn Book* 4 (August 1928): 5.

47. Bechtel, "To Be Released On . . . ," 11, LBUA.

48. Quotes taken from Bechtel, "Cold World," 7–11.

49. Bechtel, "Books on the Ladder of Time," in *Books in Search of Children*, 243. Seaman continued to be responsible for trade book publicity for two years until she went to the children's department on a full-time basis.

50. Bechtel, "Cold World," 7.

51. Tebbel, *History of Book Publishing*, 3:536.

52. Quotes taken from Bechtel, "Cold World," 7–11.

53. Bechtel, unpaged entry, LBUA.

54. Quotes taken from Bechtel, "To Be Released On . . . ," 1–11.

Chapter 5. Becoming Experts and Friends

1. Jordan, "Ideal Book," 9, 11.

2. Moore, *Roads to Childhood*, 27.

3. Saxton to Moore, July 14, 1920, box 3, ACMP.

4. Sayers, *Anne Carroll Moore*, 219.

5. *Library Journal* 45 (December 1, 1920): 964.

6. Moore, *Roads to Childhood*, 129. Others noted the very personal connection Moore made to her own childhood as well. In 1928, Constance Lindsay Skinner wrote a poem about Moore that reads, in part, "'Neath the high windows! / There she walks

and weaves / Spells for the child, magic for lad and lass, / From her own childhood she has not let pass." "Portrait Sketch," *Horn Book* 18 (January–February 1942): 18, 43.

7. Moore, *Roads to Childhood,* 61.

8. Jordan, "Ideal Book," 9–11.

9. Quoted in Tebbel, *History of Book Publishing,* 2:10.

10. Moses, *Children's Books,* 125. Moses dedicated this book, among others, to Anne Carroll Moore, who, he claimed, assisted with its writing. It is important, therefore, since presumably Moses's reflections mirror Moore's.

11. Hearne and Jenkins, "Sacred Texts," 538.

12. Moore, *Roads to Childhood,* 26, 29.

13. Dorothy Beekin to Moore, February 1920, branch library reports, 1919–30, box 2, ACMP. Moore's notion of shortage was reinforced when, in 1920, the American ambassador to Brazil asked her to select five or six hundred books to serve as the nucleus of a library in Rio de Janeiro. Distressed, Moore discovered that many of the titles she wanted to recommend were no longer in print. Moore's complaint about too few books tapped into a longstanding controversy in the book industry concerning the proper number of books to be published. Publishers, frequently assuming an inverse relationship existed between the quality and quantity of books published, had debated the presumed overabundance of them since about 1875.

14. Beekin to Moore, February and March 1920, branch library reports, 1919–30, box 2, ACMP. *Publishers Weekly* acknowledged a particular shortage of books for girls "since no one has risen to take the place of Louisa Alcott." See "What's Wrong with the Writers of Juveniles?" *Publishers Weekly* 95 (June 21, 1919): 1670.

15. Moore, *Cross-Roads,* 55; "A Discussion on Children's Books, the Concluding Lecture in the New York Public Library Course," *Publishers Weekly* 97 (April 3, 1920): 1093.

16. Moore, *Roads to Childhood,* 27, 78, 79.

17. Ibid., 108.

18. Ibid., 27, 28, 44.

19. Ibid., 48–49.

20. William Heylinger to Moore, December 12, 1920, box 2, ACMP.

21. Margaret Evans to Moore, January 14 (no year), box 2, ACMP.

22. R. Darling, *Rise of Children's Book Reviewing,* 63.

23. Minnich, *Transforming Knowledge,* 161.

24. See, for example, Daniels, "Americanization," 871–76.

25. Moore, *Roads to Childhood,* 74, 85.

26. Sayers, *Anne Carroll Moore,* 218.

27. Moore, "Children's Libraries in France," 831–32.

28. Alexandra Sanford, secretary, meeting notes, April 1925, NERTCL.

29. Ross, *Spirited Life,* 200.

30. Hugh Lofting, "World Friendship and Children's Literature," *Elementary English Review* 1 (1924): 205–7.

31. Levstik, "From the Outside In," 334.

32. Gladys B. Hastings, secretary, meeting minutes, September 29, 1920, NERTCL.

33. Beekin to Moore, February 1920, branch library reports, 1919–30, box 2, ACMP.

34. Josephine M. White to Moore, November 1922, branch library reports, 1919–30, box 2, ACMP.

35. Beekin to Moore, January and June 1920, branch library reports, 1919-30, box 2, ACMP.

36. Beekin to Moore, February 1920, branch library reports, 1919-30, box 2, ACMP.

37. Beekin to Moore, February 1921, branch library reports, 1919-30, box 2, ACMP.

38. Beekin to Moore, February 1920 and January 1922, branch library reports, 1919-30, box 2, ACMP.

39. Karlson to Moore, December 1924, and Beekin to Moore, January 1922, branch library reports, 1919-30, box 2, ACMP.

40. Wright, "Women in Publishing," 320.

41. Eaton, *Reading with Children*, 332.

42. Editorial, *Horn Book* 11 (May-June 1935): 133.

43. Shedlock, *Story-Teller*, xiii, xiv.

44. Ross, *Spirited Life*, 62; Sawyer, *Storyteller*, 111.

45. Sawyer, *Storyteller*, 92; Ross, *Spirited Life*, 62. Other storytellers at NYPL included Claire Huchet Bishop, known for her stories *Five Chinese Brothers* and *The Ferryman;* Pura Belpre' for *Perez and Martina*, and Ruth Sawyer, *The Juggler of Notre Dame, The Peddler of Ballaghadereen, Wee Meg Barnileg and the Fairies* (Sawyer, *Storyteller*, 111). Stories frequently had an international focus.

46. Louis Untermeyer to Moore, undated letter, box 3, ACMP. Also, Sayers, *Anne Carroll Moore*, 140, 141.

47. "Children's Book Week in the Libraries," *Library Journal* 45 (October 15, 1920): 836-37. Women's clubs participated in Book Week advertising. Children's reading was frequently the subject of discussion, and Book Week became especially popular with clubs. Mary L. Titcomb, librarian of Hagerstown, Maryland, and chair of the library extension committee of the General Federation of Women's Clubs, prepared and sent out programs to state headquarters for the federation and to individual clubs. See "Women's Clubs and Children's Reading," *Publishers Weekly* 102 (October 21, 1922): 1454.

48. "Book Week Activity Everywhere," *Publishers Weekly* 108 (October 17, 1925): 1416.

49. "Children's Books and Radio," *Publishers Weekly* 102 (October 21, 1922): 1455.

50. Sayers, *Anne Carroll Moore*, 194.

51. Meigs to Moore, November 15, 1919, ACMP.

52. Melcher, "Thirty Years," 5.

53. In gross numbers, Effie Power and Clara Whitehill Hunt reported that there were now 196 full-time and 496 part-time children's librarians, who accounted for between 4 and 9 percent of the total ALA membership, depending on whether they devoted all or only part of their time to children. I. Smith, *History of Newbery and Caldecott Medals*, 31, 32.

54. Ibid., 36.

55. Hunt to Moore, June 17, 1941, box 2, ACMP. In the letter, Hunt remarked that "librarianship is not merely a pleasant way of earning one's living but is a calling to which one can thankfully dedicate all one's powers, believing that in so doing one is helping to bring the kingdom of God on earth."

56. Diane Farrell, lecture notes, 5, delivered May 24, 1989, AMJC.

57. I. Smith, *History*, 36, 47.

58. The medal was designed by René Paul Chambellan, who also later designed the Caldecott.

59. I. Smith, *History,* 40, 41, 44, 46. Given the fact that *Story* was not necessarily intended for children, it was an interesting choice, revealing continued ambivalence about the separation of adult books from those of children. Van Loon had written the book for his two sons, declaring in the introduction that "history is the mighty Tower of Experience, which Time has built amidst the endless fields of bygone ages. It is no easy task to reach the top of this ancient structure and get the benefit of the full view. There is no elevator, but young feet are strong and it can be done." Shades of romanticism are evident that privilege metaphors of uplift and emulate the past.

60. Andersen, "Training for Library Service," 464; Moses, *Children's Books,* 3.

61. Downey, "Relation of the Public Schools," 885.

62. Ibid., 883, 884.

63. Florence Adams to Moore, branch library reports, 1919–1930, box 2, ACMP.

64. Beekin to Moore, March 1921, branch library reports, box 2, ACMP.

65. Mildred Nutter, secretary, meeting notes, April 1926; Dorothea K. Wetherell, meeting notes, April 1928, NERTCL.

66. New York concluded a prolonged printers' strike in January 1920; a strike in Boston in April 1921, when wage reductions were announced, affected 80 percent of the city's twenty-five hundred printers.

67. Tebbel, *History of Book Publishing,* 3:338–39. George Brett believed that books should reflect the higher cost of manufacturing, arguing that quality should not be sacrificed merely to keep prices down. He accused publishers of abandoning old quality titles in favor of bestsellers that would make up the difference in sales. But as cost of living increased about 120 percent during this decade, the public frequently complained that books were too expensive (Tebbel, *Between Covers,* 274–75).

68. Tebbell, *History of Book Publishing,* 3:341.

69. Bechtel, "The Giant in Children," in *Books,* 141.

70. Bechtel, "Books in Search of Children," in *Books,* 214.

71. Bechtel, "Ladder of Time," in *Books,* 245; Haviland, introduction, in Bechtel, *Books,* xiv.

72. Bechtel, "Books in Search of Children," in *Books,* 207–8.

73. Bechtel, WNBA speech notes, 6, LBP.

74. Bechtel, "The Art of Illustrating Books for Younger Readers," in *Books,* 42.

75. Bechtel, "When a Publisher Makes a Catalog," in *Books,* 14–16.

76. The date of the first broadcast was January 7, 1924. Seaman used the fifteen-minute program to tell stories and to talk about writers and artists, to encourage children to "set their sights higher." Broadcast notes for January 14, 1924, are in box 45, folder 685, LBP.

77. For ages four to six, Little Library offered *A Child's Garden of Verses, Little Jack Rabbit, A Visit from St. Nicholas, The Little Wooden Doll, The Baby's Life of Jesus Christ,* and the poems of Christina Rosetti; Macmillan's Children's Classics offered *The Fables of Aesop, English Fairy Tales, Mother Goose's Nursery Rhymes.* For ages six to eight, Little Library included *The Little Lame Prince, The Magic Forest, The Light Princess, The Cat and the Captain,* and *Memoirs of a London Doll;* Macmillan Classics included *Household Tales.* For ages eight to ten, Little Library offered *The Good Natured Bear, The Rose and the Ring, King Penguin: A Legend of the South Seas;* Macmillan Classics had *Fairy Tales and Stories, Granny's Wonderful Chair, Alice's Adventures in Wonderland, The Iliad.* The

Happy Hour books were five and one-quarter inches square, Singer sewn, with full color jackets, and sold for fifty cents. The Happy Hour books were quite successful, selling over a half million copies (Tebbel, *History of Book Publishing,* 3:269).

78. Bechtel, "Cold World," 11.

79. Bechtel, WNBA speech notes, 6, LBP. She mentions *Pinocchio* in particular.

80. Tebbel, *History of Book Publishing,* 3:269. Periodicals did not eliminate illustration. In fact, serial fictions were more highly illustrated than ever. And increased advertising accentuated attention to the importance of pictures. Publishers were sometimes concerned that periodicals were edging them out in this area (Tebbel, *History of Book Publishing,* 3:376).

81. Jordan, "Ideal Book," 10.

82. Seaman, *Books,* 44.

83. Margaret Pinckney King, "The Person Makes the Publisher—Louise Seaman," *Horn Book* 4 (August 1928): 30.

84. Haviland's introduction in Bechtel, *Books,* xv.

85. I. Smith, *History,* 30. Seaman was interested in illustration for personal reasons as well. Her mother and sister were both artists and frequently wrote articles about art and served on art juries.

86. Tebbel, *History of Book Publishing,* 3:341, 376–77; Wright, "Women in Publishing," 319.

87. Bechtel, WNBA speech notes, 3, LBP. In the speech, Bechtel acknowledges that "sales alone as a criterion seldom produced books that lived on, whatever their immediate success."

88. After receiving Seaman's letters, Mahony became curious enough about the new editor to meet Seaman on her next trip to New York. Mahony, personal recollections, box 24, folder 9, 6, HBR.

89. Bechtel, "Good Morning, Miss Seaman, Pray Be Seated," 6, LBUA.

90. Bechtel, WNBA speech notes, 5, LBP.

91. R. Smith, "Just Who Are These Women?" 164.

92. Bechtel, "All Those Speeches," 4, LBUA.

93. May Massee, "An Editor's Notebook," May Massee Tribute Issue, *Horn Book* 12 (July–August 1936): 218.

94. Louise Seaman Bechtel, "May Massee, Publisher," May Massee Tribute Issue, *Horn Book* 12 (July–August 1936): 208–11.

95. Wiegand, "Tunnel Vision and Blind Spots," 6.

96. Frederic Melcher, "May Massee, as Seen by the Booksellers," May Massee Tribute Issue, *Horn Book* 12 (July–August 1936): 246.

97. Bechtel, "May Massee, Publisher," 211, 213.

98. Ibid., 216.

99. Hodowanec, *May Massee Collection,* x.

100. Tebbel, *History of Book Publishing,* 3:341.

101. Bechtel, "May Massee, Publisher," 213.

102. Gertrude Andrus, "May Massee, as Seen by the Booksellers," May Massee Tribute Issue, *Horn Book* 12 (July–August 1936): 247.

103. Sayers, *Anne Carroll Moore,* 64, 267.

104. Alice Mabel Jordan Tribute Issue, *Horn Book* 37 (November 1961): 29.

105. Bechtel, "Cold World," 8.

106. *Publishers Weekly* 96 (September 6, 1919): 596.

107. Melcher, "Thirty Years," 6; Mahony, recollections, 1927, typescript by E. S. Ross, box 24, folder 9, G-9, HBR.

108. Mahony, recollections, box 24, folder 9, G-7, G-9, H-1, HBR. Until the eve of World War II, Mahony continued to document financial records on pieces of cardboard.

109. The degree to which Jordan viewed administrative duties as a secondary role was made clear in an obituary, which reported that in fifty years of employment, Jordan never had a private office (Sturges, "Alice M. Jordan").

110. Elinor Whitney Field, "Chapters from Horn Book History—III," *Horn Book* 38 (August 1962): 401–2. Darling later owned the Bay Colony Bookshop in Boston.

111. Lillian Gillig, "Members of the Staff of the Bookshop for Boys and Girls," chapters from Horn Book History—IV, *Horn Book* 38 (August 1962): 510–11.

112. Mahony, recollections, box 24, folder 9, G-11, HBR.

113. Rury, *Education and Women's Work,* 93; Weiner, *From Working Girl to Working Mother,* 84, 101. Only one in five women had a high school diploma by 1920.

114. Scharf, *To Work and to Wed,* 60–62; Weiner, *Working Girl,* 101, 104. As Weiner noted, leaving the workforce was, in some instances, welcomed by women themselves.

115. Deutsch, *Women and the City,* 236.

116. Weiner, *Working Girl,* 133. A WEIU study of Radcliffe graduates married and employed in 1927 showed that more than half of the 243 women surveyed chose not to have children (85, 104).

117. Scharf, *To Work,* 62.

118. Ross, *Spirited Life,* 71–73.

119. Mahony, recollections, box 24, folder 9, G-7, HBR. The last stop of the Caravan in 1920 was the ALA meeting at Lake Placid, where it was displayed for examination by delegates. During the following winter, it went on display in several places in Boston, for which the Bookshop had to obtain a license from the Health Department listing the driver as a "Pedler [*sic*] and a Hawker" (Ross, *Spirited Life,* 71–75).

120. Mahony, recollections, box 24, folder 9, G-8, G-9, HBR.

121. Ross, *Spirited Life,* 8, 83, 91.

122. *Publishers Weekly* 100 (October 29, 1921): 1469. At about this time, *Publishers Weekly* inaugurated a regular feature entitled "Women and Booksellers: A Monthly Department of News and Theory," edited by Virginia Smith Cowper.

123. Ross, *Spirited Life,* 62–62.

124. Fass, *Damned and the Beautiful,* 13.

125. Hawes, *Children,* 4–7, 67.

126. Horn, *Before It's Too Late,* 10.

127. At the same time, division of labor protected the distinct professional identities of team members and delineated boundaries by creating rituals—in this case, the process of diagnosis. Psychiatrists conducted examinations; social workers monitored and weighed the influence of environmental factors, including subjective interpretations of client qualities, primarily "character." Psychologists, the most narrowly defined of the professionals involved, were responsible for the mental testing on which investigation of the relationship between intelligence and delinquency was based (K. Jones,

Taming, 62, 63, 100). See also the introduction to Elizabeth Lunbeck's *Psychiatric Persuasion*.

128. Guidance advocates wrote advice pamphlets for the U.S. Children's Bureau, and popular magazines routinely reprinted articles about child management from *Mental Hygiene*, the professional journal of child guidance (K. Jones, *Taming*, 102).

129. Guiders' success with creating alliances was mixed. Some medical schools responded to child guidance overtures by introducing psychiatry in their pediatric training. But pediatricians, also relatively new "experts" in public opinion, were themselves struggling for professional identity, no doubt as eager as guiders to establish jurisdiction over the health of children. For this reason, ties between child guidance and the medical profession remained weaker than those with the legal system throughout the 1920s and 1930s. Child guiders also established a strong connection with lay organizations like the Child Study Association of America (CSAA), which became a critical mouthpiece for child guidance, including weekly broadcasts over the NBC network beginning in 1925. See K. Jones, "Building the Child Guidance Team," "Popularizing Child Guidance," and "The Problem Behavior of the Everyday Child" in *Taming the Troublesome Child*.

130. K. Jones, *Taming*, 99. Intelligence testing became the central, quantitative measurement of children and was a commercial enterprise by 1922. By the middle of the decade about four million children were tested annually. Intelligence testing was criticized by some, like Walter Lippmann, but the authority of guidance was so firmly established that such criticism had little immediate effect. See Brown, *Definition of a Profession*, 136, 138.

131. K. Jones, *Taming*, 116; see also the chapter "The Critique of Motherhood."

132. As Brown notes, "An occupation will have difficulty claiming the monopoly of skill essential to professionalism if its technical base consists of a vocabulary that sounds familiar to everyone" (*Definition of a Profession*, 21).

133. Helen T. Woolley, *Concerning Parents* (New York: New Republic, 1929), 49–70.

134. As the guidance movement consolidated its authority, old alliances like those with the CSAA seemed more dispensable; indeed, by the end of the decade, child guiders questioned the suitability of lay people to speak for them at all. A cleavage between guiders and old-style reformers became increasingly evident as well. But while the ideological divide between environmentalism and the individual seemed well defined, child guiders subsumed what tenets they considered valuable under the banner of child guidance without ever abandoning environmentalism altogether. See K. Jones, *Taming*, 107–8.

135. Eaton, *Reading with Children*, 27.

136. Gruenberg, *Guidance of Childhood*, 147, 149.

137. Ibid., 149–50. While guiders claimed that theirs was the "modern" point of view, their dislike for fairy tales was remarkably reminiscent of Puritan objections. The misrepresentation of reality (and the potential consequence for shirking adult responsibilities later on) had also concerned Puritans, as already noted. Guiders had substituted a concern over *mental* health for the older concern over *spiritual* health, but the result, insofar as children's reading was concerned, was identical: fairy tales were dangerous. Moreover, they were dangerous for many of the same reasons, including a failure to assume one's assigned place in the social scheme of things.

138. Clara Whitehill Hunt, "Recruiting for Children's Librarians," *Library Journal* 47 (December 15, 1922): 1070.

139. Charles Joseph Finger, "On Writing for Children," *Publishers Weekly* 108 (October 17, 1925): 1408–9.

140. Sawyer, *Storyteller*, 33–34.

141. Moore, *Cross-Roads*, 20–21.

142. Jenkins, "Women of the ALA," 819–20.

143. MacLeod, "Censorship and Children's Literature," in *American Childhood*, 181–82.

144. Smith-Rosenberg, *Disorderly Conduct*, 59–76.

145. The cove in which the Knolls was situated amounted to a sort of summer colony for literary and artistic folks, including Willa Cather, who lived next door to Jordan and her sister. See Helen Clark Fernald, "Alice Jordan at Grand Manan," Alice Jordan Memorial Issue, *Horn Book* 37 (November 1961): 18–21.

146. Mahony, "Anne Carroll Moore," 14.

147. Sayers, *Anne Carroll Moore*, 130, 174.

148. Ibid., 172–73.

149. Seaman to Moore, October 17, 1923, box 3, ACMP.

150. Mahony, "Anne Carroll Moore," 15.

151. Sayers, *Anne Carroll Moore*, 176, 184–85.

152. The story, as Kirkus related it to Ursula Nordstrom, was recounted by Bader in "*Only* the Best," 525.

153. Sayers, *Anne Carroll Moore*, 130, 171–72, 193–94.

154. Hearne and Jenkins, "Sacred Texts," 544.

Chapter 6. Building Professional Culture

1. Sayers, *Anne Carroll Moore*, 231.

2. McGregor to Moore, February 21, 1925, box 2, ACMP.

3. Dorothy Canfield Fisher to Moore, December 8, 1924, box 2, ACMP.

4. Sayers, *Anne Carroll Moore*, 232.

5. "Children's Book Week in the Magazines," *Publishers Weekly* 102 (October 21, 1922): 1450. Jessie Wilcox Smith (1863–1935) was a widely acclaimed illustrator of children's books during the first thirty years of the twentieth century. She studied art with Howard Pyle at Drexel, becoming one of Pyle's most successful students. Among her best known works are illustrations for *A Child's Garden of Verses* by R. L. Stevenson (1905), *The Seven Ages of Childhood* (1909, text by Carolyn Wells), *The Little Mother Goose* (1915), *Little Women* (1915), *The Water Babies* (1916), and several books of stories and poetry for young children during the early 1920s. From 1918 until 1933, her illustrations appeared monthly on the cover of *Good Housekeeping*.

6. Oran C. Miller, "Just the Right Book," *Publishers Weekly* 108 (October 17, 1925): 1405; Rowe Wright, "The Camp Fire Girls and Children's Book Week," *Publishers Weekly* 108 (October 17, 1925): 1415.

7. "Children's Book Week in New York City," *Publishers Weekly* 102 (October 21, 1922): 1449.

8. Melcher, "Thirty Years," 7, 9.

9. Moore, *My Roads*, 333.

10. Moore, *Cross-Roads,* 164, 179.

11. Bertha Everett Mahony, "'A Quick Ear for Silver Bells': Crossroads to Childhood, Books for Middle-Aged Children' by Anne Carroll Moore," *Horn Book* 3 (February 1927): 16–19.

12. Rose Dobbs, "Ten Years of Publishing Children's Books," *Horn Book* 14 (September 1938): 317. Juveniles were subject to differences in discounts and frequently carried heavy advance editorial costs, including translation fees and royalties.

13. Sayers, *Anne Carroll Moore,* 231–32.

14. Henry Beston to Moore, November 24, 1924, box 1, ACMP.

15. Sayers, *Anne Carroll Moore,* 233–34; Field to Moore, October 18, 1924, box 2, ACMP.

16. Sayers, *Anne Carroll Moore,* 232, 237.

17. Mahony and Whitney, comps., *Realms of Gold,* 684–85.

18. Sandburg to Moore, October 5, 1923, and October 20, 1922, box 3, ACMP.

19. Goldsmith, "Spare the Book and Spoil the Child," 428.

20. Tebbel, *History of Book Publishing,* 3:277.

21. *Publishers Weekly* 114 (October 13, 1928): 1552. In 1919, women opened 3 percent of new shops; within one year, the number had risen to 16 percent; to 36 percent by 1928.

22. Bader, "Realms of Gold and Granite," 528.

23. Ross, *Spirited Life,* 177.

24. As Heilbrun wrote: "What became essential was for women to see themselves collectively, not individually. . . . As long as women are isolated one from the other, not allowed to offer other women the most personal accounts of their lives, they will not be part of any narrative of their own. . . . There will be narratives of female lives only when women no longer live their lives isolated in the houses and the stories of men" (*Writing a Woman's Life,* 46–47).

25. Bertha Mahony, notes, 1927, box 24, folder 9, G-9, HBR.

26. Bertha Mahony, "Statement of Purpose and Policy," *Horn Book* 1 (October 1924): 1 (emphasis added).

27. Ross, *Spirited Life,* 121; Mahoney, "Statement of Purpose and Policy," 1.

28. Seaman to Mahony, November 15, 1924, box 1, folder 23, HBR.

29. Ross, *Spirited Life,* 114, 116.

30. Elinor Whitney Field, "Chapters from Horn Book History—VII," *Horn Book* 39 (June 1963): 328.

31. Ross, *Spirited Life,* 117. A table of contents was added to the magazine in 1926.

32. Bertha Mahony, *Horn Book* 5 (1929): 51.

33. Ross, *Spirited Life,* 97.

34. Pauline A. O'Melia to Bertha Mahony Miller, 1943, box 15, folder 7, HBR.

35. Frances Sturges, interview notes, May 4 and September 8, 1979, oral history project, box 2, folder 3, p. 14, NERTCL.

36. Goldsmith, "Spare the Book," 428.

37. Moore, *My Roads,* 201.

38. Ross, *Spirited Life,* 116, 117.

39. Bertha Mahony, "The Hunt Breakfast," *Horn Book* 10 (1934): 66.

40. *Horn Book* 2 (November 1926): 53.

41. Mahony, "Hunt Breakfast," 66.

42. Elinor Field, "Chapters from Horn Book History—VI," *Horn Book* 39 (February 1963): 92–93.

43. Elinor Field, "Chapters from Horn Book History—VIII," *Horn Book* 39 (June 1963): 329.

44. Mahony and Whitney, *Realms of Gold,* 1.

45. Ibid., 409, 413.

46. Eaton, *Reading with Children,* 37.

47. Moore, *My Roads,* 5.

48. Mahony and Whitney, *Realms of Gold,* 727.

49. Alice Jordan, "Realms of Gold," in "The Three Owls," New York *Herald Tribune,* May 12, 1929.

50. May Lamberton Becker, "Realms of Gold," *Horn Book* 5 (May 1929): 14.

51. Ross, *Spirited Life,* 85, 86, 126.

52. Cornelia Meigs, *The Trade Wind* (New York: Little, Brown, 1927), v.

53. Tebbel, *Between Covers,* 217, 231, 254, 273. Viking formed in 1925; the Doubleday-Doran merger occurred in 1927.

54. R. Smith, "Just Who Are These Women?" 164.

55. Haviland, introduction, in Bechtel, *Books,* xiii, xv. Blake later went on to head children's departments at Oxford University Press and Lippincott; Bechtel, undated notes, box 5, folder 66, LBP.

56. Mahony, "Other Children's Book Departments," 74–76.

57. Goldsmith, "Spare the Book," 428.

58. Mahony, "Other Children's Book Departments," 76.

59. Mahony Miller, "Children's Books in America Today," 207.

60. Bechtel, "Finding New Books for Boys and Girls," in *Books,* 7.

61. Bechtel, "Elizabeth Coatsworth: Poet and Writer," in *Books,* 74–75.

62. Haviland, introduction, in Bechtel, *Books,* x.

63. Bechtel, "Rachel's Gifts," 230.

64. Bechtel, "Finding New Books," in *Books,* 5.

65. Field wrote thirteen juvenile novels, *Hitty* being the best known. She also wrote children's plays before writing adult fiction, including *All This and Heaven Too.*

66. Josiah Titzell, "Rachel Field, 1894–1942," *Horn Book* 18 (July 1942): 219–20.

67. Bader, "Macmillan Children's Books," 555.

68. *Dictionary of Literary Biography* (Detroit: Gale Research Co., 1981), 22:172.

69. Field to Seaman, undated letter, box 21, folder 278, LBP.

70. Bechtel, "Finding New Books," in *Books,* 5.

71. Alice Barrett, "Hitty in the Bookshop," *Horn Book* 6 (February 1930): 31.

72. Haviland, introduction, in Bechtel, *Books,* xv.

73. Coward published subsequent editions in 1928 and 1931 as well as the Newbery honor book *Millions of Cats* by Wanda Gag. Macmillan was well represented in the Newbery awards of the 1920s. In 1922 it published three of the five honor books: *The Old Tobacco Shop* by William Bowen, *The Golden Fleece* by Padraic Colum, and *The Windy Hill* by Cornelia Meigs; in 1925, one of the two honor books, *The Dream Coach* by Anne and Dillwyn Parrish; in 1926, the honor book, *The Voyagers* by Colum; in 1929, the Newbery Medal for *The Trumpeter of Krakow* by Eric Kelly, and one honor book, *Tod of the Fens* by Elinor Whitney.

74. Ross, *Spirited Life*, 106.
75. Bader, "Macmillan Children's Books," 550.
76. Bechtel, "The Children's Librarian," in *Books*, 234.
77. Tebbel, *Between Covers*, 318–29. As a result of an intense wave of censorship after World War I, organizations such as the New York Society for the Suppression of Vice, the National Americanism Commission of the American Legion, the Sons and Daughters of the American Revolution, and Watch and Ward in Boston scrutinized book content both for violations of the Comstock law and for political sentiments deemed out of step with current, powerful pro-American sentiment. Such watchdog organizations directly affected writing for the young because they focused on textbooks, which were often revised in response to intense pressure.
78. Bertha Mahony, "The Hunt Breakfast," *Horn Book* 10 (March 1934): 66.
79. Meigs to Seaman, March 20, 1929, box 31, folder 437, LBP.
80. Stricker, "Cookbooks and Law Books," 9.
81. Scharf, *To Work*, 17.
82. Tebbel, *Between Covers*, 275.

Chapter 7. Triumph and Transition

1. Pruette, *Women Workers*, 51. In New York, unemployment figures among women rose from 13 percent in January 1931 to 23 percent by the early months of 1934, and then to 29 percent before New Deal programs stanched the hemorrhage of women out of the work force (20–22).
2. Scharf, *To Work*, 50, 82–83. As Scharf points out, women's professional status declined during the 1930s. Women in virtually all professions were hard hit. In addition to wage reductions, for example, teachers in New York were requested to donate 5 percent of their salaries for lunches, shoes, and clothing for their students, about 20 percent of whom were malnourished. In this way, expectations continued for women professionals to maintain their usual service ethos, despite severe financial hardship.
3. After surveying 1,350 women, Lorine Pruette concluded that unemployed women spent an average of sixteen months finding work, and reemployment, when found, frequently represented permanent loss of employment status. The claim was based partly on salary figures: in 1931, the median annual income among salaried female workers was $3,035. By 1934, this figure had fallen to $2,428.
4. Tebbel, *Between Covers*, 299.
5. Scharf, *To Work*, 87.
6. Mertie E. Whitlock, secretary, meeting minutes, May 1933, NERTCL.
7. Scharf, *To Work*, 87, 125.
8. Attempts at unionization in publishing, which might have provided recourse, were relatively unsuccessful. Unionism seemed inimical to the work of publishing, despite the fact that it was the most poorly compensated occupation in communications. Labor conflicts within the industry started in 1934 at Macaulay Company. A year later, about a hundred professionals held a meeting in New York to discuss the possibility of creating a union that looked more like a professional organization than a trade union (Tebbel, *Between Covers*, 283).
9. Sara Teasdale to Moore, October 11, 1931, box 1, ACMP.

10. Sayers, *Anne Carroll Moore,* 251–52.

11. Teasdale to Moore, October 14, 1931, box 2, ACMP.

12. Adams to Moore, October 10, 1931, box 1, ACMP.

13. Becker, undated memorandum, box 1, ACMP.

14. Moses to Moore, undated letter, box 2, ACMP.

15. Bertha Mahony, 1931 draft, "The Three Owls," box 24, folder 2, p. 3, HBR.

16. Sayers, *Anne Carroll Moore,* 291. The former children's room was converted to a seminar room of the library school at Pratt and named the Anne Carroll Moore Room. See Mahony, "Anne Carroll Moore," 9.

17. Tebbel, *Between Covers,* 276–300.

18. Ibid., 299.

19. Tebbel, *History of Book Publishing,* 3:535–36. Macmillan's strong-willed and conservative president stepped down in September 1931, leaving his son, George Brett Jr., in charge of the firm.

20. Bechtel, "Ladder of Time," in *Books,* 245–46.

21. Hodowanec, *May Massee Collection,* viii.

22. Bechtel to Miller, 1934, box 1, folder 23, HBR. Bechtel's successor, Doris Patee, was a Wellesley graduate, a teacher, and a librarian before joining Macmillan in 1932. She began work in the children's department in 1933 (Muriel Fuller series, *Publishers Weekly,* August 29, 1936).

23. Anne Eaton to Miller, January 24, 1935, box 5, folder 16, HBR.

24. Field to Bechtel, January 13, 1934, box 21, folder 279, LBP; Moore to Bechtel, January 10, 1934, box 468, folder 468, LBP.

25. The assistant was Margaret Lesser (1899–1979). In 1927, she worked for Massee as the juvenile publicity director at Doubleday and became the juvenile editor at Doubleday in 1934 (Muriel Fuller series, *Publishers Weekly,* August 8, 1936). Another of Massee's assistants, Dorothy Bryan, became the children's editor at Dodd, Mead in 1934 (Muriel Fuller series, *Publishers Weekly,* February 8, 1936).

26. Massee to Miller, undated letter, box 11, folder 2, HBR.

27. I. Smith, *History,* 53.

28. Miller to Massee, May 19, 1938, box 11, folder 21, HBR; I. Smith, *History,* 55–60.

29. Jenkins, "Of Nightingales," 827.

30. I. Smith, *History,* 58–62.

31. Bechtel, "Children's Librarian," in *Books,* 230.

32. When Houghton Mifflin invited the Round Table to visit their firm, Jordan readily accepted. It was the first time that many librarians had visited a publishing house (Mertie E. Whitlock, meeting notes, December 1932, NERTCL).

33. Moore to Miller, March 5, 1935, box 12, folder 10, HBR.

34. Ross, *Spirited Life,* 84.

35. Miller to Bechtel, December 19, 1934, box 1, folder 23, HBR.

36. Ross, *Spirited Life,* 146.

37. Miller told her grandniece in 1960 that even after twenty-eight years, she considered Ashburnham to be Celena's home. Ross notes that "consciously [Miller] adapted it to accommodate her peculiar needs as a professional woman; unconsciously she modified it by the gentleness of her personality" (*Spirited Life,* 150).

38. Ross, *Spirited Life,* 99, 145–49.

39. Financial records (1932–33), box 38, folder 9, HBR.

40. Folmsbee to Miller, March 21, 1934, box 38, folder 10, HBR.

41. Catherine Van Horn, "Turning Child Readers into Consumers," in Lundin and Wiegand, eds., *Defining Print Culture for Youth*, 121, 133.

42. Financial records (1932–33), box 38, folder 9, HBR.

43. Scrapbook 6, box 40, p. 78, HBR.

44. Bertha Mahony, editorial, *Horn Book* 9 (November 1933): 173; "From Good Friends," *Horn Book* 5 (November 1929): 101.

45. Van Horn, "Child Readers," 122–23.

46. Miller to Bechtel, December 19, 1934, box 1, folder 23, HBR; Ross, *Spirited Life*, 177.

47. The *Horn Book* budget also allowed three hundred dollars for annual space rental and ten dollars for each contributor. Financial records, 1934, box 39, folder 3, HBR.

48. Bechtel to Miller, 1939, box 1, folder 24, HBR; Miller to Bechtel, May 27, 1941, box 1, folder 24, HBR.

49. Bechtel to Miller, 1933, box 1, folder 23, HBR.

50. Folmsbee to Miller, March 21, 1934, box 38, folder 10, HBR.

51. Helen Smith to Miller, March 7, 1930, scrapbooks, box 40, HBR; scrapbook, 1934–35, box 40, p. 3, HBR.

52. Eleanor Jewett to Miller, May 29, 1947, box 9, folder 1, HBR.

53. Miller to Bechtel, December 19, 1934, box 1, folder 23, HBR; Miller to Bechtel, April 10, 1941, box 1, folder 24, HBR.

54. Massee to Miller, February 18, 1935, box 11, folder 21, HBR.

55. Bianco, advertisement in *Horn Book* 25 (September 1949): 425–26. Becker, book jacket, 1949 reissue of *Trigger John*. Despite the failure of Miller to review the book, *Trigger John* ultimately became a Junior Literary Guild selection.

56. Miller to Helen Dean Fish, February 5, 1935, box 6, folder 20, HBR; Mahony to Massee, February 20, 1925, box 6, folder 20, HBR.

57. Miller to Bechtel, 1935, box 1 folder 23, HBR.

58. Bechtel to Miller, December 19, 1934, box 1, folder 23, HBR.

59. Miller to Bechtel, 1935, box 1, folder 23, HBR.

60. Miller, editorial policy statement, *Horn Book* 10 (1934): 336.

61. Jenkins, "Strength of the Inconspicuous," 74–78.

62. Scrapbook, 1934–35, box 40, p. 1, HBR.

63. Scrapbook, 1934–35, box 40, p. 3, HBR.

64. Whitney to Miller, January 31, 1935, box 6, folder 14, HBR.

65. Mahony and Whitney, comps., *Five Years of Children's Books*, viii, 1, 3.

66. Miller to Bechtel, December 19, 1934, box 1, folder 23, HBR.

67. Whitney to Miller, January 3, 1935, HBR.

68. Bechtel to Miller, 1934, box 1, folder 23, HBR.

69. Miller to Melcher, January 25, 1934, box 11, folder 29, HBR.

70. Ross, *Spirited Life*, 100.

71. Jordan to Miller, May 24, 1936, box 8, folder 7, HBR.

72. Miller to Hunt, July 28, 1936, box 8, folder 7, HBR.

73. Elinor Whitney Field, "Chapters from Horn Book History—VIII," *Horn Book* 39 (June 1963): 330.

74. Ross, *Spirited Life*, 120–21; Miller to Jordan, May 27, 1941, box 9, folder 6, HBR.

75. Moore to Miller, October 12, 1936, box 12, folder 10, HBR.

76. Moore to Miller, August 27, 1936, box 12, folder 10, HBR. Circulation for 1936 was 2,291; by the end of 1937 it reached 2,866, with an annual increase thereafter (excepting 1940) of approximately 15 percent. Financial records, box 37, folder 1, HBR.

77. Ross, *Spirited Life*, 181.

78. Moore to Miller, March 23, 1938, box 12, folder 10, HBR.

79. Moore to Miller, February 9, 1937, box 12, folder 10, HBR.

80. Miller to Moore, May 16, 1939, box 12, folder 11, HBR.

81. Fish to Miller, February 11, 1938, box 11 folder 38, HBR.

82. Miller to Massee, May 19, 1938, box 11 folder 21, HBR.

83. Folmsbee oversaw *Horn Book* productions such as *A Little History of the Horn-Book* (written by Folmsbee), *Books, Children, and Men* by Paul Hazard, and *Illustrators of Children's books, 1744–1945*, compiled by Mahony, Latimer, and Folmsbee. See "Chapters of Horn Book History—VIII," *Horn Book* 39 (1963): 330.

84. Jordan to Miller, May 17, 1939, box 9, folder 6, HBR.

85. Moore to Miller, 1939, box 12, folder 11, HBR.

86. Bechtel, "Children's Librarian," in *Books*, 227–28.

Epilogue

1. Ross, *Spirited Life*, 201–40.

2. The award is given to "a distinguished living bookwoman for her extraordinary contribution to the world of books and through books to the society in which we live." Now known as the Women's National Book Association Award, it is awarded annually by the WNBA.

3. Bechtel, "Ladder of Time," in *Books*, 252–53.

4. Bechtel, "In Search of Children," in *Books*, 189.

5. Scharf, *To Work*, 93. According to Scharf, this trend could also be seen in higher education where the number of female faculty members fell precipitously. At Vassar, for example, female faculty fell from 83 percent to 70 percent between 1924 and 1934 (92). See the chapter "He Wants My Job" in *To Work and to Wed*.

6. Ibid., 96–97.

7. Vandergrift, "Female Advocacy," 709.

8. Ross, *Spirited Life*, 126.

BIBLIOGRAPHY

Addams, Jane. *The Spirit of Youth and the City Streets*. New York: Macmillan, 1909.

Allen, Frederick Lewis. *Only Yesterday: An Informal History of the Nineteen Twenties*. New York: Harper and Bros., 1931.

Andersen, Edwin. "Training for Library Service." *Library Journal* 49 (May 15, 1924): 462–66.

Andrews, Siri, ed. *The Hewins Lectures, 1947–1962*. Boston: Horn Book, 1963.

Antler, Joyce. "The Educated Woman and Professionalization: The Struggle for a New Feminine Identity, 1890–1920." Ph.D. diss., State University of New York at Stony Brook, 1977.

Arbuthnot, May Hill. *Children and Books*. Chicago: Scott, Foresman, 1957.

Augst, Tom, and Wayne Wiegand, eds. *Libraries as Agencies of Culture*. Madison: University of Wisconsin Press, 2002.

Avery, Gillian. *Behold the Child: American Children and Their Books, 1621–1922*. Baltimore: Johns Hopkins University Press, 1994.

Bader, Barbara. *American Picturebooks from Noah's Ark to the Beast Within*. New York: Macmillan, 1976.

———. "Macmillan Children's Books, 1919–1995." *Horn Book* 71 (September–October 1995): 548–61.

———. "*Only* the Best: The Hits and Misses of Anne Carroll Moore." *Horn Book* 63 (September–October 1997): 520–28.

———. "Realms of Gold and Granite." *Horn Book,* 75th Anniversary Issue (September–October 1999): 524–31.

Barnes, Earl. "A New Profession for Women." *Atlantic Monthly* (August 1915): 225–34.

Bechtel, Louise Seaman. *Books in Search of Children: Speeches and Essays by Louise Seaman Bechtel*. Selected and with an introduction by Virginia Haviland. New York: Macmillan, 1940.

———. *The Boy with the Star Lantern*. Published privately, 1960.

———. "Rachel's Gifts." *Horn Book* 18 (July–August 1942): 230–36.

Becker, May Lamberton. *Adventures in Reading*. New York: Frederick A. Stokes, 1927.

BIBLIOGRAPHY

Bernard, Jessie. *Academic Women*. University Park: Pennsylvania State University Press, 1964.

Bingham, Jane. *Writers for Children: Critical Studies of Major Authors since the Seventeenth Century*. New York: Charles Scribner's Sons, 1988.

Blair, Karen J. *The Clubwoman as Feminist: True Womanhood Redefined, 1868–1914*. New York: Holmes and Meier, 1980.

Blanchard, Phyllis, and Carolyn Manasses. *New Girls for Old*. New York: Macaulay, 1930.

Bledstein, Burton J. *The Culture of Professionalism: The Middle Class and the Development of Higher Education in America*. New York: W. W. Norton, 1976.

Bostwick, Arthur Elmore. *The American Public Library*. New York: Appleton, 1929.

Bowker, R. R. "Seed Time and Harvest—The Story of the ALA." *Bulletin of the American Library Association* 20 (October 1926): 303–9.

Brodhead, Richard H. *Cultures of Letters: Scenes of Reading and Writing in the Nineteenth Century*. Chicago: University of Chicago Press, 1993.

Brown, Eleanor Frances. *Bookmobiles and Bookmobile Service*. Metuchen, NJ: Scarecrow Press, 1967.

Brown, Joanne. *The Definition of a Profession: The Authority of Metaphor in the History of Intelligence Testing, 1890–1933*. Princeton, NJ: Princeton University Press, 1992.

Bush, Margaret. "New England Women: Their Increasing Influence." *Library Trends* 44 (Spring 1996): 719–35.

Butler, Susan Lowell. *The National Education Association: A Special Mission*. Washington, DC: National Education Association, 1987.

Carson, Jessie. "The Children's Share in a Public Library." *Library Journal* 37 (May 1912): 251–56.

Chafe, William. *The American Woman: Her Changing Social, Economic, and Political Roles, 1920–1970*. New York: Oxford University Press, 1972.

Cott, Nancy. *The Grounding of American Feminism*. New Haven, CT: Yale University Press, 1987.

Croly, Jane Cunningham. *The History of the Woman's Club Movement in America*. New York: Henry G. Allen, 1898.

Crunden, Frederick M. "The Public Library Movement and Civic Improvement." *Chautauqua* 42 (June 1906): 335–44.

Cutter, Charles A. "Pernicious Reading in Our Public Libraries." *Nation* 33 (November 10, 1881): 370–71.

Dain, Phyllis. *The New York Public Library: A History of Its Founding and Early Years*. New York: New York Public Library, Astor, Lenox, and Tilden Foundations, 1972.

Dalgliesh, Alice. *First Experiences with Literature*. New York: Charles Scribner's Sons, 1937.

Dana, John Cotton. "Women in Library Work." *Independent* 71 (August 3, 1911): 244–50.

Daniels, John. "Americanization by Indirection." *Library Journal* 45 (November 1, 1920): 871–76.

Darling, Richard. *The Rise of Children's Book Reviewing in America, 1865–1881*. New York: R. R. Bowker, 1968.

Darling, William Y. *The Private Papers of a Bankrupt Bookseller*. London: Oliver and Boyd, 1932.

Day, Serenna F. *The Horn Book Index, 1924–1989*. Phoenix, AZ: Oryx Press, 1990.

Deutsch, Sarah. *Women and the City: Gender, Space, and Power in Boston, 1870–1940.* New York: Oxford University Press, 2000.

Dewey, Melvil. *Librarianship as Profession for College-Bred Women.* Boston: Library Bureau, 1886.

———. "The Library as Educator." *Library Notes* 1 (June 1886): 1–5.

Ditzion, Sidney H. *Arsenals of a Democratic Culture: A Social History of the American Public Library Movement in New England and the Middle States from 1850–1900.* Chicago: American Library Association, 1947.

Doubleday, Frank N. *Memoirs of a Publisher.* Garden City, NY: Doubleday, 1972.

Douglas, Ann. *The Feminization of American Culture.* New York: Alfred A. Knopf, 1977.

Downey, Mary Elizabeth. "Relation of the Public Schools to the Various Library Agencies." *Library Journal* 45 (November 1, 1920): 883–86.

Duke, Judith. *Children's Books and Magazines: A Market Study.* White Plains, NY: Knowledge Industry, 1978.

Eaton, Anne Thaxter. *Reading with Children.* New York: Viking, 1947.

Egoff, Sheila A. *Thursday's Child: Trends and Patterns in Contemporary Children's Literature.* Chicago: American Library Association, 1981.

Ellis, Alec. *A History of Children's Reading and Literature: Reading with Children.* London: Pergamon Press, 1968

Fain, Elaine. "Manners and Morals in the Public Library: A Glance at Some New History." *Journal of Library History* 10 (1975): 99–105.

Fass, Paula. *The Damned and the Beautiful: American Youth in the 1920s.* New York: Oxford University Press, 1979.

Fitzpatrick, Ellen. *Endless Crusade: Women Social Scientists and Progressive Reform.* New York: Oxford University Press, 1990.

Foucault, Michel. *The Archaeology of Knowledge.* New York: Pantheon Books, 1972.

Garrison, Dee. *Apostles of Culture: The Public Librarian and American Society, 1876–1920.* Madison: University of Wisconsin Press, 2003.

———. "The Tender Technicians: The Feminization of Public Librarianship, 1976–1905." *Journal of Social History* 6 (Winter 1973): 131–59.

Gilbert, Sandra M., and Susan Gubar. *No Man's Land: The Place of the Woman Writer in the Twentieth Century.* New Haven, CT: Yale University Press, 1988.

Gillespie, John T., and Corinne J. Naden. *The Newbery Companion: Booktalk and Related Materials for Newbery Medal and Honor Books.* Englewood, CA: Libraries Unlimited, 1996.

Glazer, Penina Migdal, and Miriam Slater. *Unequal Colleagues: The Entrance of Women into the Professions, 1890–1940.* New Brunswick, NJ: Rutgers University Press, 1987.

Goldsmith, Sophie L. "Spare the Book and Spoil the Child." *Nation* 129 (October 16, 1929).

Gordon, Linda. *Heroes of Their Own Lives: The Politics and History of Family Violence.* New York: Viking, 1988.

Grotzinger, Laurel. "The Proto-Feminist Librarian at the Turn of the Century: Two Studies." *Journal of Library History* 10 (July 1975): 195–213.

Gruenberg, Benjamin C., ed. *Guidance of Childhood: Readings in Child Study.* New York: Macmillan, 1928.

Habermas, Jurgen. *The Structural Transformation of the Public Sphere,* Cambridge, MA: MIT Press, 1989.

Hall, David D. *Cultures of Print: Essays in the History of the Book.* Amherst: University of Massachusetts Press, 1996.

Hannigan, Jane Anne. "A Feminist Analysis of the Voices for Advocacy in Young Adult Services." *Library Trends* 44 (Spring 1996): 851–74.

Harris, Michael H. "The Purpose of the American Public Library: A Revisionist Interpretation." *Library Journal* 98 (1973): 2509–14.

Haviland, Virginia. "A Second Golden Age? In a Time of Flood?" *Horn Book* 47 (August 1971): 409–19.

Hawes, Joseph M. *Children between the Wars: American Childhood, 1920–1940.* New York: Twayne, 1997.

Hawes, Joseph M., and N. Ray Hiner. *American Childhood: A Research Guide and Historical Handbook.* Westport, CT: Greenwood, 1985.

Hawley, Ellis. *The Great War and the Search for Modern Order.* New York: St. Martin's Press, 1979.

Hazard, Paul. *Books, Children and Men.* Boston: Horn Book, 1944.

Hazeltine, Alice Isabel, ed. *Library Work with Children.* New York: H. W. Wilson, 1917.

———. "Opportunities for College Women in Library Work." *Bookman* 42 (February 1916): 685–91.

Hearne, Betsy. "Margaret K. McElderry and the Professional Matriarchy of Children's Books." *Library Trends* 44 (Spring 1996): 755–75.

Hearne, Betsy, and Christine Jenkins. "Sacred Texts: What Our Foremothers Left Us in the Way of Psalms, Proverbs, Precepts, and Practices." *Horn Book* 75 (September–October 1999): 536–58.

Heilbrun, Carolyn. *Writing a Woman's Life.* New York: W. W. Norton, 1988.

Heim, Kathleen M., ed. *The Status of Women in Librarianship: Historical, Sociological, and Economic Issues.* New York: Neal-Schuman, 1983.

Hewins, Caroline Maria, ed. *Books for Boys and Girls: A Selected List.* Boston: American Library Association Publishing Section, 1897.

Hildenbrand, Suzanne. "Library Feminism and Library Women's History: Activism and Scholarship, Equity and Culture." *Libraries and Culture* 35 (Winter 2000): 55–65.

Hiner, N. Ray, and Joseph M. Hawes, eds. *Growing Up in America: Children in Historical Perspective.* Urbana: University of Illinois Press, 1985.

Hodowanec, George V. *The May Massee Collection: Creative Publishing for Children, 1923–1963, a Checklist.* Emporia, KS: Emporia State University, 1979.

Horn, Margo. *Before It's Too Late: The Child Guidance Movement in the United States, 1922–1945.* Philadelphia: Temple University Press, 1989.

Hummer, Patricia M. *The Decade of Elusive Promise: Professional Women in the United States, 1920–1930.* Ann Arbor, MI: UMI Research Press, 1979.

Jagusch, Sybille Anna. "First among Equals: Caroline M. Hewins and Anne C. Moore: Foundations of Library Work with Children." Ph.D. diss., University of Maryland, 1990.

———, ed. *Stepping Away from Tradition: Children's Books of the Twenties and Thirties.* Washington, DC: Library of Congress, 1988.

Jenkins, Christine. "The Strength of the Inconspicuous: Youth Services, Librarians, the ALA, and Intellectual Freedom of the Young, 1939–1955." Ph.D. diss., University of Wisconsin–Madison, 1995.

———. "Women of the ALA Youth Services and Professional Jurisdiction: Of Nightingales, Newberies, Realism, and the Right Books, 1937–1945." *Library Trends* 44 (Spring 1996): 813–39.

Jennings, Judson. "Sticking to Our Last." *Library Journal* (July 1924): 613–18.

Johnson, Deidre. *Edward Stratemeyer and the Stratemeyer Syndicate.* New York: Twayne, 1993.

Jones, Edith Kathleen. "What a Base Hospital Should Know—Outline of a Course of Training." *Library Journal* (August 1918): 568–72.

Jones, Kathleen W. *Taming the Troublesome Child: American Families, Child Guidance, and the Limits of Psychiatric Authority.* Cambridge, MA: Harvard University Press, 1999.

Jordan, Alice. M. *From Rollo to Tom Sawyer.* Boston: Horn Book, 1948.

———. "The Ideal Book from the Standpoint of the Children's Librarian." In *Children's Library Yearbook,* 9–11. Chicago: American Library Association, 1934.

Jordan, Arthur Melville. *Children's Interests in Reading.* Chapel Hill: University of North Carolina Press, 1926.

Kerber, Linda. *Toward an Intellectual History of Women: Essays.* Chapel Hill: University of North Carolina Press, 1997.

Kett, Joseph. *Rites of Passage: Adolescence in America, 1790–Present.* New York: Basic Books, 1977.

Kimball, Melanie Ann. "Youth Services at St. Louis Public Library, 1909–1933: A Narrative Case Study." Ph.D. diss., University of Illinois at Urbana–Champaign, 2003.

Kliebard, Herbert M. *The Struggle for the American Curriculum, 1893–1958.* New York: Routledge, 1995.

Kroch, Adolph. *A Great Bookstore in Action.* Chicago: University of Chicago Press, 1939.

Kujoth, Jean Spealman. *Best-Selling Children's Books.* Metuchen, NJ: Scarecrow Press, 1973.

Lasch, Christopher. *Haven in a Heartless World: The Family Besieged.* New York: Norton, 1977.

Lears, T. J. Jackson. *No Place of Grace: Antimodernism and the Transformation of American Culture, 1880–1920.* Chicago: University of Chicago Press, 1983.

Levstik, Linda. "From the Outside In: American Children's Literature from 1920–1940." *Theory and Research in Social Education* (Fall 1990): 327–43.

Library Bureau. *Libraries.* Chicago: Library Bureau, 1897.

Library School of the University of Wisconsin. *An Apprentice Course for Small Libraries.* Chicago: American Library Association Publishing Board, 1917.

Long, Elizabeth. *Book Clubs: Women and the Uses of Reading in Everyday Life.* Chicago: University of Chicago Press, 2003.

Lunbeck, Elizabeth. *The Psychiatric Persuasion: Knowledge, Gender, and Power in Modern America.* Princeton, NJ: Princeton University Press, 1994.

Lundin, Anne. "The Pedagogical Context of Women in Children's Services and Literature Scholarship." *Library Trends* 44 (Spring 1996): 840–50B.

Lundin, Anne, and Wayne A. Wiegand, eds. *Defining Print Culture for Youth: The Cultural Work of Children's Literature*. Westport, CT: Libraries Unlimited, 2003.

Maack, Mary Niles, and Joanne Passet. *Aspirations and Mentoring in an Academic Environment: Women Faculty in Library and Information Science*. Westport, CT: Greenwood, 1994.

Mackey, Margaret. *The Case of Peter Rabbit: Changing Conditions of Literature for Children*. New York: Garland, 1998.

MacLeod, Anne Scott. *American Childhood: Essays on Children's Literature of the Nineteenth and Twentieth Centuries*. Athens: University of Georgia Press, 1994.

Macmillan Company. *The Author's Book: Being Notes for the Guidance of Authors in Dealing with Publishers*. New York: Macmillan, 1925.

Madison, Charles A. *Book Publishing in America*. New York: McGraw-Hill, 1966.

Mahony, Bertha E. "Alice M. Jordan: Her Life and Work." *Horn Book* 37 (November 1961): 4–13.

———. "Anne Carroll Moore: Doctor of Humane Letters." *Horn Book* 18 (January–February 1942): 7–18.

———. "Children's Books in America Today." *Horn Book* 12 (July–August 1936): 199–207.

———. "Other Children's Book Departments since 1918." *Horn Book* 4 (August 1928): 74–76.

Mahony, Bertha, and Elinor Whitney, comps. *Contemporary Illustrators of Children's Books*. Boston: Bookshop for Boys and Girls (WEIU), 1930.

———, comps. *Five Years of Children's Books: A Supplement to "Realms of Gold."* New York: Doubleday, 1936.

———, comps. *Realms of Gold in Children's Books*. Garden City, NY: Doubleday, Doran, 1930.

Mahony, Bertha, Louise Payson Latimer, and Beulah Folmsbee, comps. *Illustrators of Children's Books, 1744–1945*. Boston: Horn Book, 1947.

Marcum, Deanna B. *Good Books in a Country Home: The Public Library as Cultural Force in Hagerstown, Maryland, 1878–1920*. Westport, CT: Greenwood, 1994.

Marcus, Leonard, ed. *Dear Genius: The Letters of Ursula Nordstrom*. New York: HarperCollins, 1998.

———. "The Here and Now Comes of Age: Margaret Wise Brown, Lucy Sprague Mitchell, and the Early Days of Writing for Children at Bank Street." In *Celebrating Diverse Voices: Progressive Education and Equity*, edited by Frank Pignatelli and Susanna W. Pflaum. Newbury Park, CA: Corwin Press, 1993.

Marek, Jayne E. *Women Editing Modernism: "Little" Magazines and Literary History*. Lexington: University of Kentucky Press, 1995.

McQuin, Susan Coultrap. *Doing Literary Business: American Women Writers in the Nineteenth Century*. Chapel Hill: University of North Carolina Press, 1990.

Meigs, Cornelia. *A Critical History of Children's Literature*. New York: Macmillan, 1953.

Melcher, Frederic. "Thirty Years of Children's Books." In *Children's Library Yearbook*, 5–10. Chicago: American Library Association, 1929.

Minnich, Elizabeth Kamarek. *Transforming Knowledge*. Philadelphia: Temple University Press, 1990.

Moore, Anne Carroll. "Children's Books of 1919." *Bookman* 50 (November–December 1919): 376–84.

———. "Children's Libraries in France." *Library Journal* 45 (October 15, 1920): 831–32.

———. *Cross-Roads to Childhood*. New York: George H. Doran, 1926.

———. *My Roads to Childhood: Views and Reviews of Children's Books*. New York: Doubleday, Doran, 1939.

———. *New Roads to Childhood*. New York: George H. Doran, 1923.

———. "Reading Rooms for Children." *Libraries*. Chicago: Library Bureau, 1897.

———. *Roads to Childhood*. New York: George H. Doran, 1920.

———. "The Story Hour at Pratt Institute Free Library." *Library Journal* 30 (1905): 205.

———. "Viewing and Reviewing Books for Children." *Bookman* 50 (September 1919): 29–37.

Morgan, Charles. *The House of Macmillan, 1843–1943*. London: Macmillan, 1943.

Moses, Montrose Jacob. *Children's Books and Reading*. New York: Mitchell Kennerley, 1907.

Muncy, Robyn. *Creating a Female Dominion in American Reform, 1890–1935*. New York: Oxford University Press, 1991.

Murray, Gail Schmunk. *American Children's Literature and the Construction of Childhood*. New York: Twayne, 1998.

New York State Library School Association. *New York State Library School: Register 1887–1926*. New York: Rider Press, 1928.

O'Neill, William. *Everyone Was Brave: The Rise and Fall of Feminism in America*. Chicago: Quadrangle Books, 1969.

Parker, Alison. *Purifying America: Women, Cultural Reform, and Pro-Censorship Activism, 1873–1933*. Urbana: University of Illinois Press, 1997.

Passet, Joanne E. *Cultural Crusaders: Women Librarians in the American West, 1900–1917*. Albuquerque: University of New Mexico Press, 1994.

———. "Reaching the Rural Reader: Traveling Libraries in America, 1892–1920." *Libraries and Culture* 26 (Winter 1991): 100–118.

Pawley, Christine. "Hegemony's Handmaid? The Library and Information Studies Curriculum from a Class Perspective." *Library Quarterly* 68 (April 1998): 123–44.

———. *Reading on the Middle Border: The Culture of Print in Osage, Iowa, 1860–1900*. Amherst: University of Massachusetts Press, 2001.

Peiss, Kathy. *Cheap Amusements: Working Women and Leisure in Turn-of-the-Century New York*. Philadelphia: Temple University Press, 1986.

Peterson, Linda Kauffman. *Newbery and Caldecott Medal and Honor Books: An Annotated Bibliography*. Boston: G. K. Hall, 1982.

Price Sawyer, Harriet, ed. *The Library as a Vocation*. New York: H. W. Wilson, 1933.

Pruette, Lorine. *Women and Leisure: A Study of Social Waste*. New York: E. P. Dutton, 1924.

———. *Women Workers through the Depression*. New York: Macmillan, 1934.

Quandt, Jean B. *From Small Town to Great Community: The Social Thought of Progressive Intellectuals*. New Brunswick, NJ: Rutgers University Press, 1970.

Radway, Janice. *Reading the Romance: Women, Patriarchy, and Popular Literature*. Chapel Hill: University of North Carolina Press, 1984.

Robbins, Louise S. *Censorship and the American Library: The American Library Association's Response to Threats to Intellectual Freedom, 1939–1969*. Westport, CT: Greenwood, 1996.

Rosenberg, Rosalind. *Beyond Separate Spheres: Intellectual Roots of Modern Feminism.* New Haven, CT: Yale University Press, 1982.

Ross, Eulalie Steinmetz. *The Spirited Life: Bertha Mahony Miller and Children's Books.* Boston, MA: Horn Book, 1973.

Rubin, Joan Shelley. *The Making of Middlebrow Culture.* Chapel Hill: University of North Carolina Press, 1992.

Rury, John L. *Education and Women's Work: Female Schooling and the Division of Labor in Urban America, 1870–1930.* Albany: State University of New York Press, 1991.

Ryan, Mary P. *Womanhood in America: From Colonial Times to the Present.* New York: New Viewpoints, 1975.

Sanborn, Henry N. "Books for Men." *Library Journal* 41 (March 1916): 165–69.

Sawyer, Ruth. *The Way of the Storyteller.* New York: Viking, 1951.

Sayers, Frances Clarke. *Anne Carroll Moore: A Biography.* New York: Atheneum, 1972.

Scharf, Lois. *To Work and to Wed: Female Employment, Feminism, and the Great Depression.* Westport, CT: Greenwood, 1980.

Scott, Anne Firor. *Natural Allies: Women's Associations in American History.* Urbana: University of Illinois Press, 1991.

Shedlock, Marie. *The Art of the Story-Teller.* New York: D. Appleton, 1915.

Sheehan, Donald. *This Was Publishing: A Chronicle of the Book Trade in the Gilded Age.* Bloomington: Indiana University Press, 1952.

Shera, Jesse H. *Foundations of the Public Library: The Origins of the Public Library Movement in New England, 1629–1855.* Chicago: University of Chicago Press, 1949.

Showalter, Elaine, ed. *These Modern Women.* Old Westbury, NY: Feminist Press, 1978.

Smith, Irene. *A History of the Newbery and Caldecott Medals.* New York: Viking, 1957.

Smith, Rita J. "Just Who Are These Women? Louise Seaman Bechtel and Ruth Marie Baldwin." *Journal of Youth Services in Libraries* 11 (Winter 1998): 161–70.

Smith-Rosenberg, Carol. *Disorderly Conduct: Visions of Gender in Victorian America.* New York: Oxford University Press, 1986.

Solomon, Barbara Miller. *In the Company of Educated Women: A History of Women and Higher Education in America.* New Haven, CT: Yale University Press, 1985.

Stevenson, Deborah. "Sentiment and Significance: The Impossibility of Recovery in the Children's Literature Canon or, the Drowning of the Water Babies." *Lion and the Unicorn* 21 (1997): 112–13.

Stielow, Frederick J. "Censorship in the Early Professionalization of American Libraries, 1876–1923." *Journal of Library History* 18 (Winter 1983): 37–54.

Stricker, Frank. "Cookbooks and Law Books: The Hidden History of Career Women in Twentieth Century America." *Journal of Social History* 10 (Fall 1976): 1–19.

Sturges, Florence. "Alice M. Jordan, Library Pioneer, Was Maine Native." *Lewiston Journal Magazine,* April 11, 1970.

———. "The Pattern and the Ideal." *Horn Book* 37 (November 1961): 35–38.

Sullivan, Larry E., and Lydia Cushman Schurman, eds. *Pioneers, Passionate Ladies, and Private Eyes: Dime Novels, Series Books, and Paperbacks.* New York: Haworth, 1996.

Tebbel, John. *The American Magazine: A Compact History.* New York: Hawthorn Books, 1969.

———. *Between Covers: The Rise and Transformation of Book Publishing in America.* New York: Oxford University Press, 1987.

———. *A History of Book Publishing in the United States.* 4 vols. New York: R. R. Bowker, 1972.

Thomas, Fannette H. "The Genesis of Children's Services in the American Public Library, 1875–1906." Ph.D. diss., University of Wisconsin–Madison, 1982.

Townsend, John Rowe. *Written for Children: An Outline of English-Language Children's Literature.* Lanham, MD: Scarecrow Press, 1996.

Tyler, Anna Cogswell. "Library Reading Clubs for Young People." *Library Journal* 37 (October 1912): 547–50.

Vandergrift, Kay E. "Female Advocacy and Harmonious Voices: A History of Public Library Services and Publishing for Children in the United States." *Library Trends* 44 (Spring 1996): 683–718.

Van Slyck, Abigail. *Free to All: Carnegie Libraries and American Culture, 1890–1920.* Chicago: University of Chicago Press, 1995.

Wadlin, Horace G. *The Public Library of the City of Boston: A History.* Boston: Boston Public Library, 1911.

Walkley, Raymond L. "All in the Day's Work." *Library Journal* 43 (March 1918): 159–63.

Ware, Susan. *Beyond Suffrage: Women in the New Deal.* Cambridge, MA: Harvard University Press, 1981.

Weiner, Lynn Y. *From Working Girl to Working Mother: The Female Labor Force in the United States, 1820–1980.* Chapel Hill: University of North Carolina Press, 1985.

Whitehill, Walter Muir. *Boston Public Library: A Centennial History.* Cambridge, MA: Harvard University Press, 1956.

Wiegand, Wayne A. *"An Active Instrument for Propaganda": The American Public Library during World War I.* New York: Greenwood, 1989.

———. *Irrepressible Reformer: A Biography of Melvil Dewey.* Chicago: American Library Association, 1996.

———. "The Politics of Cultural Authority." *American Libraries* 29 (January 1998): 80–82.

———. *The Politics of an Emerging Profession: The American Library Association, 1876–1917.* New York: Greenwood, 1986.

———. "The Structure of Librarianship: Essay on an Information Profession." *Canadian Journal of Library and Information Studies* 24 (April 1999): 17–37.

———. "Tunnel Vision and Blind Spots: What the Past Tells Us about the Present; Reflections on the Twentieth-Century History of American Librarianship." *Library Quarterly* 69 (January 1999): 1–32.

Wright, Rowe. "Women in Publishing—Louise Seaman." *Publishers Weekly* 114 (July 28, 1928): 318–21.

Zuckerman, Mary Ellen. *A History of Women's Magazines in the United States, 1792–1995.* Westport, CT: Greenwood, 1998.

INDEX

Print Culture History in Modern America

James P. Danky and Wayne A. Wiegand, General Editors

Libraries as Agencies of Culture

Edited by Thomas Augst and Wayne Wiegand

Purity in Print: Book Censorship in America from the Gilded Age to the Computer Age, Second Edition

Paul S. Boyer

Women in Print: Essays on the Print Culture of American Women from the Nineteenth and Twentieth Centuries

Edited by James P. Danky and Wayne A. Wiegand

Bookwomen: Creating an Empire in Children's Book Publishing, 1919–1939

Jacalyn Eddy

Apostles of Culture: The Public Librarian and American Society, 1876–1920

Lora Dee Garrison

37505349R00126